W9-CRI-090

MANET

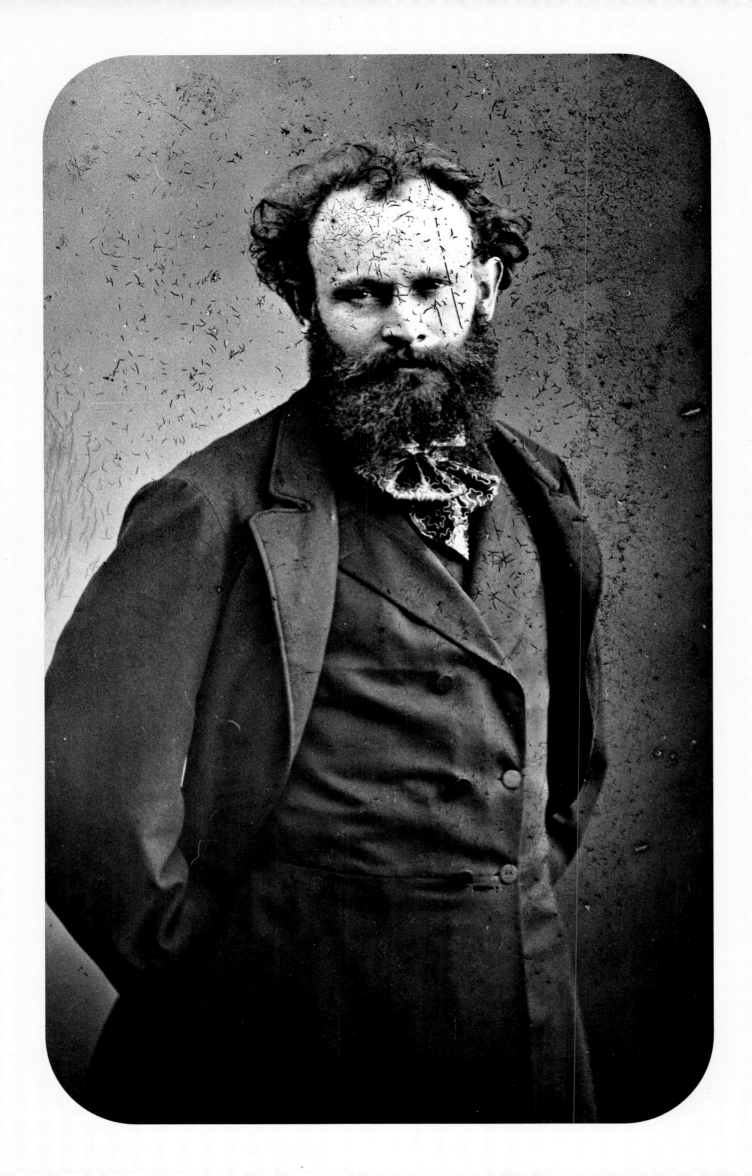

FRANÇOISE CACHIN

MANET

Translated from the French by Emily Read

KONECKY&KONECKY

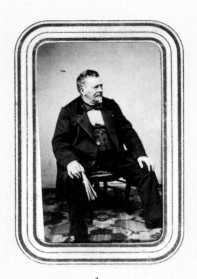

1

Manet would visit the Louvre with his
maternal uncle, Colonel Fournier.

2

Manet was born on 23 Jan. 1832 in rue des
Petits-Augustins, now rue Bonaparte, on the
bank opposite the Louvre.

3

At six he entered Canon Poiloup's institution,
and then became a boarder at the Collège
Rollin.

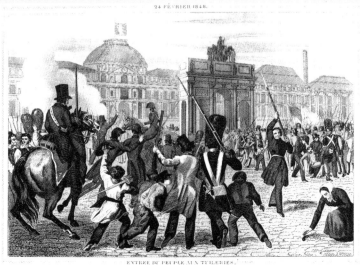

4

In 1848, after following the February insurrection in Paris, and
failing the entrance to the Naval College, he sailed for Rio on
Le Havre et Guadeloupe.

5

The letters he wrote to his parents during this voyage remain
touching accounts of life on board. On his return, he ceased to want
to be a sailor and decided to become a painter.

6

His father would have liked him to enter the Beaux-Arts,
but Edouard chose to join the studio of the painter Thomas
Couture. The family moved to the rue du Mont-Thabor.

7

The young man could now attend
drawing classes in the rue Laval, now
rue Victor-Massé.

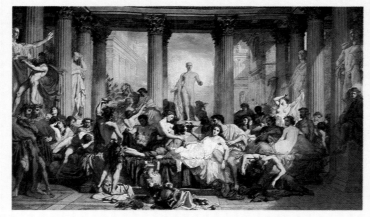

8

Thomas Couture was a young painter who had become
famous with an important composition, *Romans of the
Decadence*, which he showed at the 1847 Salon.

5

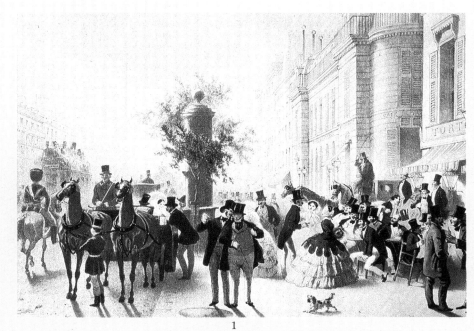

1

During his youth and for a long time afterwards, Edouard Manet frequented the Café Tortoni, on the boulevards, where artists and dandies used to meet.

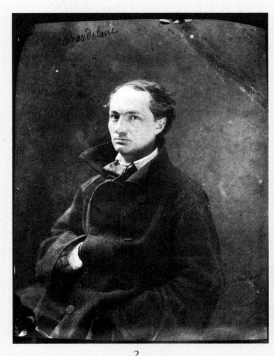

2

There he would find the poet Charles Baudelaire, whom he had met during an evening with the commandant Lejosne in 1858.

3

At that time Napoleon III's half-brother, the Duc de Morny, one of the plotters of the 1851 *coup d'état*, was preparing for the disastrous expedition to Mexico.

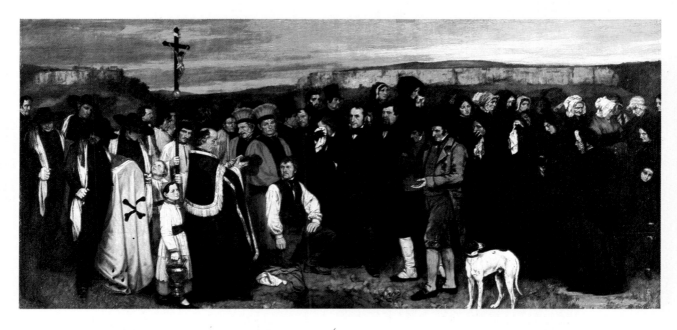

4
Manet defended Courbet's painting, but admitted: 'Yes, *Funeral at Ornans* is very good. One cannot say it often enough, it is better than anything. And yet it is not quite that. It is too black.'

5
The jury, on which Corot sat, accepted Courbet at the Salon in 1850, despite the controversies which he had aroused.

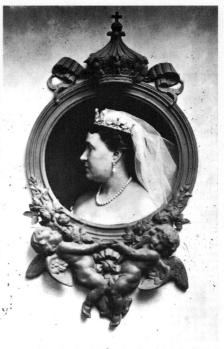

6
The artistic world flocked to Princess Mathilde's salon; she painted water-colours in her studio in the rue de Courcelles.

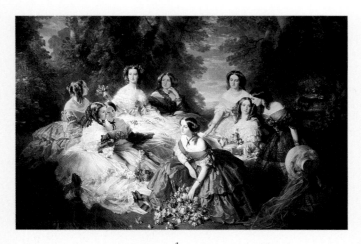

1

In Winterhalter's painting, the Empress
is shown surrounded by her ladies-in-
waiting.

2

The painting was shown during the International
Exhibition of 1855 at the Palais de l'Industrie, at the
Salon des Arts.

3

Eugénie's beauty and her Spanish origins
influenced fashion, which began to emphasise
shoulders and low necklines.

4

In 1853, the Emperor married Eugénie de
Montijo. The beautiful Spaniard had defeated her
rivals. Her beauty and grace were praised
everywhere.

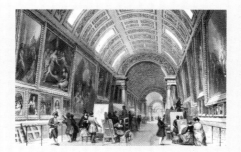

5

Manet would visit the Louvre, where, with
other copyists, he studied the masters.

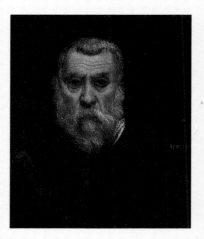 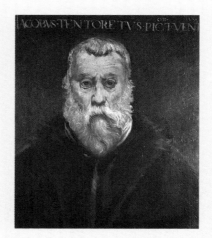

6

Thus he produced a copy of Tintoretto's *Self-Portrait*.

 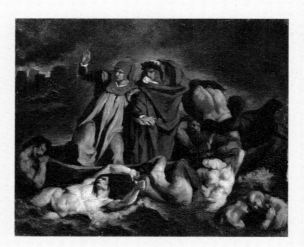

7

In the year 1855, he decided to visit Delacroix in
his studio in the rue Notre-Dame-de-Lorette to
obtain permission to copy *Dante's Ferry-Boat*.

8

As he left Delacroix's studio, Manet said to Antonin
Proust, who had accompanied him: 'It's not Delacroix
who's cold; it's his theory that's icy.'

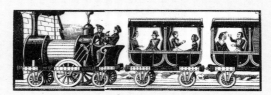

9

In 1853, the Paris-Orleans railway was
opened; its average speed was 20 km/h.

9

Page 5:
8 *Romans of the Decadence,*
1847. Thomas Couture
Oil on canvas, 466 x 775 cm
Musée d'Orsay, Paris (RMN)

Page 7:
4 *The Funeral at Ornans,*
1849-50. Gustave Courbet
Oil on canvas, 311.5 x 668 cm
Musée d'Orsay, Paris (RMN)

Page 8:
1 *The Empress Eugénie with her
ladies-in-waiting,*
1855. Winterhalter
Oil on canvas, 300 x 420 cm
Musée de Compiègne (RMN)

Page 9:
6 (left) *Self-Portrait* (detail). Tintoretto
Oil on canvas, 62 x 52 cm
Musée du Louvre, Paris (RMN)

6 (right) *Portrait of Tintoretto,* 1854
Oil on canvas, 61 x 51 cm
Musée des Beaux-Arts, Dijon

8 *Dante's Ferry-Boat,* 1854?
after Delacroix
Oil on canvas, 38 x 46 cm
Musée des Beaux-Arts, Lyons

Konecky & Konecky
150 Fifth Ave.
New York, NY 10010

Copyright © 1990, Editions du Chêne, Hachette Livre
Translation Copyright © 1991 by Emily Read

English translation used by permission of
Henry Holt, USA and Ebury Press.

ISBN: 1-56852-175-8

All rights reserved.

Printed in Italy.

Manet

Possibly no painter in the history of modern art was so much reviled at the annual Salon 'performances' as Edouard Manet; and, perhaps, none was supported so enthusiastically and by such great names as Delacroix and Baudelaire, Zola and Mallarmé, Degas and Monet . . . No 'modern' painter was ever so classical in his own way, and vice versa. His presence charmed people as much as his painting annoyed them: it caused a sensation but was not understood. Degas summed up the general view when he said, at Manet's funeral: 'He was greater than we ever thought.'

This sense of rediscovery has occurred at each retrospective of his work – in 1883, in the first great posthumous exhibition; at the International Exhibitions of 1889 and 1900, in which he was given a place of honour in the French art centennials; and in the great exhibitions in 1932 and 1983 commemorating his birth and his death. At each stage, Manet's historical stature grows a little, although the way he is perceived changes considerably. At his death he was seen as a figure of scandal, a revolutionary whose paintings were shown in the enemy camp – the Ecole des Beaux-Arts – only as a provocation, on Gambetta's orders. Manet was seen mainly as the precursor of Impressionism, and, in order to get him into the Louvre, his friend Antonin Proust chose his most 'Impressionist' painting, *Argenteuil* (1874).

And yet when Manet was accepted by the gallery in 1890, it was thanks to a group of artists and admirers gathered together by Claude Monet; and, ironically, it was his most scandalous and most classical painting, *Olympia* (1863) – 'the blood and flesh of the painter', according to Zola – which was 'destined by fate to hang in the Louvre'. Monet and his friends were, in fact, choosing to pay tribute to his work as an intermediary between great classical painting and the modern movement, rather than to his so-called Impressionist period, which would have been more flattering to themselves.

In 1932, at the time of Cubism, Abstract Art, Dada and Surrealism, when public taste had moved away from realism and figurative painting, Manet's powerful images and strong messages fell on stony ground. But in the 1950s, when men such as Georges Bataille were rejecting 'form', people appreciated the champion of the 'end of subject-matter', the man who 'liberated' pure painting: 'What Manet provides, which is not necessarily superior, but is clearly different, is the green of *The Balcony*, the pink splash on Olympia's gown, the raspberry-coloured patch behind the black jacket in the little *Bar at the Folies Bergère*.'

By the 1960s and 1970s, there was a new current running through art history, which regarded the previous theories as 'formalistic'. This was particularly so in the Anglo-Saxon countries, where a sociologically based view gave Manet most credit for having produced a critical illustration of the society of his time. What interested people now was no longer the raspberry-coloured patch, but the social origins of the girl behind the bar, and her alienated position as a female member of the proletariat.

The 1983 exhibition in Paris and New York demonstrated how much truth there was in these various attitudes: time sometimes provides different answers. Here Manet was seen to be in the great tradition of Titian, Frans Hals and Velázquez, and at the same time one of the first modern painters: a master of materials, colour and simplification, but also of subject-matter – he was the first social and artistic witness of the Paris of his time.

Average pupil from a good family

He was, both as a man and as a painter, the essence of a Parisian. He was a charming *boulevardier*, a good talker with that line of banter common to Parisians of all ranks, a cheerful educated street-urchin. Berthe Morisot tells us that he was happy only in Paris – 'It is impossible to live anywhere else' – and that, like Baudelaire, he hated the country.

Edouard was born on 23 January 1832, at 9 rue des Petits-Augustins (now rue Bonaparte). His father, Auguste, was a senior official at the Ministry of Justice, and his mother, Eugénie-Désirée, was the daughter of a diplomat. The double portrait Manet painted of them shows an archetypal Parisian bourgeois couple, both austere and distinguished. But it would be wrong to think that they were disappointed to see their son 'doing art'; they were a great deal more liberal and open-minded than has been thought, and his mother, who survived him, supplied both financial and moral support throughout his life. Certainly, they might have hoped to see him in a more traditional career such as the law or the navy; but he was an average pupil and it seems that a true vocation for drawing appeared fairly early on. Antonin Proust, his schoolfellow, lifelong friend and first biographer, relates that he spent more time drawing in his exercise books than working. As often happens, it was a much-admired uncle who confirmed his vocation. His mother's brother, Colonel Fournier, aide-de-camp to the Duc de Montpensier and an art-lover, played his part by taking the child regularly to the Louvre, while he was still very young, and on drawing expeditions outside Paris.

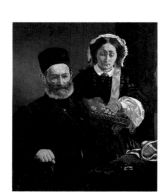

M. and Mme Manet

In 1848, when he was sixteen, having completed his studies at the Collège Rollin, Manet embarked as a cabin-boy on the cadet ship *Le Havre et Guadeloupe*, and travelled for six months, as far as Rio de Janeiro where, wonder-struck, he spent two months: 'For the European with artistic inclinations, this town offers a very special style.' His lively, playful letters to his parents are proof of his free and affectionate relationship with them. We also see in them signs of the family's pro-Republican leanings – Edouard was at sea when the Second Republic was created and wrote: 'Try and keep a decent Republic there for my return – I fear Louis Napoleon may not be much of a republican!' Back in Paris, and now finally turned down by the Naval College, he persuaded his family, without too much difficulty it seems, to allow him to devote himself to painting.

Now came the first signs of rebellion: he refused to enter the studios of the Ecole des Beaux-Arts, which prepared pupils for the Concours de Rome, and decided instead to be taught by Thomas Couture, whose success at the 1847 Salon with his decadent Romans had made him the hero of young painters, and who refused to prepare pupils for a conventional career in academic painting.

Learning from Couture and the galleries

Couture's role in Manet's development has always been minimised, by Manet himself, and by Antonin Proust, who followed him to the studio from the Collège Rollin. A lot has been made of the quarrels and outbursts that took place between the guardian of tradition and the young man obsessed with realism, who wanted to make his models pose in everyday clothes, and preferred contemporary Paris to ancient Rome. 'My poor boy,' Couture apparently said, "you will never be more than the Daumier of your time." But despite all this, Manet did remain at Couture's studio for six years, from 1850 to 1856, when he could, presumably, have left earlier had he so wished. There is hardly anything left of the work he did in those six years – perhaps he destroyed it, thinking that it bore too strongly the mark of the man who used to say: 'I am not producing geniuses, I am producing painters who know their job.' Couture's *Méthode et entretiens d'atelier* demonstrates his technical principles, and his encouragement of simplicity and pure colour, lessons, as we know, absorbed by Manet. He also probably owed his very particular drawing style to Couture – quick, nervy and unemphatic: 'You must always carry with you a little sketchbook, and draw in a few lines anything that strikes you.' Couture used to take his pupils to paint out of doors. Antonin Proust described a walking tour of the Normandy coast in 1853: 'Away from the studio, on the beaches, there was much greater familiarity between master and pupils.' All the same, Manet's insolence in the Couture studio was proverbial, and Couture, who was only in his late thirties, and irascible, found it hard to put up with this troublemaker who had such influence over his companions; he said of Manet: 'He will always be incorrigible, which is a shame because he's gifted.' Also, he probably did not like hearing it said around Paris: 'Apparently, there is a certain Manet at Couture's who is doing astonishing work.'

The painters who watched Manet at work much later, during the Impressionist period, were always struck by his traditional technique. As Jacques-Emile

Blanche so rightly wrote: 'Manet was the last to seek excellence in painting by following methods going back to the Spanish, the Flemings and the Dutch.'

Throughout the period from, say, 1850 until about 1859 – the formative years, as it were – Manet travelled a great deal. His journeys were more like the traditional grand tours of the British and other Northern Europeans than the usual journey made by young Beaux-Arts students, who simply spent long years in Rome. The first properly attested artistic journey took place in July 1859, when his name appears on the register of the Rijksmuseum in Amsterdam. There were several reasons for this choice of place: he had just become involved with Suzanne Leenhoff, a young Dutch pianist, who would eventually become his wife, and one must assume that he was travelling with her; also the traditional realism of Dutch painting would have been an excellent antidote for him to the academic formulas, a way of 'escaping from the Greeks and Romans'; an antidote, too, to the supremacy of drawing, the painting of history and the 'grand style' taught even by Couture. The 'Amsterdam Rembrandts and the Haarlem Hals' filled him with enthusiasm. He made a copy of Rembrandt's *Anatomy Lesson*, but it was the work of Frans Hals which made a lifelong impression on him. Manet's first great portrait, that of his parents, painted in 1860, bears echoes of the austere blacks of Hals's Regents, with their serious faces and the thick fluidity of the application of the paint. Nearly thirty years later, at the 1889 centennial, Gauguin forced a habitual despiser of Manet's to admire this same portrait by passing it off as an old Dutch painting.

It is known, however, from other sources, Antonin Proust and Suzanne Manet, who told Bazire, his first biographer, that the painter had already made a tour of the great galleries of Central Europe in 1853, visiting Kassel, Dresden, Prague, Vienna and Munich. There are no documents relating to this journey, no copies made by Manet, but one has only to think of the wealth of Dutch and Spanish painting in these galleries to imagine their effect on him. A little more is known about the journey he made in September and October of the same year, with his young brother Eugène, to Venice and Florence. Another young tourist, Emile Ollivier, a future minister under Napoleon III, tells in his diary of how he met and guided the Manet brothers around the two cities. It is interesting to note that during the week in Florence, Manet copied Titian's *Venus of Urbino*, to which a clear allusion can be seen in *Olympia*, ten years later. We know that he made a longer visit to Florence in 1857, and asked for permission to spend a month in the cloister of the Annunziata, in order to copy the Andrea del Sarto frescos. Several sketches, now in the Louvre, demonstrate his passionate interest in many other painters too, from Rosso to Luca della Robbia, from the Ghirlandaios in Santa Maria Novella to the Fra Bartolommeos in San Marco. But the Louvre, in the end, was for Manet, as it was for most painters of the time, even the rebels, a second and more real 'studio'. Here he copied Titian (*Virgin with Rabbit, Jupiter and Antiope*), Tintoretto (*Self-Portrait*), Velázquez (*The Little Cavaliers*; even though there has now been a change of attribution), Brouwer (*The Drinker*), and Rubens (*Hélène Fourment and her Children*). One must remember that the Louvre of his childhood and adolescence still had, up until 1848, the famous Spanish gallery, some paintings of which may have inspired the 'Spanish' phase of the 1860s.

It was as a copyist, too, that he went to visit Delacroix, to ask permission to reproduce *Dante's Ferry-Boat*, then in the Musée du Luxembourg, which was where live painters were hung, and was an antechamber to the Louvre. 'Delacroix received us in his studio in rue Notre-Dame-de-Lorette with perfect grace,' Proust wrote, 'asked us about our preferences, and told us his. We had to look at Rubens, be inspired by Rubens, Rubens was God!' Manet liked both Rubens and Delacroix, but not passionately. 'I don't like his craftsmanship,' he was supposed to have said of the latter. On the other hand, we know that he was one of the people who ferociously defended Courbet's *Funeral at Ornans*, which was attacked at the 1852 Salon, and that he admired Corot, Daubigny and, most of all, 'Jongkind, who was in his opinion the best of all the landscape artists'.

Manet finally left Couture's studio in 1856, and moved into one of his own in the rue Lavoisier, which he shared with Balleroy. He was working on two paintings indicating already the dual tendency of his work: one of these was very much influenced by the art of the seventeenth century, which had increased his knowledge of painting during these years. This was *Moses Saved from the Waters*, which, cut up later, became the *Nymph Surprised* (1859-61), and it was largely inspired by Rembrandt's *Bathsheba* in the Louvre.

Up to now, we have followed the career of a confused and rebellious young artist, classically trained

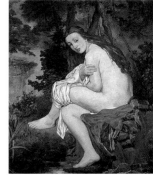

Nymph Surprised

13

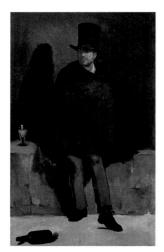

The Absinthe Drinker

but seeking to challenge the accepted standards of the official galleries. From now on we must think in terms of a 'boulevard studio' and inspiration from poets, as the second painting is *The Absinthe Drinker* (1859), a work that flabbergasted many viewers and the first of Manet's frequent Salon refusals. 'We were sitting at his house with Baudelaire when news of the refusal came.' There followed a discussion about Couture. 'You were never really his pupil, any more than he was Gros' pupil.' The conclusion, said Baudelaire, was that one must always be oneself. 'I have always said so, my dear Baudelaire,' replied Manet, 'but have I not been myself in *The Absinthe Drinker?*'

'One of the first to understand him'

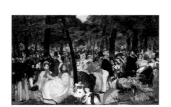

Music in the Tuileries

The great novelty of the rejected painting was its Baudelairian subject-matter – the dandified vagabond, drunk, with the top hat and the empty bottle at his feet – and, even more importantly, the incredibly casual way in which such a large canvas is painted like a small sketch, with the accent on the sinister green glow of the absinthe.

The common inspiration of poet and painter is illustrated in two paintings of that time, one of which, *Music in the Tuileries* (1862), was worked on out of doors, with Baudelaire as companion. It is a sort of collective portrait of the semi-elegant, semi-Bohemian society that was the natural milieu of these two men. The work seems to be a pictorial representation of Baudelaire's aesthetic plan – 'to extract from contemporary fashion its poetical and historical significance' and 'find the eternal within the transitory'. Baudelaire himself appears in the centre of this notable illustration of contemporary life, as if to co-sign the work.

The Old Musician (1862) is a more ambitious painting if only because of its size, almost 2 m long. We no longer have here the public from the Café Tortoni, or Madame Lejosne's salon or an Offenbach opera; these are the poor from the Petite-Pologne quarter, with its vagabonds (the absinthe drinker reappears), travelling musicians, little beggar-girls, but

clothed here with the grandeur and mystery of Baudelaire's 'floating subterranean lives in the great city'; they are the heroes of the gutter, sharing the Bohemian lives of poets and painters.

This was also Haussmann's Paris, changing, according to Baudelaire, 'faster than the hearts of men', and, amongst the buildings being demolished on what would be the plaine Monceau, where one of his early studios was, Manet was struck by an image: 'At the entrance to the rue Guyot, a woman was emerging from a sordid bar, holding up her skirt and clutching a guitar.' This would become *The Street Singer* (1862), in which Manet arranged for a professional model to assume the same pose. This was the first appearance of Victorine Meurent, Manet's favourite model, with her combination of elegance and crudity. She was soon to reappear dressed as a matador (1862); naked, in *Le Déjeuner sur l'Herbe* (1863) and *Olympia*; or in a pink dressing-gown in *The Woman with a Parrot* (1866).

Baudelaire officially associated his work with Manet's when the subject was a touring Spanish dancer rather than a street singer, with the famous quatrain written on the picture-frame of *Lola de Valence* (1862). The association between poet and painter did not work here in Manet's favour. Baudelaire himself wrote a note, which he demanded to have published, defusing the idea of any complicity in the scandal: 'People are so suspicious of M. Charles Baudelaire's muse that they have chosen to find an obscene hidden meaning in "the pink and black jewel" . . . The poet only wanted to say that this beauty, both dark and playful, makes one think of the combination of pink and black.'

Everything indicates that Manet and Baudelaire were very close to one another, but their relationship remains mysterious. They were friends from the end of the 1850s, as can be seen by *Music in the Tuileries*. Some of Manet's paintings appear in Baudelaire's writing, such as the *Boy with Cherries* (1859), whose model was found one day hanging in the studio, inspiring Baudelaire's *The Rope*, which he dedicated to Manet. He makes the painter speak: 'My profession forces me to look carefully at the faces that cross my path, and you know what satisfaction there is in this faculty which enables us to derive deeper satisfaction from our eyes than other men can attain.' When Baudelaire wrote these lines in 1864, he was posing alongside the painter for Fantin-Latour's *Homage to Delacroix*, although, as far as he was concerned, his young friend did not attain the genius of the dead master they were honouring. He said in a letter to Manet that he was only 'the leader in the decrepitude of art'.

Much has been made of this remark, and it was indeed a meagre response to Manet's call for support at the time of the *Olympia* scandal. 'I wish you were here, my dear Baudelaire, insults are hailing down upon me . . . Clearly someone is wrong . . .' The poet reproached him for not being above these attacks and quoted the haughty indifference of Chateaubriand or Wagner. Not having any doubts about Manet's immense talent, the solitary Baudelaire was irritated by this need for recognition which he found slightly vulgar. 'Painters always want immediate success; it would be sad, really, if Manet, with his light and brilliant talent, were to become discouraged. He will never be able to completely overcome the flaws in his temperament. But at least he has a temperament, that is the main thing.' The flaws were first a lack of imagination, for Baudelaire the most important of all faculties (not for Manet, for whom the main priority was realism), and no doubt this anxiety about the opinion of others.

Baudelaire has often been reproached for not publicly supporting Manet. They forget that he was already ill, was writing less and less, and had not written about the Salons for a long time – Manet had appeared too late in his career as art critic. And we must recall the poet's words about the painter, who was still young – hardly thirty: 'He had faults, weaknesses, a lack of assurance, but his charm is irresistible. I know this, and I was one of the first to realise it.'

Spain

Spain, the legendary land of freedom and colour, had been made fashionable by romantic literature, and for Manet it was, too, a reminder of the New World that he had discovered as an adolescent in South America. And, above all, it reminded him of the dazzling effect of the Velázquezs that he had seen in Dresden, Vienna and Paris. Hence the first painting that Manet offered to the Salon after the failure of *The Absinthe Drinker*: 'There I painted a Parisian character, seen in Paris but executed with the simple technique that I saw in Velázquez's paintings. They didn't understand; perhaps they will if I do a Spanish character.' He was right, and *The Spanish Singer* or *Guitarrero* (1860) was his first real success, at the 1861 Salon, both with painters and critics. Théophile Gautier, an influential journalist and author of

Travels in Spain, wrote: 'Velázquez would have given him a friendly wink . . . There is a lot of talent in this full-sized figure, painted with a full brush and in lifelike colours.' Suddenly Manet was the leader of the young realists, a group that included Fantin-Latour, Legros, Whistler, Carolus-Duran, and which had Spain as its emblem. He even tried to include his beloved Dutch painters: 'I cannot get rid of the idea that Frans Hals was of Spanish descent. It would not be surprising, since he came from Malines!' In two years, between 1860 and 1862, he painted at least fifteen pictures on the theme of Spanish folklore. The most important of these were: *Boy with Dog, The Salamanca Students, The Spanish Studio, The Spanish Ballet, Lola de Valence, Mariano Camprubi, Child with a Sword, Young Man in Majo Costume, Mademoiselle Victorine in Espada Costume* and *Reclining Young Woman in Spanish Costume*.

Each one shows the Spain of theatre, disguise, mantillas and castanets. And yet nothing is further from genre painting – the remoteness of the subject only emphasises the unselfconsciousness of the style. Folklore is used more for the colour of the clothes than for 'local colour', and there is a kind of lively speed and realism about the execution that deliberately distances this work from the classical Italian model. Since the success of *The Spanish Singer*, Spain and modernity were coupled together in Manet's mind, along with his own growing reputation. It is relevant to note that, at the Salon des Refusés in 1863, he took care to hang the famous *Le Déjeuner sur l'Herbe* between the *Young Man in Majo Costume* (his brother) and *Mademoiselle Victorine in Espada Costume*, as if they were two guardian angels, or interceding saints, dressed as Spaniards, to accompany the shocking central panel of this strange triptych. It was as if Spain and his nearest and dearest were holding hands to support the beginnings of the scandalous career that Manet would follow for the rest of his life. Two years later, in 1865, after the outcry over *Olympia*, which was to affect him deeply, his first reaction was to go to Spain, to seek an antidote to the doubts afflicting him. It was his first and only visit. Letters relating to his stay show a singular indifference to the pictu-

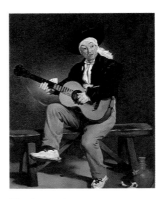

The Spanish Singer

resque aspect of a country which generally impressed travellers so much at that time. There was only one concession to this – a *Bull Race* seen in Madrid and painted on his return to Paris. The culinary aspect of Spanish folklore horrified him, causing him to cut short his stay. However, according to Théodore Duret, whom he met in Madrid, 'he spent a long time every day in front of the Velázquezs in the Prado.' 'I have at last got to know Velázquez, my dear fellow, and I declare that he is the greatest painter that has ever been,' Manet wrote to Baudelaire; and to Astruc: 'I found in him the realisation of my ideal in painting; the sight of his masterpieces has given me great hope and renewed confidence.'

The series of portraits of actors and vagabonds, painted in the year following his return, figures from the stage or the Parisian streets, were deliberately conceived as a contemporary re-working of Velázquez: *The Tragic Actor* (1865-6) echoes *Pablillos de Valladolid*, the three paintings on the theme of *Beggar-Philosophers* (1865) are in reply to *Aesop* and *Menippus*, and the *Portrait of Théodore Duret* (1868), his Madrid friend, is, despite the bowler hat and stick, a wave in the direction of the portraits they admired together.

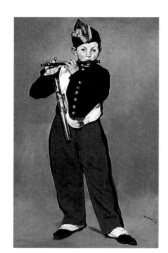

The Fifer

As for the jaunty *Fifer* (1866) with his flatly painted red and black costume, scornfully compared by some at the time to a playing card, it may have been partly inspired by Japanese engravings and images d'Epinal, but it is more than anything a variation on what Manet had so much admired in the master of the Prado: 'The background disappears, the fellow is surrounded by air!'

From his letters, Manet does not appear to be particularly enthusiastic about Goya, with the exception of the *Clothed Maja*, which he partly transposed two years later from a photograph with *Reclining Young Woman in Spanish Costume* (1862). And what can one say of his two masterpieces of 1867 and 1868 – *The Execution of Maximilian*, obviously directly inspired by Goya's *3 May 1808* which we know he saw in a corridor of the Prado, and *The Balcony*, clearly a modern version of Goya's *Majas on a Balcony*?

The reasons for this borrowing were partly non-artistic ones. For his 'first historical painting' done as a demonstration of his hostility to the Empire, he needed a historical as well as artistic model. Goya's disgust for the man behind the massacre of the Spaniards is echoed by Manet's in the face of an execution for which, like all the liberals of his time, he held Napoleon III responsible. The composition of *The Balcony* is more of an act of homage towards the dark beauty of Berthe Morisot, with her fan and Andalusian eyes. This was, in effect, a farewell to

Spain, which, after the 1860s, ceased to be a direct inspiration – what he had learned had now been absorbed and assimilated.

1863: the crucial year

What happened between the early success of *The Spanish Singer* in 1861, and the period of doubt which four years later took him to Spain? According to Malraux and Gaétan Picon, everything important in Manet's life, and in the history of modern painting, took place in 1863, the year of his marriage to Suzanne Leenhoff. It was the year of the final break, which had been brewing for the past ten years, away from the academic methods, whose adherents were in power at the Beaux-Arts and the Salon, deciding everything about the training and future success of painters. He now moved towards the moderns, led successively by Daumier, Courbet and finally himself. It was Manet's luck – or misfortune – that he reached maturity at such a key moment. When Nieuwerkerke, Napoleon III's Minister of Fine Arts, decided to open an exhibition designed to show the public what sort of thing the Salon had refused, it was due to the pressure of a strong group of discontented artists, of whom Manet was the figurehead. With hindsight, the painting he chose to show, *Le Déjeuner sur l'Herbe*, looks like a deliberate provocation, which it partly was. The result was beyond the slightly ingenuous Manet's wildest expectations.

It is hard to say what this first scandal consisted of and what it was all about. This is how Antonin Proust describes it: 'Just before he produced *Le Déjeuner sur l'Herbe* and *Olympia*, we were lying on the river bank one Sunday at Argenteuil ... Women were bathing. Manet looked at their bodies as they came out of the water. "Apparently," he said, "I must do a nude. Well – I'll do them one."' Until then the works Manet had shown at the Salon had been minor ones in the academic hierarchy, genre scenes and portraits. He had not attempted a grand historical painting, or a mythological subject – the Salon's usual justification for a nude. 'When we were at the studio [presumably Couture's] I used to copy Giorgione's women, women with musicians. It was a very dark painting, overwhelmed by the background. I want to redo it with a transparent atmosphere, with women like those over there. They'll tear me to pieces, or say that I'm copying the Italians now, after the Spanish. They can say what they like.' Although one must be cautious about something written after Manet's

death, and which tends to exaggerate his role as an early exponent of 'painting light' and precursor of the Impressionists, the general tone of this memoir must be correct, although Manet was referring to a painting by Raphael, reproduced as an engraving by Marc-Antoine. There was certainly an element of provocation in this lighthearted reworking of a studio practice piece. It was a joke whose effect would exceed all expectations.

The extreme reaction of the critics, the laughter of the bystanders, the surprise effect of the technique as much as the subject-matter, all made the picture, according to Zacharie Astruc, 'the sensation, the spice, the inspiration, the amazement of the Salon'. It shocked people, but also aroused interest; according to Jules Claretie, 'Many cried scandal, some smiled, others applauded, all remembered the bold painter's name.' People were shocked by the realism of the nude and the immodesty of the scene – 'two art students, dressed in velvet, talking about aesthetics, with a woman wearing only her virtue' – and also by the carelessly painted background. It was a manner of painting with 'all the qualities needed to make it unanimously refused by all the juries in the world. The sharp and irritating colours attack the eye like a steel saw; the figures are crudely stamped out, with no softening touch. Here is all the sourness of a green fruit that will never ripen.' The technique and style, just described by E. Chesneau, was to serve as an example to a whole generation, and become the source of all the innovations of modern art, as much by his style as by his whole attitude towards painting.

the fuss surrounding Baudelaire's *Les Fleurs du Mal*, and that, more recent, provoked by Renan's *Vie de Jesus*. Perhaps Manet, in choosing this theme after the scandal of the Salon des Refusés, was drawing a parallel between Jesus mocked by the soldiers and the artist attacked by the critics. Blaspheming as she did against artistic and religious dogma, *Olympia* became, overnight, the steamy heroine of every piece of shocking modernity, the scandalising figurehead of the new style – and remained so, long after Manet's death.

But all he had done was to transpose a student exercise in a realistic way, echoing, beyond the odalisques regularly shown at the Salon since the beginning of the century, Titian's *Venus of Urbino*, which he had copied in Florence. As well as the bipartite composition of the background, he copied the 'modest' position of the hand, here slightly ambiguous, and the animal at the end of the bed, transformed here from a quiet dog to a demonic parody of a cat. Manet certainly did not foresee the storm he would unleash: 'Like a man falling into snow, Manet has made a hole in public opinion,' wrote Champfleury to Baudelaire. Manet understood only later how much he had shocked people. For a long time he continued to say: 'I painted what I saw.' He probably did not want the fuss, which may be why Baudelaire reproached him for his feebleness of character, though adding: 'Manet has a great talent, and one that will last' and 'what I am also struck by is the joy of those who think him ruined', showing that he had complete confidence in the painter's future.

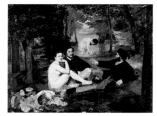

Le Déjeuner sur l'Herbe

Zola

In that same year, Manet painted *Olympia* but waited two years before showing it at the Salon in May 1865, alongside *Jesus Mocked by the Soldiers*, which in no way diminished the scandal. This courtesan with her impudent stare, her chalky nudity emphasised by three shades of black – in the face of the servant, the cat with its bristling fur, and the ribbon around her neck – makes the whole picture, shoes and flowers included, into – even more than *Lola de Valence* – a genuine Baudelairian 'pink and black jewel'. And here she was, side by side with a too human Christ, a cadaverous figure with proletarian feet and the same empty bored stare. Together they embodied all the scandals of the day: Manet's style,

In the year Baudelaire died, a new writer came to the defence of the current scapegoat. Although he later failed to appreciate Manet's development, the young Emile Zola's arrival on the scene was providential in the years between 1866 and 1868. In 1867 a long article, 'A new style of painting: Edouard Manet', described the artist as the hero of modern painting, representing, as Zola did in literature, Manet's own vision of reality: 'Every great artist has given a new and personal interpretation of nature, and Manet is that man today; his masterpiece *Olympia* is the complete expression of his personality.' This combative article, written with Zola's usual energy and verve,

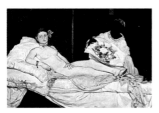

Olympia

also contains transcriptions of Manet's own remarks, chosen to coincide with the writer's naturalistic convictions.

'Olympia, lying on white sheets, makes a large pale patch against the dark background; . . . At first sight one sees only two violent shades in the painting, one against the other. Also, the details have disappeared. Look at the young girl's head: the lips are merely two thin red lines, the eyes a few black ones. But then, I beg you, look closely at the bouquet: yellow, blue and green patches. . . . If you want to reconstruct reality you must stand back a few paces. And then a strange thing happens: each object finds its plane, Olympia's head stands out in striking relief against the background, the bouquet becomes a miracle of freshness and colour – a miracle achieved by an accurate eye and simple brushstroke; the painter has done what nature herself does, with pale masses and large shafts of light, and his work has something of the rudeness and austerity of nature. There is, of course, a bias; art can exist only by taking sides. The bias here is towards an elegant dryness with the violent contrasts that I have pointed out. They provide the personal touch, the particular flavour of the work. . . . Usually when painters give us Venuses, they improve on nature, they lie. Edouard Manet has asked himself why it is necessary to lie, why not tell the truth: he gives us Olympia, a girl of our time whom you could meet on any pavement, hugging a thin shawl around her bony shoulders.

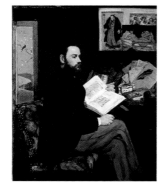

Portrait of Emile Zola

As usual the public has been careful to avoid understanding what the painter intended, and there have been people who have looked for a philosophical meaning. The coarser ones would have been happy to find an obscene message in the painting.

Well, you must tell them out loud, my dear master, that you are not what they think, and that a painting for you is simply an opportunity for analysis. You wanted a nude, you chose the first comer, who happened to be Olympia; you needed light and bright patches, so you painted a bunch of flowers; you needed black patches, so you placed a Negress and a cat in the corner. What does it all mean? You don't know, and neither do I. But what I do know is that the result is the work of a painter, and a great painter at that: you have, vigorously and in your own language, shown the truth about light and shade, and the reality of objects and creatures.'

Manet painted a portrait of Zola (1868), largely to thank him. He is shown with the emblems of the writer beside him, and signs of gratitude for his help: the Japanese print so popular with the modernists, an engraving after Velázquez and, of course, a reproduction of *Olympia* gazing gratefully at the young writer.

The elegant reprobate

By the end of the 1860s, after the scandals of *Le Déjeuner sur l'Herbe* and *Olympia*, Manet's image was that of someone undermining the status quo, masked beneath the charming and conventional exterior of a Parisian grand bourgeois. The more he was attacked, the more elegant he appeared; he became more insolent when turned down, more confident when criticised, at least when it came to his painting. He was surprised to be greeted by incomprehension, and the welcome he received in society and amongst writers was in marked contrast to that accorded him in official artistic circles. Zola, the young provincial, ultra-sensitive to social nuances, was quick to seize on this apparent paradox: 'This rebellious painter, who loved society, had always dreamt of the sort of success you can find in Paris, the flattery of women, drawing-room praise, a fast-moving luxurious journey through the admiring crowds.' Manet's strength and determination are all the more admirable in the face of such temptation. Much as he liked to charm and affect people through his painting, he made none of the concessions demanded by those who found his work 'loose', his portraits of women 'ugly', his subjects provocative, and so on. To give in to pressure, or artificially compose subjects, was not his style – he was ready to please, but not to sell his soul. This inflexibility, deep self-confidence and indeed genius were concealed behind an exceptionally charming manner, to which many people testified. Here is Théodore de Banville: '*The laughing, blond Manet/Emanating grace/Gay, subtle and charming/With the beard of an Apollo/Had from head to toe/The appearance of a gentleman.*' And his childhood friend, Proust: 'He was of medium height, very muscular . . . However much he tried . . . to effect the whiny slang of the Paris streets, he was never able to appear vulgar. . . . He had a high forehead . . . small but mobile eyes . . . There have been few men as attractive as he was.' These

descriptions are confirmed in the fine portrait by Fantin-Latour (1867).

Journalists were surprised by this dandy, accustomed as they were, as with Courbet for example, to associating artists with the Bohemian life. Pierre Véron expressed his astonishment in these words: 'This fellow, seen by the bourgeoisie as a wild dauber, is in fact a spotless dandy. The ferocious tribune of the people is a meek slave to fashion, a cross between Marat and Beau Brummell.'

His appearance did not bely his convictions – Manet wanted to make his mark, but within his own society. Throughout his life he continued, against all the tides of public opinion, to try to prove that he was right in the very place where he was most attacked, the Salon. This was apparent, too, in his relationship with the Impressionists, when he chose not to exhibit alongside them.

In 1866 the jury turned down *The Fifer* and *The Tragic Actor*, despite the fact that they were both directly in line with tradition, Spanish but classical all the same. In May of the following year, Manet decided to imitate what Courbet had done in 1855 and mount his own exhibition on the fringe of the International Exhibition, erecting a pavilion near the Pont de l'Alma. 'I am going to risk it', he wrote to Zola, 'and, backed by people like you, I expect to succeed.'

This was the thirty-five-year-old painter's first retrospective, and he showed fifty large paintings. Champfleury, the critic of realism and defender of Courbet, wrote to Zola: 'I was struck mostly by the consistency between works conceived at different periods. From the first canvas to the last there is total cohesion, which, for sceptics, belies all talk of masquerade.' Manet himself – perhaps helped a little by Zola or Astruc – wrote the introduction to the catalogue, calling on the public to come and 'settle the question by looking at honest painting. It is this very honesty that makes it appear provocative, when in fact all the painter is seeking to do is *convey his impression* of what he sees.' So the word appears in 1867, seven years before the exhibition officially baptised with the word Impressionism.

Despite all this, to his renewed amazement, the exhibition was greeted with almost unanimous hostility from press and public alike. At worst there was indifference, and the less hostile ones, such as Jules Claretie, referred to him as a 'Velázquez of the boulevards'.

He no longer referred to the latter in his masterpiece of the following year, *The Balcony*; this time the inspiration was Goya, whose *Majas on a Balcony* had just been sold in Paris (it was, as we now know, a copy). There is no intention of parody in this modern-day version; everything is arranged around the figure of Berthe Morisot, the painter friend who here makes her first striking appearance in Manet's painting. When one sees Morisot's fierce and melancholy beauty in this painting it is hard to understand the constant criticism at the time that Manet uglified his models. Her looks are both modern and eternal, combining the steady stare of the paintings of Fayoum with the expressive mouth of the English or Russian heroine of a nineteenth-century novel. She said of herself: 'I am more strange-looking than ugly – it appears that I have been labelled as a *femme fatale* . . .' It was a scene of modern life such as Baudelaire, who had died recently in 1867, would have loved. The two women look as though they are acting two quite different roles – little Fanny Claus, on the right, playing a comic fool, while Berthe Morisot, all mystery and drama, is from a piece by Chekhov. And yet it is not a genre scene, but one posed, as if for a photographer, the mysterious atmosphere combined with the most direct realism – the sharp green railing in the foreground caused the work to be attacked as 'coarse painting'. Simultaneously elegant and ferocious, it is the very reflection of the person who painted it.

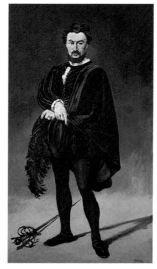

The Tragic Actor

Painting and political life

With *The Execution of Emperor Maximilian* (1867), Manet produced his own great contemporary historical painting. He made several sketches before the final painting, as soon as the details of Maximilian's death reached Paris. Manet had several reasons for embarking on a subject so different from his usual ones; one, the most immediate, was in order to express his indignation against Napoleon III, who had sent the young Habsburg to Mexico without the means of defending himself. The news broke in Paris at the end of June, in the euphoria following the International Exhibition, and in the midst of Manet's disappointment at the failure of his own exhibition. He, too, had been shot down, by the critics! His anti-Napoleonic feelings mingled before this painful event with his unhappiness at not being understood. He was, like the young Emperor, amazed, and, like him, he was dignified under fire.

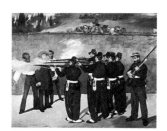

The Execution of Emperor Maximilian

The amiable painter and man-about-town concealed, as Prins tells us, 'a neurasthenic mind behind the cheerful appearance' and a tragic sensibility which underlaid many of his paintings with a faint sadness. 'Images of heroism or love will never be as powerful as images of pain,' he is reputed to have said to Proust, when speaking of his wish – never fulfilled – one day to paint Christ on the cross.

There were other tragedies, closer to home: the war and the defeat of 1870, the Commune. Although he was not in Paris during the latter, he did live through the siege of Paris by the Prussian army (with Degas at his side) between September 1870 and February 1871; he served during this time in the National Guard, as a gunner and then on the staff. His correspondence with his wife, sent out secretly during the siege, bears sober witness to the sufferings of the Parisians and to his own loneliness – he was deeply attached to his family. When he returned to Paris after the 'bloody week', he was horrified by stories he heard about the tragic suppression of the Commune. A pen and wash drawing of a barricade reproduces the layout of the execution of Maximilian, which he had not been able to exhibit.

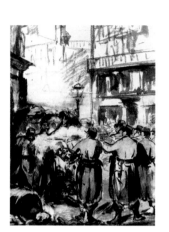

The Barricade

In 1871, Manet felt crushed as much by recent events as by material and financial problems. He did little painting. In 1872, at the first post-war Salon, he showed an eight-year-old marine painting of the *Battle between the Kearsarge and the Alabama*, a naval engagement which took place off Cherbourg in 1864 between two American ships at the time of the Civil War. He was transposing in time and space the more recent episodes of defeat and civil war. Manet was a true patriot and saw France's military defeat as a catastrophe. Proust reports that already 'before the 1870 war . . . as the news became worse, he became more and more silent. Very patriotic . . ., he had an argument one evening with Mazerolle which nearly turned nasty. He would not allow any criticism of the army, particularly the soldiers who were victims and had to be respected. If the bad policies of the Empire had caused harm, then the Empire must be got rid of, but the army should not be insulted. Gambetta agreed . . .'

And yet the arrival of the Republic, 'which had seemed so beautiful during the Empire', did not bring with it the hoped-for breath of freedom in the arts. Gambetta, for example, when Manet offered him one of his paintings, declined politely, saying he already had a picture he was perfectly happy with – Henner's *Alsatian Woman*. He also failed to obtain permission to paint Gambetta's portrait. 'Another one committed to Bonnat!' he is supposed to have said – Bonnat, having been the official portrait-painter for the Empire, was now working for the Republic.

He was able, a little later, to fulfil his plan to paint the portrait of a public figure whom he admired. This was the formidable *Clemenceau* (1879) in which, with Matisse-like economy, humour and force, he suggests not only the appearance, but also the energy and eloquence of the politician. Unfortunately the latter did not like the portrait: 'I haven't got it, and I don't mind a bit! . . . It is in the Louvre, I can't think why!' he would say later. Poor Manet sighed: 'It is curious how reactionary republicans are when it comes to art!' He never fulfilled his dream of a public commission for the Third Republic.

However, disappointed as he might be by the new leaders' tastes, he remained a loyal republican, as demonstrated in his portrait of the anti-imperial polemicist *Rochefort* (1881), the paintings commemorating the latter's escape (1881), and the flags with which Manet decorated his letters after the Communards were freed by amnesty on 14 July 1880.

The first picture he painted after the war was a great popular success at the 1873 Salon. *The Glass of Beer* was inspired probably by his recent visit to the new Frans Hals museum in Haarlem, but the cheerful and satisfied air of the character, his 'moral and physical roundness' were seen as an allegory of national reconciliation. Paul Mantz summed up the general view: 'In the troubled times we live in, this peaceful drinker symbolises eternal serenity.' But this genre painting was not really one of Manet's best: the critic Wolff, for once on the side of the avant-garde, mocked: 'This year, M. Manet has watered his beer.'

Manet and Impressionism

This popular success was counterbalanced, however, by sharp criticism of another, much better, painting shown at the same Salon, *The Rest* (1870), a vigorously executed and psychologically truthful portrait of Berthe Morisot. This painting already

belonged to Paul Durand-Ruel, who was to become the Impressionists' dealer, and was a Manet enthusiast. In January 1872, he bought twenty-five canvases in two days, which immediately brought' in other buyers and financial success for Manet. Durand-Ruel took Manet up after he became interested in Monet and Renoir, as though the younger men's work helped him to better understand that of the older Manet.

It was true, too, that those who were soon to be known as the Impressionists had known and admired Manet for almost ten years. This was the famous group of independent painters, whose main point in common was hostility to the Beaux-Arts dogmas, and whose meeting-place was, until the war, the Café Guerbois, and afterwards, the Nouvelle Athènes. These painters of the Batignolles group – Bazille, Cézanne, Degas, Fantin-Latour, Monet, Pissarro, Renoir – would gather around Manet and meet the writers and critics of the new wave, such as Duranty, Duret, Zola and Silvestre, who wrote: 'Manet was not their teacher – nobody had a less didactic temperament, he was incapable of solemnity; but all the same he had considerable influence . . . Less magisterial, less intense, and certainly less sure of himself than Baudelaire, he did all the same affirm in painting, as the latter did in poetry, a sense of modernity, which although part of a general aspiration, had not yet been enunciated.'

Fantin-Latour's two paintings, *Homage to Delacroix* (1964) and *Studio at the Batignolles* (1870), demonstrate Manet's growing importance among the younger painters. In the first he is, with Baudelaire, Fantin-Latour and Whistler, among those 'honouring' the recently deceased painter. The second, six years later, is like an official statement: all the new school is present, but this time surrounding a magisterial Manet with a paint-brush in his hand. Unlike Manet, his friends – all except Pissarro, nearly ten years younger – were landscape painters. They worked out of doors, and were in a direct line from Corot, Daubigny or Jongkind, painters whom Manet had long admired. What they owed Manet was something else – perhaps the free shorthand technique and a new way of seeing and painting, but also because he was a human model of independence and courage. 'Manet was as important for us as Cimabue and Giotto were for Renaissance Italians,' said Renoir, who also wrote to him: 'You are like an old Gaul who hates nobody; I love you for your cheerfulness in the face of injustice.' Duret and Proust, who were Manet's biographers in the early 1900s, at the height of the Impressionists' success, tried to make him into their precursor and their equal, seeming to regret the fact that he had not joined in the group's battles by exhibiting alongside them after 1874. Degas, his friend from the 1860s, who had had a far more academic training at the Beaux-Arts and the Villa Medicis, and was the least 'self-taught' of the 'independents', was also the one most fiercely opposed to the official Salon. He was very irritated by the position Manet took when he refused to take part in the group's first exhibition in 1874, in which Impressionism was baptised. 'The realist movement no longer needs to fight with others. It *is*, it *exists*, it must show itself *separately*. Manet does not understand this. I think his vanity outstrips his intelligence,' Degas said to Tissot at that point. Manet had always chosen to fight from within the system, and to impose himself on the Salon despite numerous setbacks, always refusing to make the concessions that would have assured him success. His attitude was quite deliberate: 'I will never exhibit in the shack next door; I will enter the Salon by the main door, and fight for you there,' he once said to Caillebotte.

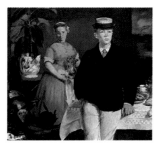

Lunch in the Studio

Throughout his life he showed, or tried to show, two or three paintings at the Salon every year; they were carefully chosen, sometimes in relation to one another, portraits or scenes from modern life, painted mostly in the studio, since he was not interested in pure landscape, apart from marine subjects. Here are the works shown from the period in which he became linked with the 'independents': in 1869, *The Balcony*, and *Lunch in the Studio*, enigmatic scenes which were above all portraits; the same thing in 1870: *The Music Lesson* and the *Portrait of Eva Gonzales*; in 1872, he showed an old picture, the *Battle between the Kearsarge and the Alabama*; in 1873, portraits of two completely different artists: *The Glass of Beer* (the debonair engraver Merlot) and *The Rest* (a nervous Berthe Morisot); in 1874 two of his paintings were turned down: *The Swallows*, a portrait of his wife and mother on a lawn, and *Masked Ball at the Opera*, but *The Railway* was accepted. Despite its title, this was essentially a portrait – only the steam from an engine behind the fence between a garden and the railway justifies its

title. In it we meet again the heroine of the 1860s, Victorine Meurent, hardly plumper, loyal to *Olympia*'s velvet choker, but now chastely dressed in what Burty tells us is 'the navy blue twill that was the fashion until last autumn'. It is a scene from contemporary life, where the reality of a noisy and smoky industrial life, observed by the child, is presented with calm sympathy, like an eclogue of modern life. This was painted three or four years before the famous pictures of the Gare Saint-Lazare and the Pont de l'Europe by Monet and Caillebotte. The black railings were a godsend to the Salon satirists: 'These unfortunate women, seeing themselves painted in this way, wanted to escape, but he has foreseen this and placed a railing to cut their escape . . .'; they are similar to the green ones in *The Balcony* and to some of the Japanese prints that Manet had been fond of for some time.

Throughout the end of the 1860s and the beginning of the 1870s he never showed any of the seascapes that he had done in such great numbers over the years at Boulogne, or the racing scenes, or the first outdoor portraits, *In the Garden* and *On the Beach*. And yet it was he who provided Impressionism with its first triumphal entry to the Salon with *Argenteuil*. This holy site of Impressionism was well known to Manet, whose family home was at Gennevilliers, opposite Argenteuil. It was he who found a house for Monet, to whom, of all the young painters, he was closest, and whose portrait he had recently painted on board his studio boat. With this choice of an open-air subject, already done by his younger colleague, and with the new bright colours, Manet caused his second great scandal at the Salon, ten years after *Olympia*, and a year after the first Impressionist exhibition.

The work was seen as more provocative than ever. The subjects were trivial, the drawing non-existent, the colour extreme, and the background virtually 'painted by the four-year-old son of the family'; in short, 'every year the Manet problem crops up, like the Eastern problem, or the Alsace-Lorraine problem'. Even his friends could not understand this double wish to please and to provoke simultaneously, which summed up his relationship with the Salon; as Philippe Burty wrote: 'It would be more useful if M. Manet chose to fight the good fight on ground chosen by him, and with the group of which he is one of the leaders, and which he now abandons at the door of the Exhibition [the Salon]; he goes there not because he respects it, but because he is afraid of what constant refusal would entail.' E. Darragon was justified in suggesting that 'Manet went to Monet to find material for a new scandal.' It was as though he had taken up a challenge, and needed to renew himself by confronting his younger, more radical followers. He worked this atmospheric, colourist seam systematically throughout 1874 and 1875, at Argenteuil and in Venice. But figures were always more important to him than landscapes. He painted a few at Bellevue and Rueil, towards the end of his life, but this was because he was forced by illness to go to the country, which had always bored him to death.

Mallarmé

Manet was very much a writers' painter: Baudelaire and Zola were the friends of his youth, and Mallarmé that of his middle age. Manet and Mallarmé met in 1873, and quickly became friends; Mallarmé would leave the lycée Fontane, where he taught English, at the end of the afternoon, and come and chat with Manet in his studio and meet painters, critics and beautiful women. When the painter died, Mallarmé wrote to Verlaine: 'For ten years I saw my dear Manet every day; his absence today seems quite unbelievable.' A portrait of him in 1876 commemorates the friendship between the two men. 'In the history of art and literature,' wrote Georges Bataille, 'this picture stands out, illuminating the friendship between two great souls.' And, indeed, the portrait of Zola does appear stiff and official, compared to this intimate and spontaneous show of affection. Mallarmé, too, describes Manet 'freed from the anxieties of creation, talking brilliantly in the studio by lamplight, explaining what he meant by painting, his future plans, why and how his irrepressible instinct inspired his work . . .'

Each responded to the exceptional charm of the other, even if Mallarmé may have been more convinced of Manet's genius than Manet was that of Mallarmé, who was ten years his junior. However, he was delighted with two articles that Mallarmé wrote about him in 1874 and 1876, 'The Impressionists and

Edouard Manet', and commented, 'If I had a few more supporters like you, I would tell the jury to go to the devil.'

Mallarmé listened to Manet talking about painting; he must also have asked him about his friendship with Baudelaire, which made the conversations doubly interesting. He also used to watch him painting, discovering the other side of Manet – no longer the charming man of the world, but the violent, dissatisfied, impulsive artist: 'the elegant joker at Tortoni's; in the studio, a fury attacking the blank canvas, in confusion, as if he had never painted before.'

Above all, Mallarmé defended the 'Impressionist' Manet, in the pictures that he had watched him paint, now rejected at the Salon – *The Swallows* and, particularly, *The Washing* in which 'everywhere the luminous and transparent atmosphere, mingling with the figures, the clothes, the leaves, seems to take on some of their substance and solidity, . . . the air itself is completely real.'

This atmospheric enchantment was, with Manet, more the result of a momentary wager, a response to a challenge, rather than a true expression of his temperament; this was reflected more in urban scenes such as *Rue Mosnier* (1878), and portraits, or scenes of contemporary life, such as the dazzling series that leads from *Masked Ball at the Opera* (1873) to the last masterpiece, *A Bar at the Folies Bergère* (1881).

Boulevard in the studio

Ten years after *Music in the Tuileries*, *Masked Ball at the Opera* shows another contemporary crowd, this time in the old opera house in the rue Le Pelletier. Manet, as in previous paintings, plays on the contrast between the bright colours – worn mainly by the women – and the blacks of the men's suits and top hats. The scene was a doubly contemporary one, as it had taken place quite recently – Manet had sketched it on the spot – and it showed the scenery of the Goncourts' naturalistic play, *Henriette Maréchal*, which had caused a scandal in the same year as *Olympia*. The rather gloomy preponderance of men in black caused Baudelaire to remark 'we all seem to be celebrating a funeral'. The red boot that can be glimpsed above the hats is typical of the erotic and humorous female accessories with which Manet decorated his paintings and letters.

The famous *Nana* (1877) is entirely a light-hearted tribute to female vanity, from the embroidered stocking to the powder-puff, by way of the blue corset. A courtesan like Olympia, but a naturalistic version this time, this satisfied redhead gives a saucy intimate look, different from Victorine's hard *femme fatale* stare. Painted three years before Zola's novel of the same name, she is already the cocotte keeping her old roué waiting. It was not surprising, given the subject-matter, and the Impressionist light colours, that the painting was turned down by the Salon. Manet showed it all the same, but in the window of a boutique in the boulevard des Capucines, where it caused riots. 'M. Manet's great crime', wrote J. de Marthold, a critic who supported him against the Salon, 'is not so much the fact that he paints modern life, but that he paints it *life-size* . . . Only the Romans had the right to do that . . . Lesbia, perhaps, but not Nana . . ., helmets, but not hats!' Manet's attitude was summed up by the very fact that he chose to exhibit his painting on the boulevard, demonstrating his insolence and his need to be seen and recognised, and to maintain the aura of admiration and scandal. 'You are as famous as Garibaldi!' Degas said to him sarcastically. This popularity in the boulevards and cafés may have consoled him for the repeated insults of the art establishment, to which he was far from indifferent.

During the previous year, he had, in a similar gesture, exhibited the rejected paintings in his own studio, alongside several others, in a fortnight-long retrospective. He wrote on the invitations his chosen motto: 'Paint the truth, let them talk.' It was a great success, and the studio was described in several articles, as was the painter himself, whose Parisian character was stereotyped as a 'respectable revolutionary'. 'I talked to him one day,' wrote a journalist, 'and he astonished me with his classical views. He certainly does not mix with rabble. . . . He lives in a house where the concierge makes the model for *The Glass of Beer* go in by the servants' entrance.' The critic from *L'Evénement*, observing Manet's everyday life, concluded that he must have a dual personality: 'On one hand the painter, in his studio at number 4 rue Saint-Pétersbourg; on the other, the man of the world, the good bourgeois with his family along the same street at number 49!' None of the journalists seemed really interested in his painting. To them he was a figure from the boulevards, and they could not see that this same Paris was at the heart of his work. And yet, between 1877 and 1879, he painted a whole series of characters in cafés, café-concerts, restaurants and skating-rinks, reconciling his interest in modern realism with his taste for theatre

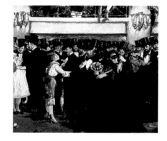

Masked Ball at the Opera

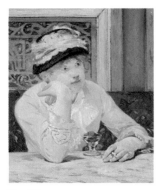

The Plum

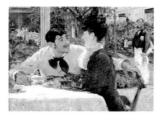

At Père Lathuille's

and his increasingly vibrant technique in portraits that were both posed and spontaneous. We are familiar with the delightful *Girl Reading*, the drinker in *The Plum* and the skater in *Skating*. For the Salon he prepared more complex arrangements, such as that intended for the large painting of Brasserie de Reichshoffen, which, cut up and reworked would be the origin of several paintings, such as *At the Café*, *The Café-Concert* and the two versions of *The Waitress*. He often used his friends, or actual waitresses as models – they would come to his studio and re-enact their work.

He did, however, make his friends pose on the spot for a naturalistic little scene in a restaurant in the avenue de Clichy, *At Père Lathuille's* (1879). 'Here is the modernism I have been speaking about,' said Huysmans, when he saw the painting at the Salon in 1880, 'here is life shown without exaggeration, just as it is . . .' In the same year Manet painted *The Conservatory*, a more formal portrait depicting M. and Mme Guillemet. Zola had used this indoor jungle as the background for famous scenes in *La Curée*, and here this winter garden in a corner of Manet's studio in the late 1870s provides a dark background to highlight the faces and hands of the distinguished couple. Manet showed this painting at the 1880 Salon with a second one painted five years earlier, *In the Boat*, in which another, more ordinary couple, a boatman and his companion, stand out against a bright blue background. These two large paintings – they are about the same size – almost form a diptych such as the one Renoir was to complete a few years later with *Dance in the Town* and *Dance in the Country*. Manet must have felt particularly pleased with these two pictures as he wrote at the time of the 1879 Salon to the Under-Secretary of State for the Fine Arts in the hope of a state purchase – a wish that was to fall on deaf ears. He was also hoping that year for a public commission for the decoration of a room in the new Hôtel de Ville, but, unfortunately, his 'naturalist' plan was not adopted. He had wanted to 'paint a series of compositions representing, to use a common phrase and which sums up my idea, the "guts of Paris"; the different corporations operating in their areas, the entire commercial and public life of our times. I would show the Paris of the Halles, the railways, the port, the sewers, the race-course and the parks. On the ceiling there would be a gallery around which would circulate, in appropriate postures, all the living men who have, in civilian life, contributed to the greatness and prosperity of Paris.'

It is doubtful that he would have been able to complete this grand enterprise. He was already suffering from locomotor ataxy, caused by syphilis, of which he would die three years later, and which was the reason for the cures he underwent during his last three summers, at Bellevue, Versailles and Rueil; hydrotherapy was, at the time, the only way of dealing with this illness. He would still paint several garden views, and a dazzling series of portraits in pastel of his many young and elegant women friends, society girls such as Isabelle Lemonnier, singers and actresses, such as Emilie Ambre and Jeanne Demarsy, *demi-mondaines* of varying degrees of glamour such as Valtesse de La Bigne or Irma Brunner, as well as Mallarmé's muse and Manet's closest friend in his final years, Méry Laurent.

His friend Prins wrote: 'Manet had been suffering since 1878, physically in spasms, but mentally all the time . . . The curious thing was that the presence of a woman, *any woman*, was the only thing that cheered him up.' He was enchanted by frivolity, light conversation and elegant costumes. He used clothes in his portraits, particularly hats, to provide emphasis and bring out the individuality of a face. In his great portrait of Berthe Morisot, known as *The Bunch of Violets* (1872), the dramatic, almost hallucinatory character is provided as much by the black hat with its ribbons as by the dark staring eyes; in *The Conservatory*, Mme Guillemet's little yellow hat accentuates her refined elegance; and Méry Laurent's generous beauty is enhanced by her large fur stoles and feathered hats.

A less triumphal, more melancholy beauty would be at the centre of Manet's final masterpiece, the famous *A Bar at the Folies Bergère*, the ultimate expression of the Parisian world, which Manet had been depicting since *Music in the Tuileries*, *Olympia*, *The Balcony*, *Masked Ball at the Opera*, and the café series. The picture is both sparkling and poignant, painted as it was by someone already seriously ill. A

real waitress from the Folies Bergère posed for him in his studio. This realistic subject, with the play of reflections in the mirror behind the young woman, of the room, the spectators and even the little legs of an acrobat at the top left-hand side of the canvas, represents a sort of farewell to the lively, slightly seamy Paris that Manet had made his own. The foreground is a kind of repository of the traditional ingredients of a party, champagne, liqueurs, exotic fruit and flowers – roses contrasting with the jacket, the bunch at the neckline – which symbolise the waitress's proffered innocence. The space is deceptive – her back is on the right although the mirror appears to be flat and her interlocutor faces her, although not in reality since we, the spectators, have taken his place; the waitress's full-frontal position, her reserved attitude and her melancholy assurance all provide her with strange dignity. The lighting, half natural and half artificial, veiled with smoke, is unreal. 'Manet was not a naturalistic painter, he was a classical one,' observed Jacques-Emile Blanche who watched the picture being painted. 'As soon as the paint goes on to the canvas, he is thinking of the painting rather than the subject.' By its very technique, its ambiguities, its deliberate errors of perspective, the painting appears to be the reflection of a reflection, the shimmering image of a disappearing world. The power of this painting lies perhaps in the fact that it is in itself a farewell to painting itself, which was his life.

to the human form, neglected by the Impressionists to whom he bequeathed a new freedom of pictorial form. His humanity was part of his own time, but timeless as well, since he never dabbled in sentimentality – hence the subtlety and honesty of his work. Whether it was Victorine Meurent, Berthe Morisot, Suzanne Leenhoff's son Léon, waitresses or tribunes, nobody tried to give a message, to instruct or to seduce. The same immobility appears in the 'Spanish' models of the 1860s as in the 'Impressionist' ones of the 1870s and 1880s, leaving all the emotional power to the painting alone, the true expression of a great 'modern'.

FRANÇOISE CACHIN

'I must be seen completely'

The Spain of Manet's youth reappeared at the end of his life in his only real self-portrait, known as *Self-Portrait with Palette* (1879). Here he appears as an elegant *boulevardier*, showing himself in the very guise that prevented him from being taken seriously, that of an ageing but still sprightly dandy. Mallarmé described it: 'Through the hangover, a virile simplicity emerges from the brown overcoat, the beard and thinning blond hair, going grey with style.' But alongside this image, he is also proclaiming himself a master, with the same gesture and paintbrush as Velázquez. He was indeed perfectly aware of his own value, even if, having first been victim of his own image, he became that of the Impressionist avant-garde who stole his limelight. But he knew quite well that he had, before them, created a new kind of beauty, a modern mythology which perpetuated the values of great art in contemporary terms. His urban scenes and his portraits demonstrate his attachment

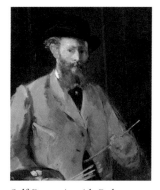

Self-Portrait with Palette

'I have painted a Parisian character'

Before the advent of the Second Empire, the Louvre contained Louis-Philippe's 'Spanish museum', a prestigious collection which was returned in 1848 to the Orleans family. When he left Couture's studio in 1856, Manet had not yet found his own personal style. In order to perfect his technique, he used to go to the Louvre to copy the great masters, particularly Velázquez, whom he admired. His *Spanish Cavaliers* are directly inspired by *The Little Cavaliers*, attributed to Velázquez, which was then in the Louvre. With the Salon in mind, he had composed a painting which was both personal and in the tradition of the masters.

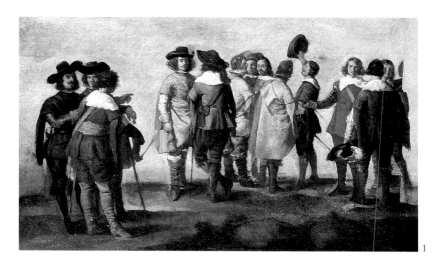

1

In the Louvre galleries one day, he met a rag-and-bone man by the name of Collardet, and straight away saw the potential of this figure with his worn top hat: he produced a pictorial version of his friend Baudelaire's prose poem: 'He catalogues and collects all that the great city has smashed and rejected. He keeps the archives of debauchery, the storehouses of waste . . .' By giving his painting a Baudelairian aspect, Manet was turning his back on the current trends, which tended to romanticise poverty. He was not quite aware then of what separated him from Couture, and, in the hope of winning his old teacher round, he invited him to come to the rue Lavoisier to see his contribution to the Salon. The master exclaimed at the sight of his pupil's work: 'My friend, this is only an absinthe drinker; it is the painter who has produced the insanity.' Manet chose to laugh at this, and broke finally with the teacher with whom he would clearly never agree. In 1859, he offered the painting to the Salon, held in the Palais de l'Industrie – it was, obviously, rejected, but it did have the support of one painter, Delacroix.

2

'I have painted a Parisian character, studied in Paris, and I have executed with the simplicity of method that I found in the paintings of Velázquez.
They won't understand. They might have understood better if I had painted a Spanish character.'

1
Velázquez, installed at the royal palace, was then painting portraits of Philip IV, the royal family and the courtiers. In Manet's time, young painters used to go to the Louvre to study paintings, amongst them *The Little Cavaliers*, attributed to Velázquez.

2
Antonin Proust remembered the day Manet heard that his *Absinthe Drinker* had been turned down and exclaimed: 'I've known it would be for the last three years. I never said anything to you about it . . . But I'm consoled by the thought that Delacroix liked it.'

3
Manet's *Spanish Cavaliers* includes a figure out of Velázquez. The little boy carrying a tray with a carafe was modelled by Léon Leenhoff, who was then seven or eight years old.

1 *The Little Cavaliers*
Undated. Attributed to Diego Velázquez
Oil on canvas, 47 x 77 cm
Musée du Louvre Museum, Paris (RMN)

2 *The Absinthe Drinker*, 1859
Oil on canvas, 181 x 106 cm
Ny Carlsberg Glyptotek, Copenhagen

3 *Spanish Cavaliers*, 1859
Oil on canvas, 45 x 26 cm
Musée des Beaux-Arts, Lyons

After the failure in 1859, Manet offered the Salon two years later the austere and uncompromising portrait of his parents, which had enabled his father to recognise Edouard's talent. The work, despite its severity, was dismissed as vulgar by the public, unlike *The Spanish Singer*, which he showed alongside it, and which was highly praised. This picture, very much in the current taste, showed a gypsy singing and plucking a chord on his guitar. The jury was sceptical and hung it very high up, but it was later lowered to a better position in response to general demand. Everybody admired *The Spanish Singer*, particularly Ingres, and Delacroix, who had supported Manet at the previous Salon. Théo-

1
Great works were beginning in Paris. Haussmann was modernising the city, building huge straight avenues, and digging up the streets to install gas and water pipes and a sewage system.

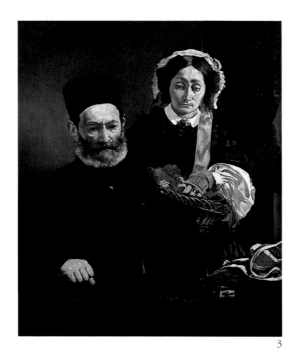

2
Boy with a Dog, although very clearly inspired by Velázquez and Murillo, is still recognisably by Manet. He continued with this subject in a series of engravings, a technique he had mastered with great ease, and used as an art form in itself rather than just a vulgar means of reproduction. In 1874, when he needed money, he agreed to bring out a new edition of 100 prints each of two engravings. So he reissued *Boy with a Dog*, a subject he thought would be agreeable, accompanied by another, more dramatic one, *Civil War*.

3
Auguste Manet, an important magistrate, would have liked his eldest son to follow the same career as himself. Manet probably undertook this portrait to prove the seriousness of his artistic vocation. It is an austere and faithful representation of a father who is already old and ill. There is a certain melancholy in the face of the mother, who was a god-daughter of the Queen of Sweden. There is, however, some colour, in the work-box she is holding, and the ribbon on her bonnet.

phile Gautier praised it in the *Moniteur Universel*. This singer, although he looked so Spanish, lacked some of the characteristic accoutrements: his costume is not entirely Spanish, and his clothes come from several different regions. However, the general style was Spanish, and it appealed to the public's growing interest in Spain. Manet returned to the subject in a series of etchings, commissioned by Alfred Cadart, a dealer in engravings. One of this series was *Boy with a Dog*, an engraving from a painting begun in 1860, very much inspired by Murillo, whom he did not much admire 'except', he said, 'in some of the studies of beggars'.

2 *M. and Mme Manet*, 1860
Oil on canvas, 110 x 90 cm
Musée d'Orsay, Paris (RMN)

3 *Boy with a Dog*, 1862
Lithograph, 2nd print., 20.9 x 14.8 cm
Bibliothèque Nationale, Paris

4 *The Spanish Singer*, 1860
Oil on canvas, 147.3 x 114.3 cm
Metropolitan Museum of Art (gift of William Church Osborn), New York

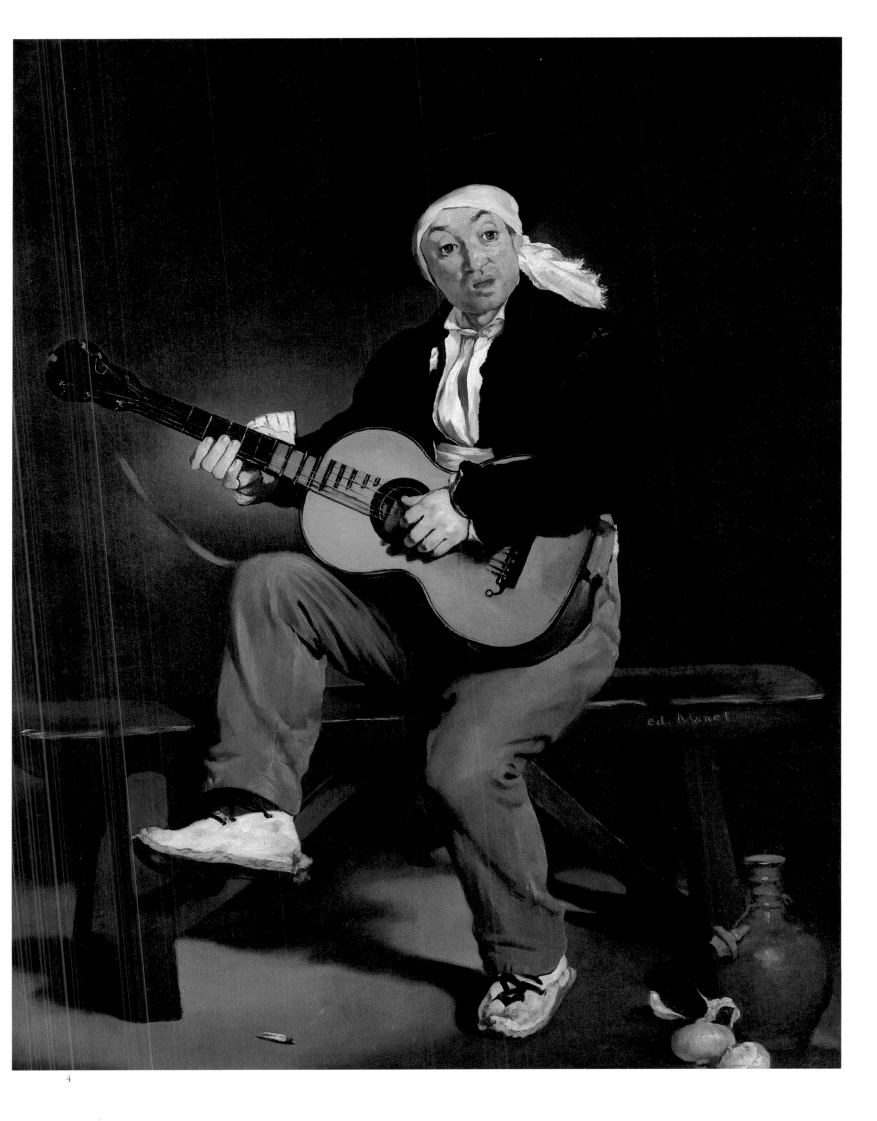

4

In 1859, Manet left the studio he had been sharing with the animal painter Balleroy, and moved to the rue de la Victoire. Here he completed the portrait of Alexandre, the little boy he had taken in, who cleaned his palette and washed his brushes. *Boy with Cherries* is a charming piece, traditionally composed, but with Manet's style already emerging, for example, in the way flesh is painted, with the touches of light that would continue to appear throughout his work. The smile on the child's face gives no hint of the tragedy that later occurred. Baudelaire put himself in Manet's place in the poem entitled *The Rope*, and gives an account of this sad episode: 'The child, when he had been cleaned up, became charming, and the life he led with me seemed like a paradise compared to the parental hovel. But he did surprise me sometimes with bouts of immoderate sadness, and he developed an uncontrollable taste for sugar and liqueurs; so much so that, after several warnings, I threatened to send him back to his parents.' When he returned to the studio, Manet found the child hanging from a nail.

In 1861, he moved to the rue Guyot, near the parc Monceau. He would stay there until 1870. Here he began *Fishing*, a composition borrowed from Rubens and Annibale Carracci. In it, for the first time, he shows himself, as well as Suzanne and Léon. The couple in

1

In *The Park of the Château de Steen*, Rubens shows himself with Hélène Fourment, thirty-seven years younger than himself, whom he had married five years earlier. Manet's painting is a copy of this one, right down to the costumes.

2

This painting can be interpreted as representing Manet's family life around 1860; it contains the traditional elements of a marriage painting: the rainbow and the dog, symbols of unity and fidelity, as well as the church, whose spire can be seen in the background.

2

'My job as a painter forces me to look very closely at faces.'

3

3

Annibale Carracci, one of the leaders of the Bologna school, was famous for his decoration of several palaces in which the brightness of his pale colours contrasts with the violent tones of the luminists. He excelled in compositions with landscapes, of which *Fishing* and *Hunting*, both in the Louvre, are the best examples.

Fishing at Saint-Ouen, himself and his young wife, is modelled on the one in Rubens' *The Park of the Château de Steen*. Léon, who was then thought of as Suzanne's brother, stands in the background, seeming to indicate by this position where he stood in Manet's life. It is now known that he was Suzanne Leenhoff's son and was brought up by Manet. It is not, however, certain that he was Manet's son.

1 *The Park of the Château de Steen*
c. 1635. Rubens
Oil on canvas, 52.7 x 97 cm
Kunsthistorisches Museum, Vienna

2 *Fishing at Saint-Ouen*, 1861-3
Oil on canvas, 76.8 x 123.2 cm
Metropolitan Museum of Art (gift of
Mr & Mrs Richard J. Bernhard), New York

3 *Fishing*, 1585-8. Annibale Carracci
Oil on canvas, 136 x 253 cm
Musée du Louvre, Paris (RMN)

4 *Boy with Cherries*, 1859
Oil on canvas, 67 x 54 cm
Calouste Gulbenkian Foundation, Lisbon

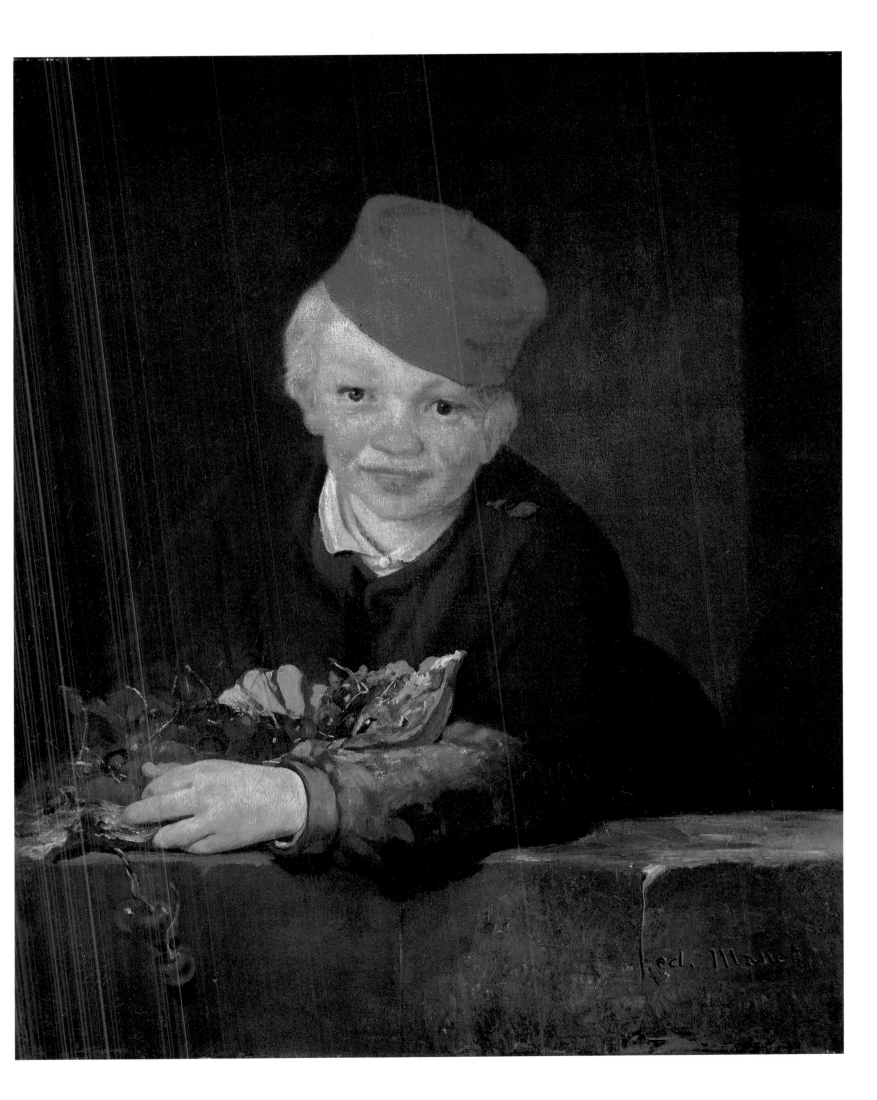

Emerging from Couture's studio, Manet turned against the tradition which insisted that the composition of a painting should be indoors and not against a natural background. 'There are fields and, at least in summer, one could do nude studies in the countryside, since the nude is, apparently, the last word in art.' But, at that time, nudes had to be idealised. This is why *Nymph Surprised* shows Manet's hesitation and caution. The work completed between 1859 and 1861, is a real laboratory piece. The artist was not yet free from the influence of the masters that he used to copy in the Louvre, such as Boucher's *Diana Emerging from the Bath* or Rembrandt's *Bathsheba*. According to Antonin

Proust, Manet had undertaken a great composition in his studio in the rue Lavoisier: this *Moses Saved from the Waters* seemed to be nothing more than a pretext for painting a nude since, according to the artist's contemporaries, the figures of Moses and the Pharaoh's daughter bore no relationship to one another. Manet was not satisfied with it and cut up the canvas, keeping only the nude. The young Egyptian girl, posed by Suzanne, then became a nymph. The servant behind her disappeared, and the child was replaced by a satyr. The latter was added with a clear commercial intention. The painting was shown at the Exhibition of the Imperial Academy of St Petersburg. In the end, Manet removed the satyr in the final version, and the nymph is surprised only by the spectator's gaze. He had crossed a barrier on the path towards personal expression, which was to lead, a few years later, to *Le Déjeuner sur l'Herbe*.

2
Hendrickje Stoffels posed as Bathsheba for Rembrandt. She entered his service in 1645, and became his mistress. One can understand why Manet was inspired by this master, who introduced a new type of beauty to the history of art.

1
Boucher, who was Mme de Pompadour's drawing teacher, had an extraordinary facility. He was adept at rendering mythological landscapes and subjects, and had a particular talent for the nude.

3
Jean-Baptiste Santerre was accepted by the Royal Academy of Painting with his *Suzanne au Bain*. However, he did cause scandal with his licentious treatment of holy scenes. The position of the arm and the treatment of the material were probably what inspired Manet.

1 *Diana Emerging from her Bath,* 1742. Boucher
Oil on canvas, 56 x 73 cm
Musée du Louvre, Paris (RMN)

2 *Bathsheba,* 1654. Rembrandt
Oil on canvas, 142 x 142 cm
Musée du Louvre, Paris (RMN)

3 *Suzanne au Bain,* 1704. Santerre
Oil on canvas, 205 x 145 cm
Musée du Louvre, Paris (RMN)

4 *Nymph Surprised,* 1859-61
Oil on canvas, 146 x 114 cm
National Art Gallery, Buenos Aires

4
This painting was originally part of a much larger one, as one can see in the sketch in Oslo. Almost 2.5 m wide, it was, until *The Old Musician,* the first large painting of his youth. He retained only the realist section, and destroyed the more academic parts thus refusing to make any concessions to fashion.

This uncompromising style was confirmed in the following year with *Baudelaire's Mistress*. Jeanne Duval is shown with harsh realism, ageing and ill as she was; Manet's contemporaries had already noted his severity towards his models. This portrait remained in the studio, which leads one to suppose that Baudelaire himself was not

1

pleased with the painting. In 1859, the young woman had suffered an attack of hemiplegia, which explains her strange position, and the stiff leg emerging from the white dress. Baudelaire, whose stormy relationship with her was one of mingled passion and pity, used to call her his 'black Venus' (although, strictly, she was creole), and his 'old child'. This exotic type of woman reappears in *Gypsy with a Cigarette*, a portrait which may have been part of a large composition, *The Gypsies*, which Manet is thought to have cut up after his exhibition near the Pont de l'Alma in 1867. The bright colours of the gypsy's costume contrast with the grey and white harmonies in the portrait of Jeanne; the relaxed gesture with the formal pose; and the horses and fresh air with the drawing room décor.

1
Ten years before this portrait was painted, Baudelaire wrote to his mother about his despair 'living with a person who has no liking for your work, and thwarts it with constant tactlessness and ill will, who regards you as no more than her servant and her property . . . a creature who *will not* learn anything, who *does not admire me*, who would throw away my manuscripts rather than publish them, if that were to make more money.'

2
Degas acquired this canvas at the sale of Manet's studio in 1884. The centering of the painting, unusual for 1862, must have pleased him, famous as he was for his close-ups of theatrical scenes, and his photographic cut-outs of racecourses.

'Duranty is wrong about my great plans. He imagines me painting huge pictures. I certainly will not.'

1 *Baudelaire's Mistress*, 1862
Oil on canvas, 90 x 113 cm
Szepmuveszeti Museum, Budapest

2 *Gypsy with a Cigarette*, 1862?
Oil on canvas, 92 x 73.5 cm
Art Museum, Princeton University
(gift of A. Alexander), New Jersey

Manet was often accused of painting ugliness. The accents he placed in his painting and his way of working with shadows were not understood at the time by the critics and the public. Madame Brunet, the wife of the sculptor Eugène-Cyrille Brunet, was one of the first victims. But the one most mocked was undoubtedly the young eighteen-year-old model whom he had just discovered: Vic-

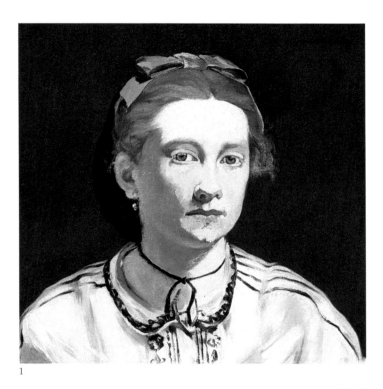

1

torine-Louise Meurent. The critics showed the same incomprehension before *The Street Singer*, for which she posed, as they had done with the *Portrait of Mme B.* Manet had found his subject in the course of one of his walks with his friend Antonin Proust. 'At the entrance to the rue Guyot,' Proust tells us, 'a woman emerged from a low bar, holding up her dress and carrying a guitar. He went straight up to her and asked her to come and pose at his house. She began to laugh. "I'll get her another time," cried Manet, "and if she won't, I'll use Victorine."' And, indeed, it was Victorine who posed for this painting, which was turned down by the 1863 jury. Manet was reproached for not continuing in the successful vein of *The Spanish Singer.* The critic Paul Mantz, who had seen the painting at Martinet's, observed this straying from the path: 'Monsieur Manet has, with his usual courage, travelled into the world of the impossible. We absolutely refuse to follow him.'

1
Manet apparently met Victorine Meurent at the Palais de Justice and was 'struck by her original appearance and trenchant manner'. Although only eighteen, she was already a professional model, and also sat for Couture's pupils. In this portrait, Manet shows her harshly lit, without any of the subtleties of shade that were then the fashion.

2
Manet had begun a portrait of Mme Brunet, photographed here, but when she saw how ugly he had made her, she ran away crying. M. Brunet, not wanting to force this picture on his wife, turned it down. Manet kept it and showed it along with several other paintings at the Martinet gallery under the title *Madame B.*

2

1 *Victorine Meurent,* 1862
Oil on canvas, 43 x 43 cm
Museum of Fine Arts (gift of R.C. Paine), Boston

2 *The Street Singer,* 1862
Oil on canvas, 175.2 x 108.6 cm
Museum of Fine Arts (gift of Sarah C. Sears), Boston

3
This strange portrait of Victorine Meurent was rejected by the 1863 Salon. In it Manet mingles several themes; there is elegance in the costume and the little hat, but an element of downfall is also suggested by the setting, and the fact that she is eating cherries from a paper and holding a guitar. 'By some deeply worrying fluke, the eyebrows have abandoned their normal position and placed themselves vertically along the nose, like two dark commas; we are left with the clash between the black and the plaster-like pallor. The effect is pale, hard and gloomy.' Only in 1884 did Philippe Burty acknowledge some grace in this work: 'By 1861, Manet was already attempting a modern style which our contemporaries are still finding hard to accept, painting a street singer, a tall girl emerging from a brasserie, eating cherries, carrying a guitar as if it were a handbag. He was the first to be so bold.'

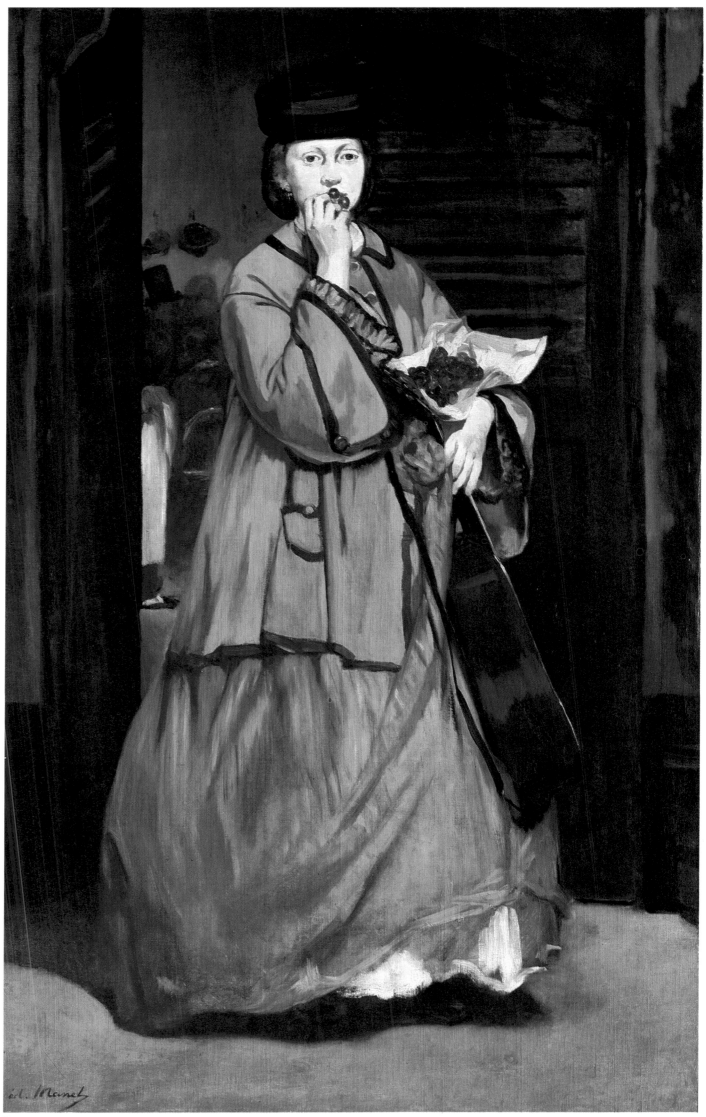

It was not only his technique, but also the subjects he chose, which shocked people. The limits of this provocation were finally breached with *Le Déjeuner sur l'Herbe* and *Olympia*. Already by 1862, the details Manet was fond of – the languid pose and enigmatic presence of a cat – could be found in *Reclining Young Woman in Spanish Costume*. This is probably the mistress of Félix Tournachon, known as Nadar, the friend of the Impressionists and admirer of Goya's work. The costume she is wearing probably belonged to the artist and came from the Spanish tailor in the rue Saint-Marc. The young woman's masculine costume hints at the female form more effectively than the

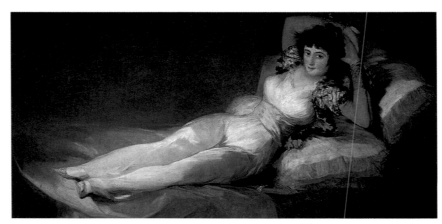

1

1/3
The photographer Nadar particularly liked Goya's *Majas*, which is probably why Manet painted his mistress in the Spanish painter's style.

'I paint what I see
and not what it pleases others to see,
I paint what's there, not what is not there.'

crinolines that were then in fashion. The short black jacket can be seen again in *Mademoiselle Victorine in Espada Costume*. This painting was shown at the 1863 Salon des Refusés, alongside *Young Man in Majo Costume*. The two pictures were hung on either side of *Le Déjeuner sur l'Herbe*, the work which had aroused such controversy. Manet was not looking for a realistic interpretation, which was why he dressed his models in strange clothes, putting them on the level of fantasy. He was often reproached for his carelessness with perspective, but he was not seeking to show a realistic scene. Victorine's gesture recalls a Raimondi engraving, the background depicting one of Goya's bull-fighting scenes, but the sum of the parts forms a deliberately artificial composition. So the touch of yellow from the scarf under the figure's arm would reappear in many of Manet's later paintings, in the shape of a lemon. In *A New Way of Painting*, Zola was the only person who praised this very modern style: 'very brutal, but unusually vigorous and extremely powerful in tone. My view is that the painter here is more of a colourist than usual. The painting is still light, but brighter and wilder.'

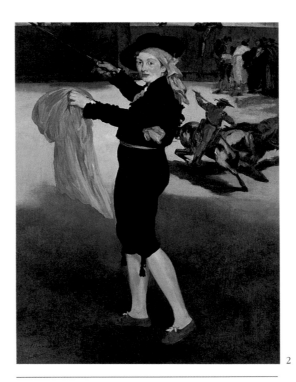

2

2
'There is a lot of talk about this young man. Let us be serious. The *Bath*, the *Majo*, the *Espada* are good sketches, I admit. There is a certain liveliness in the colour, and boldness in the brushstroke which are certainly not vulgar. But what more? Is this drawing? Is this painting?' (The critic Castagnary at the Salon des Refusés in 1863.)

1 *Clothed Maja*, 1801-3. Goya
Oil on canvas, 95 x 190 cm
Prado Museum, Madrid.

2 *Mademoiselle Victorine in Espada Costume*, 1862
Oil on canvas, 165.1 x 127.6 cm
Metropolitan Museum of Art
(gift of Mrs H.O. Havemeyer), New York

3 *Reclining Young Woman in Spanish Costume*, 1862
Oil on canvas, 94.7 x 113.7 cm
Yale University Art Gallery, Connecticut

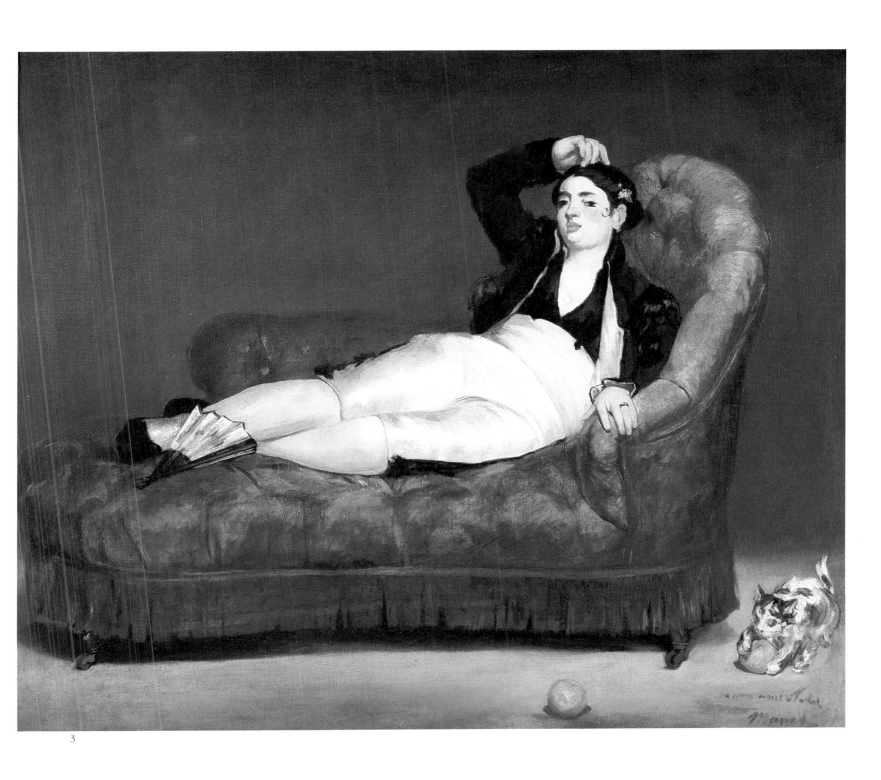

3

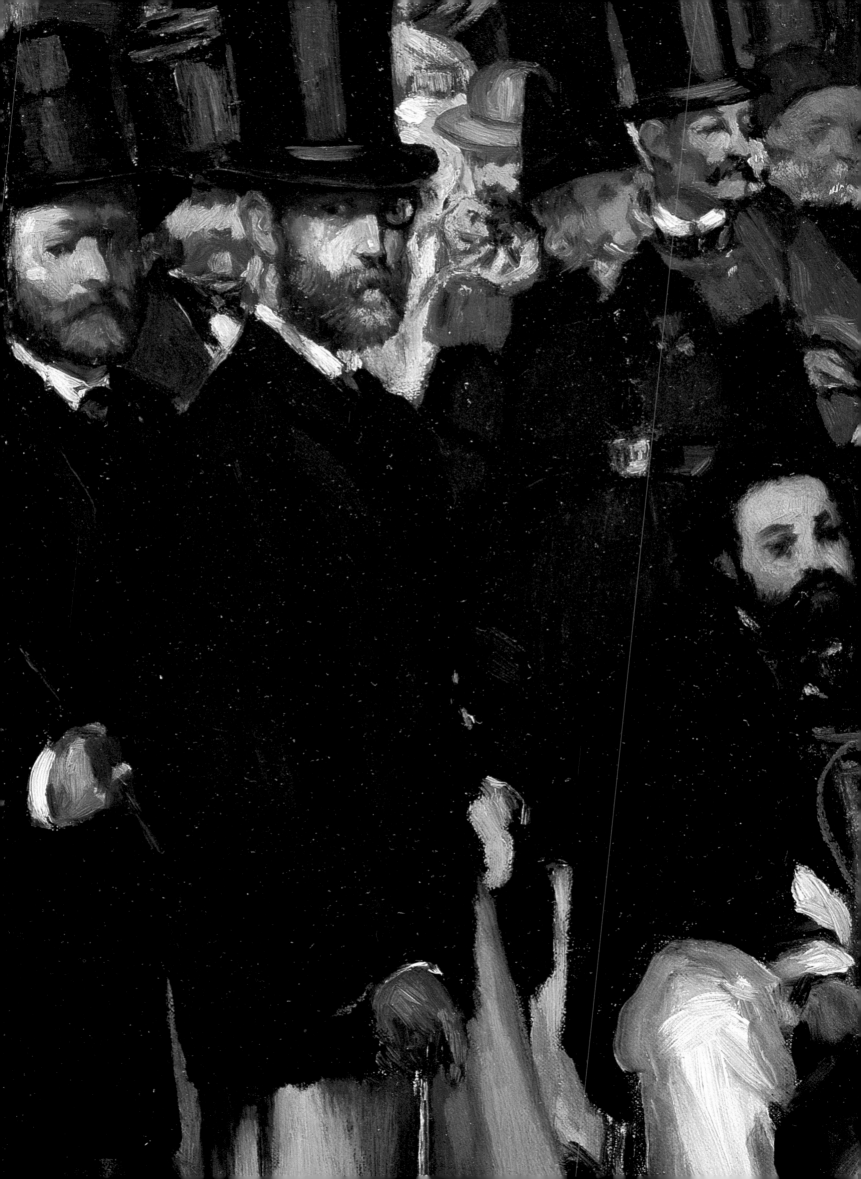

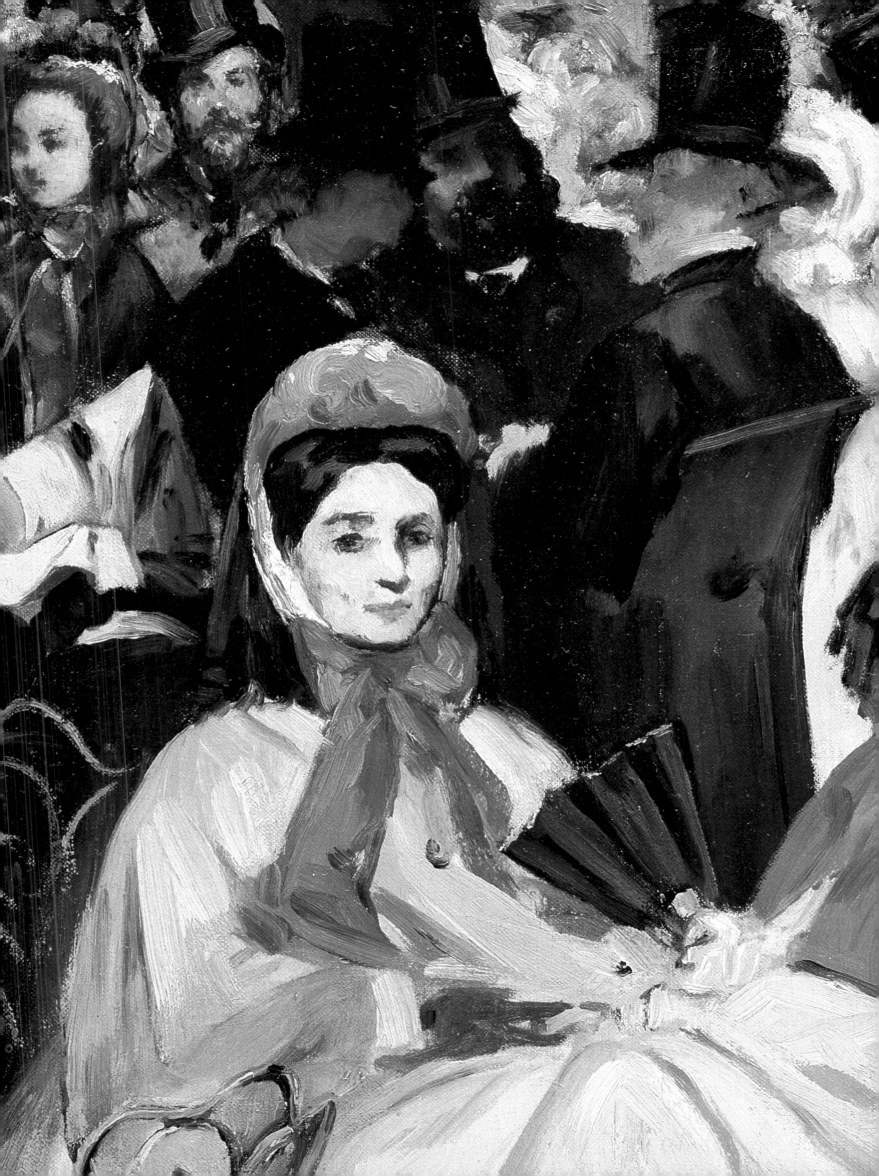

'Each figure is a little patch, hardly formed...' (Zola)

1
All the people shown here are identifiable. One can recognise, from left to right, Manet and Albert de Balleroy, with whom the painter had shared his first studio. Between them is probably Champfleury. Zacharie Astruc is in

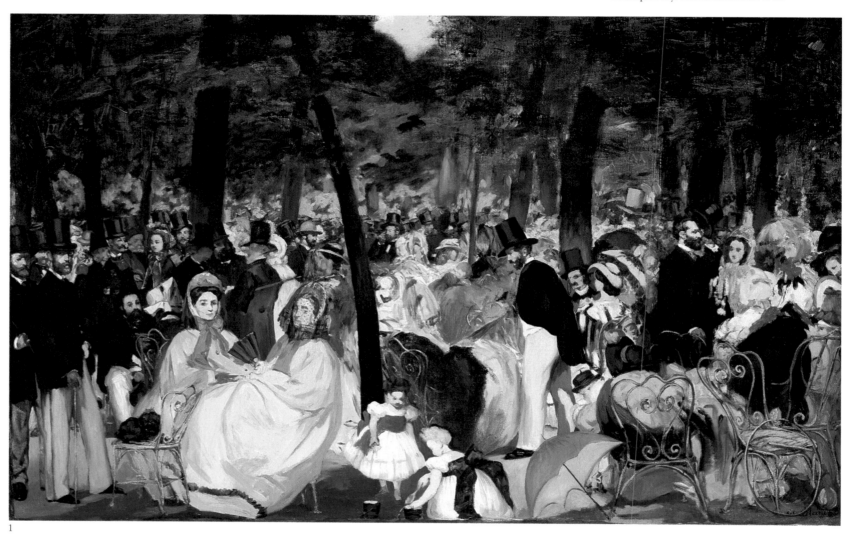

1

the background, and behind him stands the journalist Aurélien Scholl. The group of men standing under the tree consists of Baudelaire, who is recognisable from the engraving Manet had already done of him (3), Baron Taylor, a great admirer of Spanish painting, on the left of the poet, and behind him Fantin-Latour. The two women in the foreground are Mmes Lejosne and Offenbach. Standing, in the centre of the canvas, leaning over a woman, is Eugène Manet, the artist's brother. Sitting in the background is Jacques Offenbach, and, finally, the figure on the right gallantly raising his hat is Charles Monginot.

2

Preceding pages (detail) and 1
Music in the Tuileries, 1862
Oil on canvas, 76 x 118 cm
National Gallery, London

2 *The Tuileries Gardens.* Drawing by M. Hédouin
Engraving by M. Delduc
Bibliothèque Nationale, Paris

3 *Portrait of Baudelaire,* 1862-9
Etching, 1st plate, 13 x 7.5 cm
Bibliothèque Nationale, Paris

5 *The Balloon,* 1862
Lithograph, 40. 3 x 51.5 cm
Bibliothèque Nationale, Paris

3

'At that time,' recalls Théodore Duret, 'the château des Tuileries, where the Emperor had his court, was a centre of elegant social life, which spread into the gardens. There was music there twice a week, which attracted a smart and worldly crowd.' In *Music in the Tuileries*, in which the kiosk is missing, Manet shows himself in the midst of a crowd of friends. Velázquez had done the same thing with *The Little Cavaliers*, also known as *Gathering of Artists*. Although they are very much simplified, all the portraits can be identified. This seemingly casual style aroused criticism when the painting was shown at the Martinet gallery in 1863. Also Manet had chosen a subject thought of as too popular,

4

The Tuileries Gardens

'One must be of one's own time, and paint what one sees, without worrying about fashion.'

5

5

Manet was as happy to paint popular gatherings in the streets of Paris as he was the colourful society of the Tuileries. The launching of a balloon, probably Nadar's, was a great excitement for the nineteenth-century Parisian, and when Manet received three engraving plates from Cadart, he quickly recorded his sketch of it. Cadart intended to publish the lithographs in a bound edition. Unfortunately, Manet's drawing was muddled and lacked the perfect finish of traditional lithographs, and so the project was abandoned.

and mostly seen in the magazines of the time. He wanted to be a witness of his own times, and condemned Diderot for criticising painters who showed hats that would soon go out of fashion. Emile Zola was soon the chief defender of *Music in the Tuileries*: 'If I had been there, I would have told the spectator to stand well back. He would have seen then that the patches were alive, that the crowd was talking, and that this painting was most typical of the artist – he obeys both his eyes and his temperament.'

This work is a milestone in the history of art in that it represents one of the first steps towards modern painting; Bazille, Monet and Renoir would continue to paint outdoor scenes of everyday life, one of the great themes of Impressionism.

On 12 August 1862, the Mariano Cam-prubi troupe from the Theatre Royal, Madrid, arrived at the Hippodrome. For the second year running the Spanish ballet had a triumphal season with a new work, *La Flor de Sevilla*. The principal dancer was called Lola Melea, and known as Lola de Valence. This dark and 'manly' woman (according to Tabarant) became the toast of the Parisian artists. Manet saw in her a dreamt-for opportunity to paint a Spanish type. After *The Spanish Singer* (or *Guitarrero*), an imaginary Spaniard, here was a chance to paint the real thing. He first invited the whole ballet to come and pose in Alfred Stevens's studio in the rue Taitbout, which was big enough to hold all the dancers. There he painted *The Spanish Ballet*. According to Baudelaire, Lola de Valence then sat for Manet on her own in

1

2

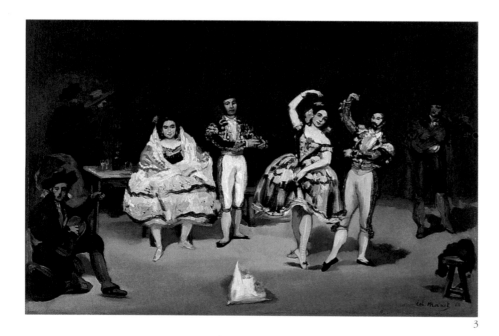

3

1
In this painting *Lola de Valence*, Manet echoes the composition of the famous *Portrait of the Duchess of Alba* by Goya.

2
The Spanish dancer was a recurring theme in popular imagery, as in this engraving by Gustave Doré, which shows the dancer in the same position as in Manet's painting, but in reverse.

3
Manet got the entire troupe of the Theatre Royal, Madrid, to pose for him while they were on tour in Paris. In this work, it appears that Manet composed the painting group by group, with great rigour. The two guitarists provide the diagonal axis, and the bunch of flowers on the ground indicates the centre, while the group at the back on the left is echoed by the stool at the front on the right.

his studio. He probably saw in her an opportunity to triumph at the Salon with a Spanish subject, as he had done with *The Spanish Singer*. However, the picture was not accepted. He later reworked it, introducing a theatrical background behind the dancer. Baudelaire was inspired by her to write a quatrain to go with his friend's painting:
Entre tant de beautés que partout on peut voir
Je comprends bien, amis, que le Désir balance;
Mais on voit scintiller dans Lola de Valence
Le charme inattendu d'un bijou rose et noir.
He sent these lines to the artist, suggesting that he might 'perhaps write these lines at the bottom of the portrait, either in the paint, or in black letters on the frame'. The second suggestion was adopted.

1 *The Duchess of Alba*, 1797. Goya
Oil on canvas, 210 x 149 cm
Hispanic Society of America, New York

2 *La Amparo Dancing the Fandango*
Gustave Doré. Drawing
Viollet Collection, Paris

3 *The Spanish Ballet*, 1862
Oil on canvas, 60.9 x 90.5 cm
Phillips Collection, Washington

4 *Lola de Valence*, 1862
Oil on canvas, 123 x 92 cm
Musée d'Orsay (Camondo legacy), Paris (RMN)

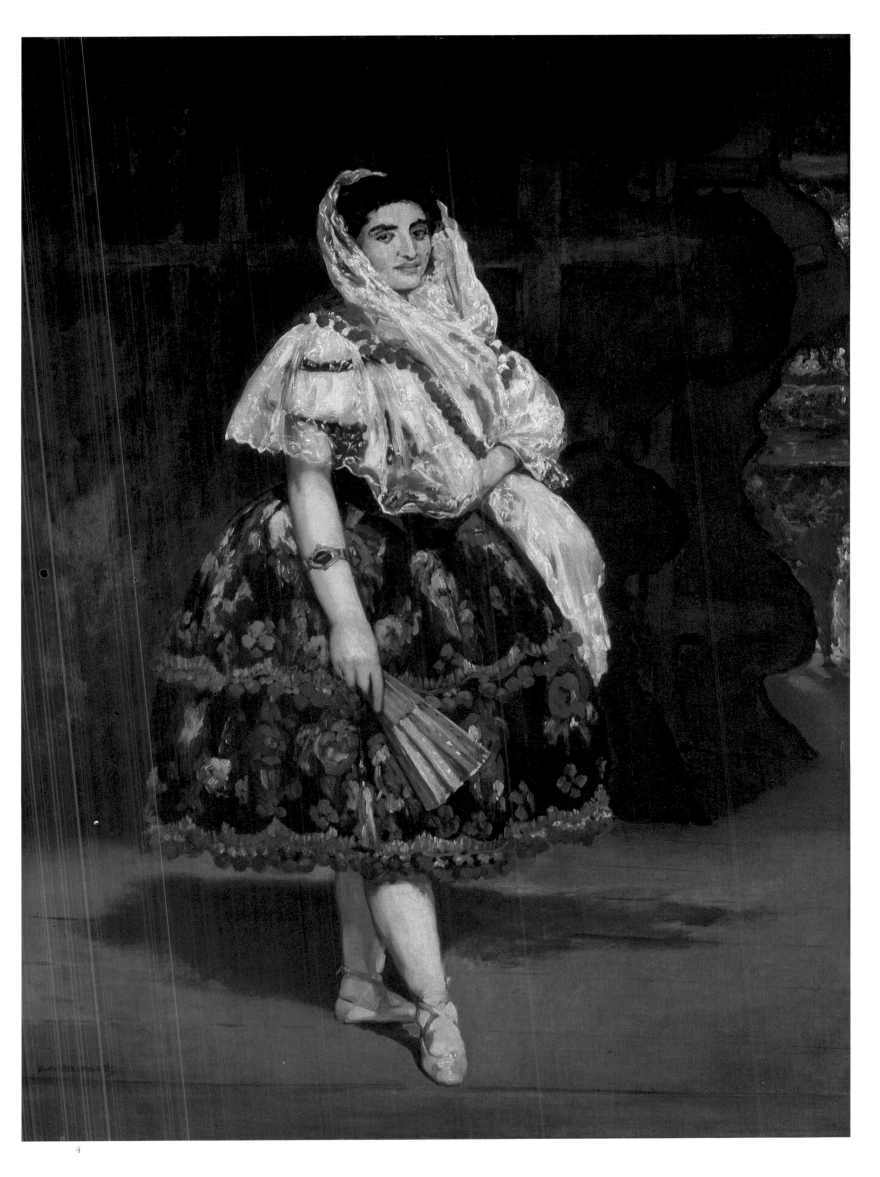

At the beginning of the year 1863, the Salon's new rules forbade artists to submit more than three paintings at a time. A petition, signed by everybody, was immediately handed to Count Walewski by Manet and Gustave Doré. Meanwhile, no doubt fearing refusal from the Salon, Manet showed a collection at the Martinet gallery, including *The Street Singer, Lola de Valence, The Spanish Ballet*, and *Music in the Tuileries*. The Salon jury, presided over by Nieuwerkerke, was extremely severe and rejected two-thirds of the entries. There was great consternation in artistic circles, so much that on 23 April, *Le Moniteur* dropped a bombshell with the following information: 'The Emperor has received many protests on the subject of works of art turned down by the Exhibition jury. His Majesty wishes to let the public decide for itself on the justice of these protests, and has decided that the rejected paintings should be shown in a part of the Palais de l'Industrie.' Some artists withdrew their paintings, but others, such as Manet, took up the challenge and thus it was that his most controversial work made its first appearance at the Salon des Refusés: *Le Déjeuner sur l'Herbe*.

More than 7000 people visited the Salon on the first day. The painter Cazin, one of the refusés, later said: 'The exhibition was separated from the other only by a turnstile. One went in as if to the Chamber of Horrors at Madame Tussaud's. In the furthest room, Manet exploded from the wall with his *Le Déjeuner sur l'Herbe*.' Some agreed that it was a truly innovative work, but for others he was transgressing the laws both of perspective and morality. He therefore became the archetypal refusé, since the majority of the critics did not understand the work and found it shocking and unprincipled.

1 *Le Déjeuner sur l'Herbe*, 1863
Oil on canvas, 208 x 264 cm
Musée d'Orsay (gift of E. Moreau-Nélaton), Paris (RMN)

Le Déjeuner sur l'Herbe'

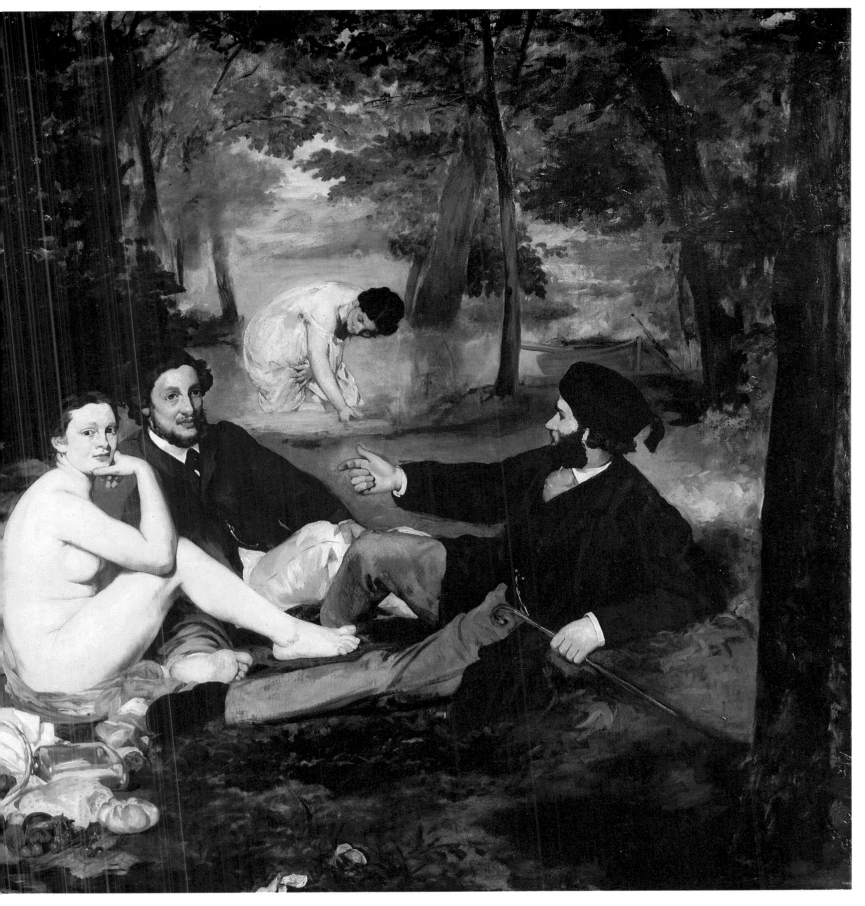

'Apparently, I must do a nude.

1

1
This painting illustrates the difference between a classical *Déjeuner sur l'Herbe*, such as this one by Boudin, and Manet's 'real' interpretation. The man's gesture is similar to that of the man on the left in Manet's painting. Boudin excelled in painting huge blue skies, just cloudy enough to be romantic, whereas Manet, whose painting was done in the studio, reduces the sky to a small square behind the trees.

2/3
There are many nudes in landscapes throughout the history of art. With the pretext of myth or allegory, painters went from judgements of Paris (Raphael) to pastoral concerts (Giorgione). Manet's *Le Déjeuner sur l'Herbe*, which caused such scandal in the mid-1860s, inspired the modern painter Alain Jacquet to reinterpret the theme a century later.

2

3

Well – I'll do them one.'

4/5

On 28 October 1863, Manet married Suzanne Leenhoff at Zalt-Bommel in Holland. This came as a surprise to all his friends, even Baudelaire who wrote to a friend: 'Manet has just told me the most unexpected news. He is setting off this evening for Holland whence he will bring back a *wife*. He does seem to have an excuse for this; apparently she is beautiful, good and artistic. Such gifts, all in the same woman, it's monstrous, isn't it?' Léon, who was eleven, came to live with the young couple when they returned from Holland a month later.

6/7

Zola, who had just discovered Manet's painting, was the first journalist to defend the painter against the opinion of the Salon jury. He tried, too, to explain this new type of painting to the general public. He also used to gather material for his novels at the Café Guerbois, never hesitating to make use of his painter friends.

1 *Déjeuner sur l'Herbe,* 1866. Eugène Boudin
Oil on canvas, 17 x 25 cm
Musée d'Orsay, Paris

2 *Pastoral Concert,* 1576. Giorgione
(Sometimes attributed to Titian)
Oil on canvas, 105 x 136.5 cm
Musée du Louvre, Paris (RMN)

3 *Déjeuner sur l'Herbe,* 1964. Alain Jacquet
Silk-screen on canvas, 175 x 196.5 cm
Museum of Painting & Sculpture, Grenoble

And yet Manet had never thought that such a scandal would arise. Antonin Proust remembered a day at Argenteuil, when they were both watching the boats on the Seine and the women coming out of the water. Manet had said to his friend: 'When we were at the studio I used to copy Giorgione's women, women with musicians. It was a very dark painting, overwhelmed by the background. I want to redo it with a transparent atmosphere, with women like those over there. They'll tear me to pieces, or say that I'm copying the Italians now, after the Spanish. They can say what they like.'

The painting brought together Manet's friends and family. Opposite the naked Victorine, who is looking at the spectator, Manet placed a composite of his two brothers, Eugène and Gustave. The bearded figure is Suzanne's brother, Ferdinand Leenhoff.

Amongst the crowd massed at the entrance to the exhibition was a young man from the South of France, who had come with his friend Cézanne: Zola. He was a journalist and an admirer of Manet's, and took up his defence at the following Salon over *Olympia*.

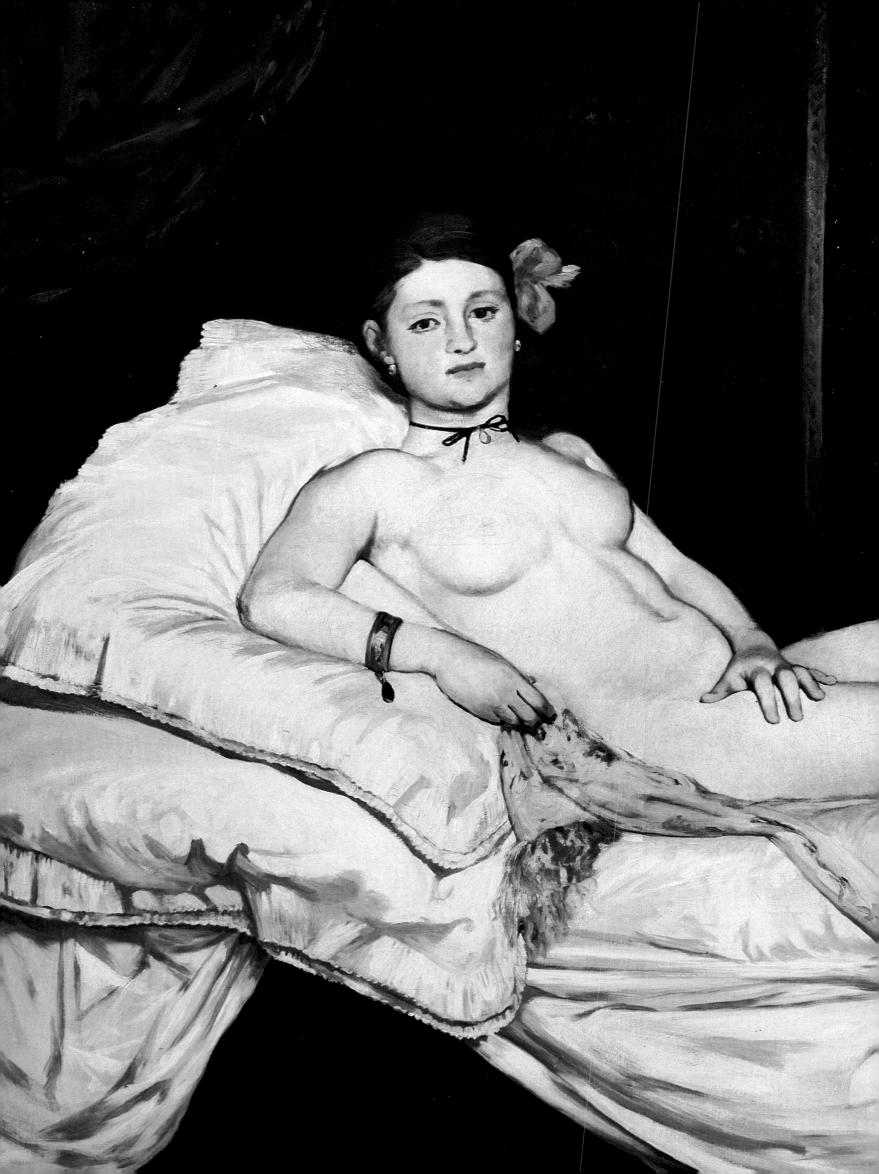

When *Olympia* appeared in 1865, he did not expect a renewed scandal. The critics had already been virulent on the subject of *Le Déjeuner sur l'Herbe*; this time Manet would become the most notorious painter of his time.

He had set out to represent a nude in the tradition of the masters he so admired at the Louvre, not this time a Venus or an odalisque, but simply a naked woman, a realistic contemporary individual. This nude was clearly one of the courtesans of the time, of which there were some flamboyant ones – the public was not fooled, this modern Venus was quite simply a prostitute. Olympia has the features of Victorine; she is not the idealised image prescribed at the Ecole des Beaux-Arts. And yet Manet was placing himself in a direct line from the masters he appeared to be parodying. One can see traces of both Velázquez and Goya, whose *Nude Maja* is clearly referred to. In the hope, perhaps, of playing down the scandal, Manet asked his friend Zacharie Astruc for a five-line extract from one of his poems to be inscribed on the frame and printed in the catalogue. His feeble poem, however, served only to emphasise the 'vulgarity' of the painting.

The critics were unleashed. 'The body has the livid tones of a corpse at the morgue; the outlines are in charcoal, her eyes are greenish and frayed at the edges . . .'

1

'I render, as simply as possible,
the things that I see.
So, in *Olympia*, what could be simpler?
They say there is harshness in it.
Well, it was there. I saw it. I painted what I saw.'

2

3

1 *Study for Olympia,* 1862-3
Chalk, 24.5 x 45.7 cm
Louvre/Musée d'Orsay;
graphic arts archive, Paris (RMN)

2 and preceding pages
Olympia, 1863
Oil on canvas, 130.5 x 190 cm
Musée d'Orsay, Paris (RMN)

3 *Caricature of Manet's Olympia,* 1865. Bertall
Drawing in *Le Journal Amusant*
Viollet Collection, Paris

4

In 1863, the year Manet painted *Le Déjeuner sur l'Herbe* and *Olympia*, Cabanel produced *The Birth of Venus*, which was a triumph at the Salon that year. Manet waited for two years before submitting his nude, but *Olympia* caused a scandal nonetheless. Cabanel's painting was bought in 1863 by Napoleon III; *Olympia* had to await a subscription by the artist's friends, in 1890, to get it into the Musée du Luxembourg. The painting went to the Louvre only in 1907, to be hung next to Ingres's *La Grande Odalisque*, and become the occasion for another outcry.

5

Manet's *Olympia* is based, indisputably, on Titian's *Venus of Urbino*. But where her pose is gentle and modest, *Olympia* lies provocatively, looking towards the spectator. The little dog is replaced by a black cat, a traditional sign of bad luck, and a clear erotic reference. The two servants in the background are replaced by a Negress holding a bunch of flowers, referring us to the invisible admirer who may be waiting behind the green curtain of the antechamber.

4 *The Birth of Venus, c.* 1863
Alexandre Cabanel.
Oil on canvas, 130 x 225 cm
Musée d'Orsay, Paris (RMN)

5 *Venus of Urbino,* 1538. Titian
Oil on canvas, 119 x 165 cm
Uffizi, Florence

6 *Odalisque,* 1844. Benouville
Oil on canvas, 124 x 162 cm
Musée des Beaux-Arts, Pau

Despite these scandals, Manet was still recognised for his still lifes. Critics, after tearing apart his works, would still concede the great virtuosity of the fragments of still life included in them: the dress and the picnic in *Le Déjeuner sur l'Herbe*, or the bunch of flowers in *Olympia*. Manet loved painting flowers, particularly peonies of which he was most fond. These flowers, which had only recently been imported into France, were considered to be luxuries. At the end of his life, when he

A knife for perspective

was immobilised by illness, he would paint them straight from the garden, quite simply thrown into a glass. But in 1864, Manet's still lifes were still impregnated with the tradition of the 'vanities' of the seventeenth-century Flemish and Spanish: a cruel image of ephemeral beauty. He painted peonies in the way that Chardin, whom he admired so much, would paint a dead rabbit, even going as far as to arrange *Peony Stem and Secateurs* in the manner of a hunting picture. He also painted fish and fruit, and where tradition demanded opulence he would choose sobriety: a white cloth on a dark background, with a pair of secateurs or a knife to indicate perspective. The knife would reappear in 1868, in his great virtuoso still-life composition, *Lunch in the Studio*.

Preceding pages:
White Peonies with Secateurs, 1864
Oil on canvas, 31 x 46.8 cm
Musée d'Orsay (Camondo legacy), Paris (RMN)

1 *Still Life with Carp,* 1864
Oil on canvas, 73.4 x 92.1 cm
Art Institute (Coburn Memorial Collection), Chicago

2 *Peony Stem and Secateurs, c.* 1864
Oil on canvas, 56.8 x 46 cm
Musée du Louvre (Camondo legacy), Paris (RMN)

3 *Fruit on a Table,* 1864
Oil on canvas, 45 x 73 cm
Musée d'Orsay (gift of E. Moreau-Nélaton), Paris (RMN)

4 *Vase of Peonies on a Pedestal,* 1864
Oil on canvas, 93.2 x 70.2 cm
Musée d'Orsay (gift of E. Moreau-Nélaton), Paris (RMN)

3

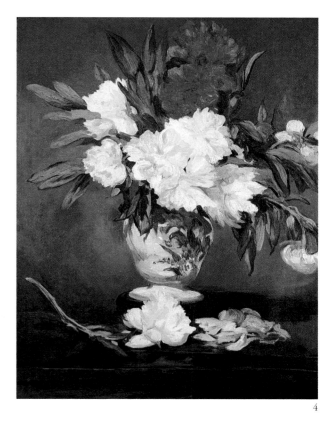

4

1/3
Manet had begun to paint fish during the summer of 1864, when he was on holiday at Boulogne-sur-Mer. In *Still Life with Fish*, as in *Fruit on a Table*, the composition was based on a diagonal axis, as Chardin had done in *The Silver Tureen, c.* 1729.

2/4
Manet liked growing peonies in his garden at Gennevilliers. He loved their loose shape, which suited his full and generous brushstrokes.

'Do you remember a day
when we saw at the Hotel Drouot
a bunch of peonies by Manet?
The pink flowers, the green leaves,
thickly painted, not glazed. . .
It was very sound.'
(Vincent van Gogh to his brother Theo)

The American Confederate barque rig steamer, *Alabama*, a commerce raider, had put in at Cherbourg to take on supplies, repair damage and avoid the blockading *Kearsarge*, a Union wooden screw sloop. For people in that part of France, that spring of 1864, the

1
This Japanese-style water-colour was painted on the spot by Manet, who went to Boulogne after the battle. The *Kearsarge* was anchored beyond the port. This water-colour was a preparatory study for *The Kearsarge at Boulogne*, which he painted soon afterwards.

2
In 1860, Abraham Lincoln became President of the United States, and abolished slavery. The Southern states, fearing bankruptcy, followed South Carolina's lead and seceded from the Union. In 1861, the North and South embarked on a war which would last for four years and cost the lives of 617,000 men. The naval battle off the coast of France between the *Kearsarge* and the *Alabama* caught the imagination of the French people. The *Alabama*, a Confederate ship, was the origin of a quarrel between Great Britain and the United States, which was resolved only in 1872, when Great Britain was forced to pay fifteen million dollars in war reparations to the United States. Britain had recognised the Southerners and encouraged them to arm themselves against the Union. The captain of the *Alabama* had boasted of having captured and destroyed several Union ships.

prospect of a clash had become a tourist attraction. Eventually, on 19 June, a battle took place between both vessels, in the course of which the *Alabama* was sunk. During the following week, there were numerous eye-witness accounts and comments in the press. It is not known whether Manet actually witnessed the battle himself, but it is quite probable that the painting was done largely from photographs.

Having always refused to paint historical pictures, he had now produced a work that was not only contemporary but historical as well. The whole composition is minutely detailed, as for example, in the depiction of the French ship, flying the regulation white flag, coming to the help of the Southerners. His year spent on board *Le Havre et Guadeloupe* in his youth, and his great knowledge of the sea, inspired him in this superb seascape. When he later presented the painting at the 1872 Salon, the boldness of the centring was once again misunderstood. The critic Cham wrote this caption to his caricature of Manet's painting: 'The *Kearsarge* and the *Alabama* consider M. Manet's sea to be improbable, so they have decided to do their fighting within the frame.' And Stop added: 'Without bothering with vulgar bourgeois ideas about perspective, M. Manet has had the clever idea of showing us a vertical section of the sea.'

2

1 *The Kearsarge at Boulogne*, undated
Water-colour, 25.5 x 35.5 cm
Musée des Beaux-Arts, Dijon

2 *Battle between Kearsarge and Alabama*, 1864.
Lebreton Engraving.
Bibliothèque Nationale, Paris

3 *Battle between Kearsarge and Alabama*, 1865
Oil on canvas, 134 x 127 cm
Museum of Art (J.G. Johnson Collection), Philadelphia

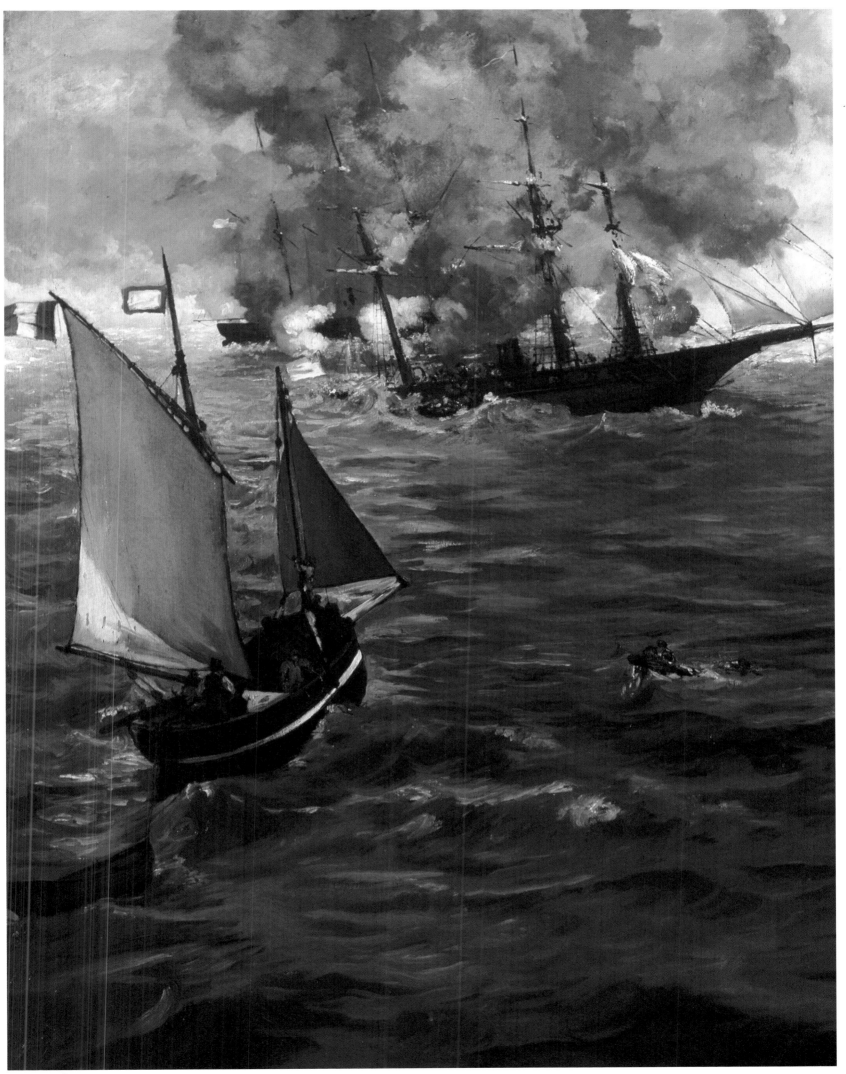

In March 1864, Baudelaire wrote to the head of the Salon, the Marquis de Chennevières: 'I would like to warmly recommend to you two of my friends, one of whom has already had cause to be grateful to you: M. Manet and M. Fantin-Latour. M. Manet is sending you *Episode from a Bullfight*, and a *Christ with Angels*. M. Fantin-Latour will send a *Homage to Delacroix* and *Tannhäuser at Venusberg*. You will see what wonderful talents there are in these paintings, and whatever category you place them in, please do your best to find them good places.' Baudelaire seems to have been successful, and on 22 March he wrote to Fantin-Latour: 'When Manet's porters arrived, Chennevières asked to see the pictures straight away.' Manet got a good place in the exhibition, but unfortunately his work was severely criticised. Théophile Gautier complained that his Christ 'did not know about ablutions'.

There were critics at the same time who, without understanding the artist's intentions, picked out several powerful pieces – Callias was one of these.

With all this in mind, Manet returned to the theme the following year. Alongside *Olympia* he showed *Jesus Mocked by the Soldiers*. This studio group was heavily attacked; there were

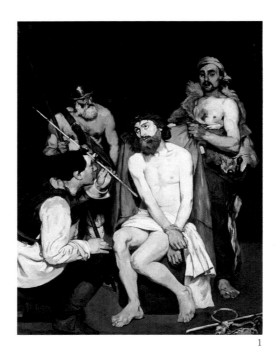

1

2
Delacroix died in 1863. Fantin-Latour paid tribute to him by gathering together on one canvas all those who had admired him. On the left are Whistler, Fantin-Latour holding his palette, Duranty, Legros and Cordier. On the right are Champfleury and Baudelaire, seated, with Manet, Bracquemond and Balleroy, standing behind them.

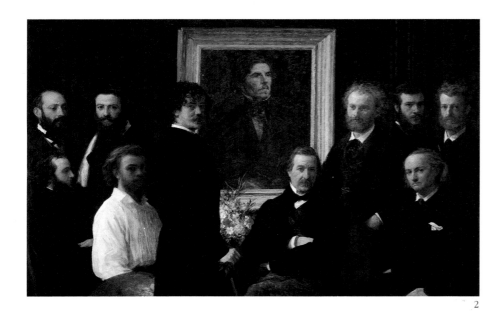

2

complaints about the soldiers' clothes and the model, a locksmith who had posed for Christ. It is possible that, in showing these two paintings together, Manet was thinking of Titian, who had given Charles Quint a *Crown of Thorns* and a *Venus*.

1 *Jesus Mocked by the Soldiers*, 1865
Oil on canvas, 190.3 x 148.3 cm
Art Institute (gift of James Deering), Chicago

2 *Homage to Delacroix*, 1864. Henri Fantin-Latour
Oil on canvas, 160 x 250 cm
Musée d'Orsay (gift of E. Moreau-Nélaton), Paris (RMN)

3 *Christ and the Angels*, 1865-7
Water-colour, pencil, gouache,
pen & China ink, 32.4 x 27 cm
Louvre/Musée d'Orsay; graphic arts archive, Paris (RMN)

3
This water-colour was a sketch preparatory to an etching. It is a reverse of the painting, so that the etching would be an exact reproduction of it. Executed in pencil and water-colour, it is the best example of Manet's talent as a draughtsman. The gouache highlights emphasise the angel's blue wings which are more subtle in the painting. Baudelaire feared that his friend would be mocked, and had warned him shortly before the Salon opened: 'By the way, it appears that the spear wound is definitely on the right, so you must go and change the place of the wound before the opening. Check it in the Gospels – you must take care not to become a laughing-stock for your enemies.' It does appear, however, that if one considers the water-colour to be the exact opposite to the painting, then Manet did not change the wound.

'I wanted to paint a dead Christ, with the angels,
a variation of the scene of Mary Magdalene at the sepulchre, according to St John'

In 1865, Manet began a portrait of the actor Philibert Rouvière, in the role of Hamlet, which had made him a success in 1846. The actor was, by then, very ill, and once the pose had been decided upon, Manet had to use friends as substitutes. Antonin Proust provided the hands, and Paul Roudier the legs. This was not a new subject, and ever since the seventeenth century, a large number of actors had been immortalised in their most famous role. He depicted the actor in the manner of a Velázquez painting seen during his trip to Spain that August. He enthused about this work, discovered in the Prado: 'The most astonishing piece in this splendid oeuvre, perhaps the most extraordinary painting of all time, is the one described in the catalogue as *Portrait of an Actor Famous at the Time of Philip IV*. The background disappears: the man is surrounded by air, alive and dressed in black.' He had visited Toledo, Burgos and Valladolid. In Madrid he met a young Frenchman returning from Portugal, Théodore Duret, and they became friends. Unfortunately,

1/2
Manet had at last seen the Spanish on their home territory. He faithfully reproduces the matador's costume, with the correct gesture, as can be seen from this photograph, taken later.

1

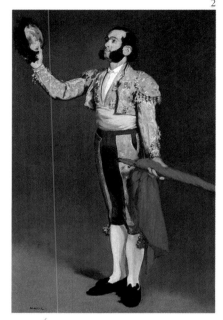

2

View of Valladolid in 1864 3

Spanish cooking did not suit Manet, and he returned tired to his family in the Sarthe, where he fell ill with cholera. However, despite the cuisine, he remained enthusiastic about Spain and the bullfights: 'One of the most beautiful, strange and terrible spectacles that one can possibly see.' Of Goya, discovered in the galleries, he said: 'What I saw of him did not please me enormously.' He was mainly enchanted by Velázquez and his philosopher-beggars, Aesop and Menippus: 'I have found in him the realisation of my ideal in art, the sight of these masterpieces has given me great hope and new confidence.'

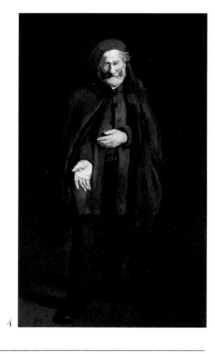

4

Manet was inspired by Velázquez's *Philosophers* when he embarked on three paintings on the theme of beggar-philosophers. He remained in the Spanish tradition when illustrating a theme dear to his friend Baudelaire: 'In the heart of the old town a muddy labyrinth crawling with humanity in stormy ferment.'

6
Philibert Rouvière, after three years at the Comédie-Française, could not find work. He took up painting again, and in 1863 showed a self-portrait of himself as Hamlet. In January 1865, he attempted a comeback in this role which had made him famous, but he was ill and the performances were interrupted; he died on 19 October 1865, before Manet could complete his portrait.

2 *Matador Saluting,* 1866
Oil on canvas, 171.1 x 113 cm
Metropolitan Museum of Art (gift of
Mrs H.O. Havemeyer), New York

4 *The Philosopher,* 1865
Oil on canvas, 187.7 x 109.9 cm
Art Institute (A.A. Munger Collection), Chicago

5 *Portrait of Théodore Duret,* 1868
Oil on canvas, 43 x 35 cm
Musée du Petit Palais, Paris
City of Paris Photographic Library (SPADEM)

6 *The Tragic Actor,* 1865-6
Oil on canvas, 187.2 x 108.1 cm
National Gallery (gift of Edith Stuyvesant
Vanderbilt Gerry), Washington

5

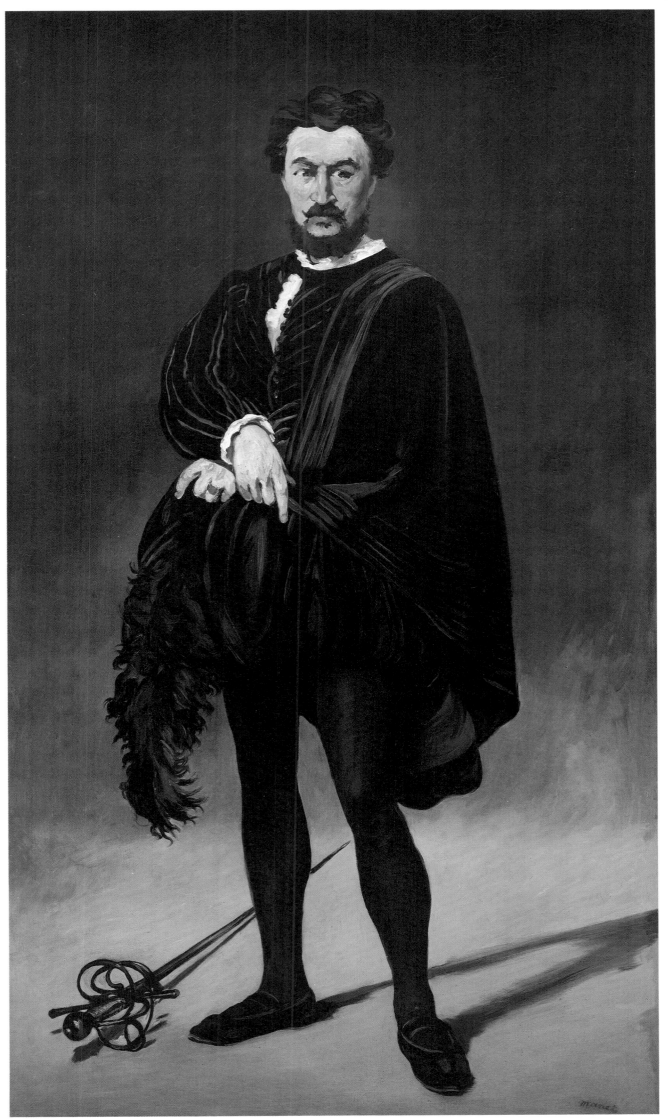

Historians remain divided as to which year Manet painted the *Portrait of Zacharie Astruc*. He was one of those men with many gifts who abounded in the nineteenth century. He came from Toulouse, and arrived in Paris in 1855, where he met Manet, probably through Fantin-Latour. He arrived at the artist's house 'in sandals and breeches, bringing pieces of carved wood painted in Spanish style, and poems in beautiful ornamental writing, according to Prins'. For the painter, Astruc was the friend of his youth, who, with no great talent of his own, but with great charm, and seeing the gifts of others, longed to make himself useful and get their genius recognised. He was Manet's great supporter long before Baudelaire and Zola, and it was through him that Monet, Zola and Manet would meet. He was a great connoisseur of painting and Spanish architecture, and he prepared a stage-by-stage itinerary for Manet's trip to Spain. It is not surprising that he fell in love with the strange Lola de

1
The jury of the 1866 Salon increased from twelve to twenty-four members. Their selection process was extremely severe, and Manet was probably refused on his name alone. The Salon opened in chaos. Demonstrators fought with the police: feelings were running particularly high as the news had just arrived that the painter Jules Holtzapfel had killed himself after hearing that he had been turned down.

2
In 1866, the first transatlantic cable was laid. This was how news of Emperor Maximilian's execution arrived so fast to cast a pall over the International Exhibition which had just opened in 1867.

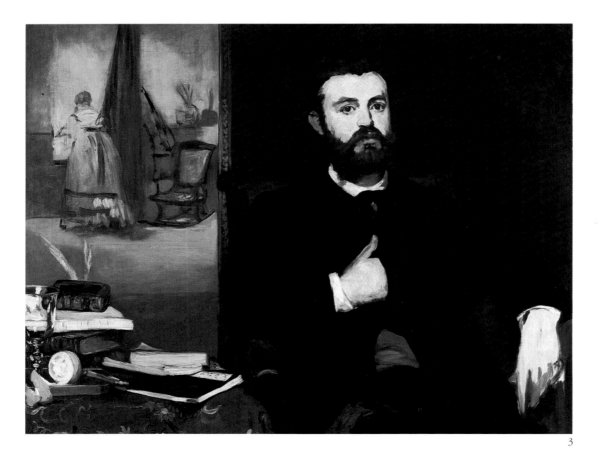

3
In the foreground, on a rug laid over a table, are scattered a fews books, ancient and modern works, and a Japanese album. These indicated Zacharie Astruc's principal occupation at that time – writing – although later he became a sculptor. We see here the first appearance in Manet's work of a half-peeled lemon, a yellow splash against the dark books, a motif from Dutch painting. The 'finished' face contrasts with the dangling nonchalantly sketched hand. This picture must have seemed very strange since Astruc's wife refused to have it hanging in her drawing room.

Valence, and he wrote her a serenade, the sort of thing that was fashionable at the time, but now forgotten.

Zacharie Astruc had already posed for Manet in *Music in the Tuileries*, and *The Music Lesson*, where we see him nonchalantly plucking the strings of a guitar.

3 Portrait of Zacharie Astruc, 1866
Oil on canvas, 90 x 116 cm
Kunsthalle, Bremen

4

'I have sent two paintings to the exhibition, and I am planning to get them photographed and send you the prints: one is a portrait of Rouvière in the role of Hamlet. . . and the other a fifer from the Guards Light Infantry, but you have to see them to get an idea.' Almost in anticipation of the Salon being blackened by fresh controversy, the jury rejected Manet's submissions. Faced with a large number of *refusés*, the Beaux-Arts administration allowed them to exhibit, not in a Salon des Refusés, but in their own studios. *The Fifer* is one of Manet's most simplified works. He had been reproached with drawing his figures with soot to make them stand out against their background, but this time there was no background. Like the Japanese engraver Utamaro, he uses in the silhouette of the fifer, great patches of blacks, reds, and whites. There is no conventional background. White and black are colours with as much value as any other tone. Standing in full light, the fifer is a negation of shadow, although this is summarily indicated under the child's feet and hands. To accentuate the 'playing card' or 'image d'Epinal' appearance, Manet uses the stripes on the trousers, surrounding him with black. Zola, who had instinctively foreseen the evolution of art in his time, was the artist's only supporter, in an article explaining his admiration: 'M. Manet's temperament is a dry one, and it carries the day. His figures are powerfully caught, and he does not back away before the bluntness of nature; he goes unhesitatingly from white to black. . . I find in this painting a man who is searching for truth, and who produces from within himself a world of individual and powerful life.'

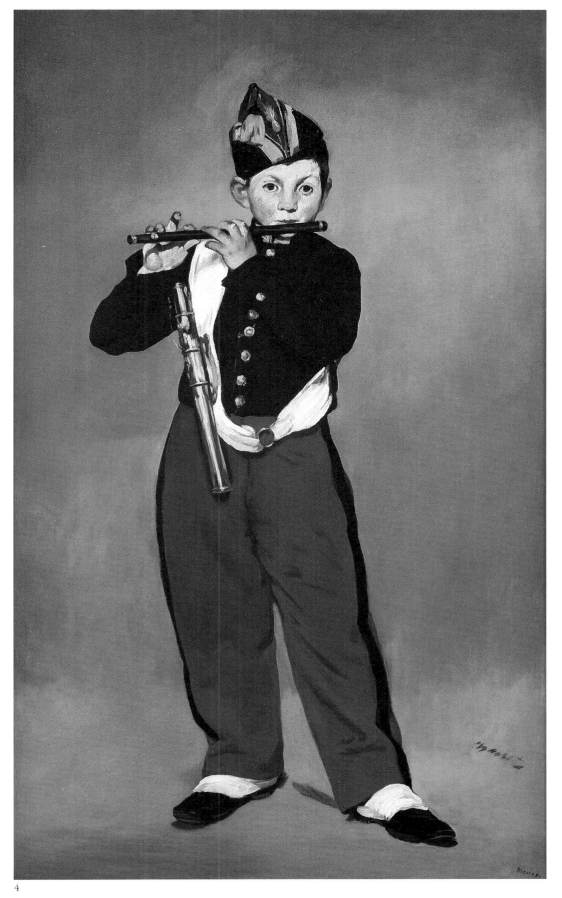

4

4 *The Fifer,* 1866
Oil on canvas, 161 x 97 cm
Musée d'Orsay (Camondo legacy), Paris (RMN)

At the beginning of 1867, Edouard Manet was still hoping to be one of the painters chosen to represent France at the International Exhibition. His new supporter, Emile Zola, had just published an article in the *Revue du XIXème Siècle* under the title 'A New Style of Painting'. Manet replied happily: 'My dear Zola, new and unexpected friends appear each day and it is in large part thanks to your courageous initiative . . .'

1
Courbet may have painted his *Woman with Parrot* in response to *Olympia*. He mocked Manet's *Christ and the Angels*, but all the same recognised his great talent.

Battle of Sadowa: Prussian victory over Austria

2
While Paris was preparing for the International Exhibition, Europe was changing. Germany had tried to expel Austria from the Confederation. The Emperor of Austria had then been crowned King of Hungary, and his brother Maximilian had become Emperor of Mexico. Napoleon tried to reassure the Chamber of Deputies: 'The unification of Germany could never worry a country like ours.'

All the same, Manet changed his mind and decided not to submit anything to the International Exhibition. Instead, he exhibited on his own, as Courbet had done in 1855. In this exhibition was one painting which particularly delighted Zola, *Young Woman in a Pink Peignoir*.

Manet had noticed a little garden at the corner of the avenue Montaigne and the avenue de l'Alma, and it was there that he built his pavilion, on the edge of the International Exhibition. He borrowed 18,000 francs from his mother, an enormous sum at that time. Mme Manet was extremely worried about his extravagance: 'You must stop this slide towards ruin.'

But, despite the care he took with the show and with the modest entry fee, the public did not come and the press did not report the event.

'I have at least forty paintings to show. I have already been offered some very good sites near the Champ-de-Mars. I'm going to risk everything, and, backed by people like you, I expect to succeed.'

'I've decided to put on a one-man show.'

1 *Woman with Parrot*, 1866. Courbet
Oil on canvas, 129.5 x 195.6 cm
Metropolitan Museum of Art
(gift of Mrs H.O. Havemeyer), New York

2 *Woman with Parrot* (or *Young Woman in a Pink Peignoir*), 1866
Oil on canvas, 185.1 x 128.6 cm
Metropolitan Museum of Art
(gift of Erwin Davis), New York

3
Victorine reappears here, clothed, with the famous ribbon round her neck in a painting shown at the Salon under the title *Young Lady in 1866*. 'In the *Young Woman in a Pink Peignoir* I find the personnification of the native elegance that Manet has deep within him,' wrote Zola.

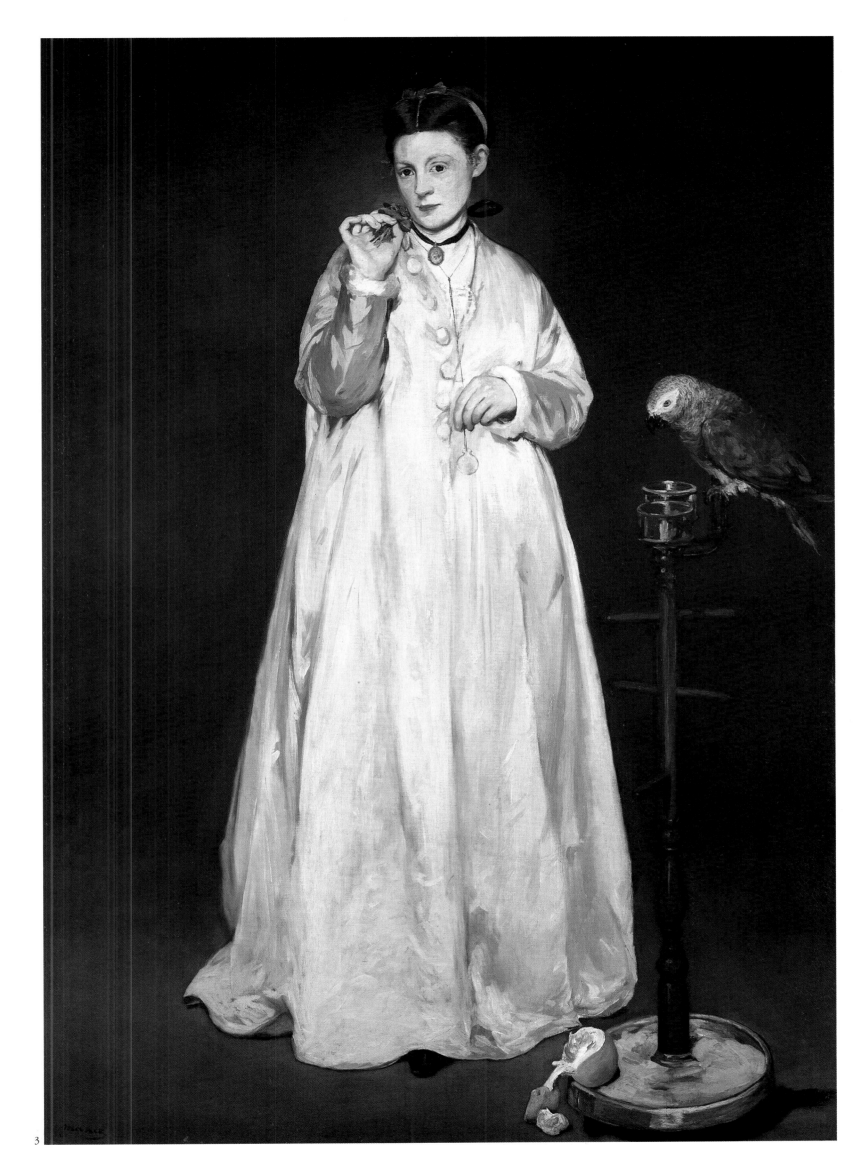

International Exhibition: 52,000 exhibitors

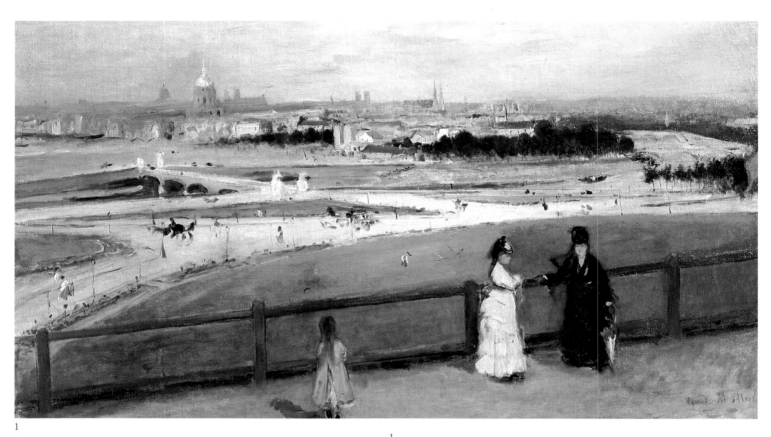

1

1
Painting Paris in 1871, once peace had returned, was a tempting proposition for Berthe Morisot. She said of the view from the terrace overlooking the Champ-de-Mars where the International Exhibition had taken place, no doubt referring to this painting: 'The arrangement resembles a Manet. I realise that and it annoys me.'

The year 1867 would be remembered as the year of the International Exhibition. Royalty came to Paris from all over the world – princes from faraway Japan, King William, the Emperor Alexander, Sultan Abdul-Aziz, the King and Queen of the Belgians, the Queen of Portugal, Grand-Duchess Marie of Russia, Prince Oscar of Sweden and Queen Victoria.

The opening ceremony took place in the midst of political uncertainty; the unification of Germany was worrying, and the news from Mexico alarming. But, with the coming of spring, the anxiety evaporated, and the Exhibition, with 52,000 exhibitors, turned into a six-month-long party.

It was like a huge fairground with stalls, bars, booths and games. A huge circular construction housed the exhibits: Saint-Gobain glass, Sèvres porcelain, Gobelin rugs, and crystal from Baccarat and Bohemia. In the machinery section, a new metal could be seen – aluminium. The Prussians brought a huge

2

The Champ-de-Mars was chosen as the site for the Exhibition because the Palais de l'Industrie was no longer large enough.

1 *View of Paris from the Trocadero*, 1872. Berthe Morisot
Oil on canvas, 46.1 x 81.5 cm
Santa Barbara Museum, California

3 *The Great Exhibition*, 1867
Oil on canvas, 108 x 196.5 cm
National Gallery, Oslo

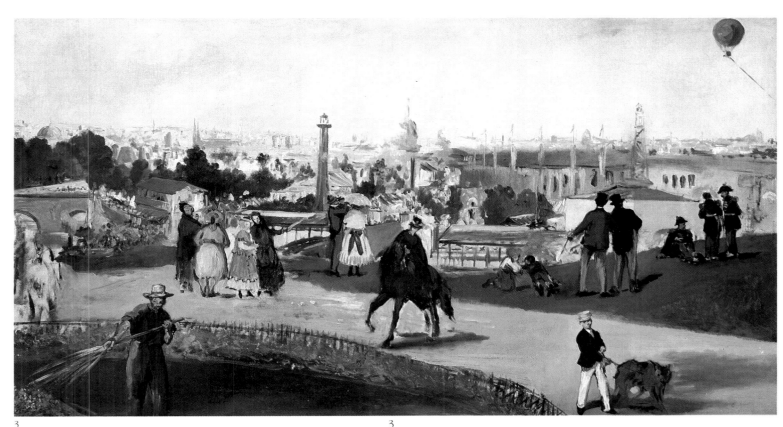

3

3

On the left can be seen the arches of the Pont de l'Alma. In the foreground is the National Panorama which was reserved for military displays. Above the pavilions or 'magic palaces' are two lighthouses, one English, one French, demonstrating the power of electric light. High in the air is *Le Géant*, the photographer Nadar's balloon. The little boy with the dog, obviously Léon, is wearing the same costume as in *Lunch in the Studio* which Manet painted the following year.

Krupp canon, which, three years later, would be booming at the gates of Paris.

The Fine Arts gallery showed Gérôme, Meissonier, Cabanel, Théodore Rousseau, Corot, Millet and Breton. Towards the end of May the cheerful atmosphere changed: the Tsar narrowly escaped an assassination attempt, and Archduchess Matilda, about to go to a ball, accidentally set fire to her dress and was burned alive. Then, during the night of 29 June, a transatlantic cable arrived in Vienna from Washington: Maximilian, Emperor of Mexico, had been executed by firing squad.

Manet, who had intended to record on canvas the International Exhibition, changed his mind on hearing of Maximilian's death, and decided to paint the execution instead.

4

Racing at Longchamp

With the return of the *émigrés* after the defeat at Waterloo, and then with the influence of Napoleón III who had spent his childhood in England, came the fashion for horse-racing. Horses did, of course, already play an important part in French society, in provincial fairs, military parades and the Royal hunts. The hunt, which was part of a highly complex aristocratic ritual, gave rise to several more bourgeois rituals in the nineteenth century, although the idea of racing horses on a marked track became established only towards 1830. The racecourse, begun at the same time as the laying out of the Bois de Boulogne, was opened in 1857. Its importance in Parisian high society bore no relation to the length of the racing season. In the past, a pilgrimage to the abbey at Longchamp had been a pretext for a social event. With the building of the hippodrome the whole of high society, under the aegis of the Jockey Club, gathered in the stands.

The first Grand Prix was won by an English horse in 1863, and then, the following year, by a French one, Vermouth. The prize was awarded by the Jockey Club, an ancient society for the improvement of bloodlines; it had originally been made up of English people living in France and descendants of *émigré* aristocrats, but it eventually opened its doors to financiers, industrialists and politicians, as well as foreign businessmen and diplomats. Artists met there to paint – Degas indeed did a sketch of Manet at the races. Longchamp society rules did not insist on people actually watching the races, and Manet often used to paint the elegant crowd massing against the railings. The women were of a higher class than usual, since it cost twenty gold francs to enter the enclosure with a carriage.

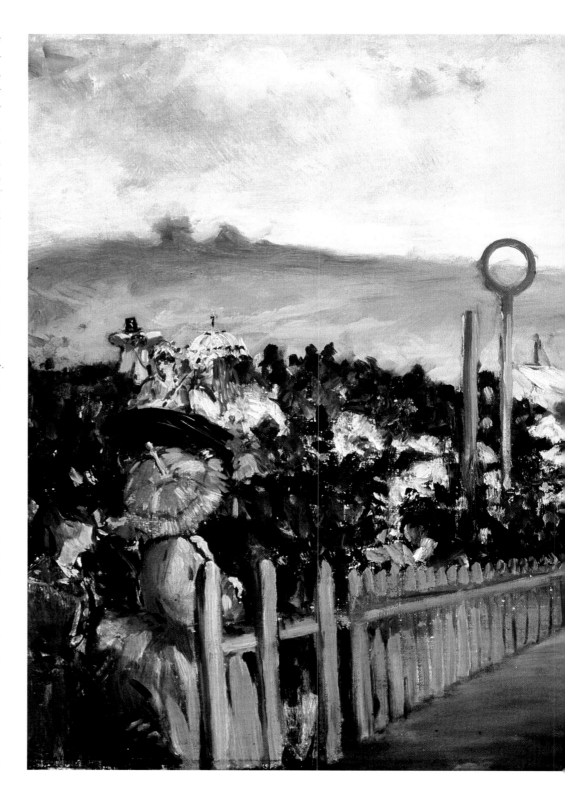

1 *Racing at Longchamp,* 1864
Oil on canvas, 43.9 x 84.5 cm
Art Institute (Potter Palmer Collection), Chicago

1
In this painting, Manet attempts
something completely new by showing
the horses head-on, coming straight
towards the spectator. It was the first
time they had been shown in this way –
the tradition was to show them in profile
in a flying gallop, which was imposst

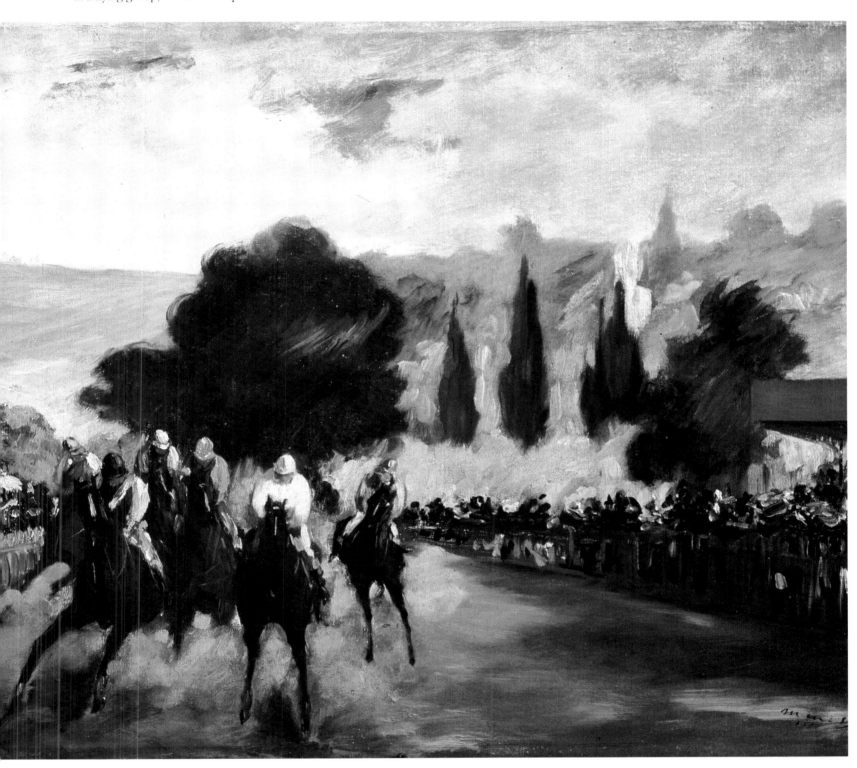

as Degas found out from Muybridge's
photographs. This is part of a larger
work that Manet cut up the following
year – the other part is missing. The
painting is executed in large
brushstrokes, and was for a long time
treated as a sketch or study, and was not
popular with the public.

Baudelaire's funeral was cursed with bad luck in the same way as Musset's and Heine's. It was the wrong time of year to start with, many people being out of Paris, and the wrong day, forcing us to distribute tickets on a Sunday, so that many got them only the next day, when they got back from the country. There were about a hundred people at the church, and fewer at the cemetery. The heat had prevented many people from following all the way, and a clap of thunder as we entered the cemetery nearly frightened off the rest,' wrote the publisher Charles Asselineau.

Baudelaire was dead, and this may be an unfinished painting of his funeral that Manet, his friend for seven years, painted in 1867. Baudelaire was ten years older than him and had lavished advice and good cheer upon the young painter. When he was being attacked over *Olympia*, Baudelaire, away lecturing in Belgium, wrote to him: 'It seems I must talk to you again about yourself, and explain how much you are worth. It is really absurd how much you expect. Do you think you are the first person to find himself in this position? Are you more of a genius than Chateaubriand or Wagner? People certainly laughed at them, and they didn't die of it.'

'It seems you are privileged to inspire hatred. . .' (Baudelaire)

1

1
1867 was a bad year for Manet – he had not had the success he had hoped for with his private exhibition, and he lost his close friend Baudelaire. However, despite his absence from the Salon, he had starred there: his friend Fantin-Latour had shown a portrait of him, very clearly marked: 'To my friend Edouard Manet'.

In response to this gesture of friendship, Manet went to visit his friend as soon as he returned from Belgium; while he was there, in February 1866, Baudelaire had suffered the first of the attacks that would result in total paralysis. Suzanne often came to his bedside with Mme Paul Meurice, and in the months preceding his death, she would go and play Wagner to him at the hydrotherapy clinic at Chaillot.

Soon after his friend's death in 1867, Manet wrote to Charles Asselineau, who was planning to publish a work on Baudelaire: 'I have a Baudelaire in a hat, a stroller, which might not be bad at the beginning of the book, and another, better one, bare-headed, which would be good in a book of poetry. I would be very happy to be given the job. Of course, in suggesting this, I would be *giving* my plates.' Asselineau accepted, and the portraits were engraved by Félix Bracquemond, another of his friends.

2

2
Corot refused to paint 'imposing structures', preferring small landscapes. The Impressionists had recognised his talent well before 1874, and had asked his advice. 'Beauty in art', he replied 'is the truth bathed in the impression we have of nature.'

1 *Portrait of Edouard Manet,* 1867. Henri Fantin-Latour
Oil on canvas, 117.5 x 90 cm
Art Institute (Stickney Fund), Chicago

2 *Bridge at Mantes,* undated. Corot
Oil on canvas, 38.5 x 55.5 cm
Musée du Louvre, Paris (RMN)

3 *The Funeral,* 1867-70?
Oil on canvas, 72.5 x 90.5 cm
Metropolitan Museum (Wolf Foundation), New York

72

Death of Baudelaire

3

'When you see Manet, tell him what I say – that greater or lesser trials by fire, mockery, insults and injustice are all excellent things and he should be grateful for them. I know he will find it difficult to understand my theory, painters always want immediate success; but Manet really has such a brilliant and light-handed talent that it would be tragic if he became discouraged.' (Baudelaire)

1

2

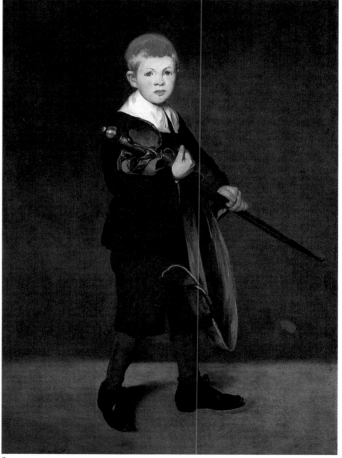

3

Soap bubbles in the history of art are linked to the theme of the 'vanities' of the seventeenth century, and symbolise the precariousness of life. But Manet did not choose this theme in order to depict – as his master Couture had shown – a child plunged into philosophical or moral meditations (2). He was more inspired by Chardin, whose still lifes he admired. But where Chardin's child (1) is leaning forwards, concentrating on making his bubble, Manet's stands, facing the spectator, in a manner that was completely new and that softened the melancholy in Léon's expression. The Second Empire had discovered the photographic portrait, and family albums were full of clichés, little boys standing stock-still in their new clothes, on a rocking horse or holding a wooden gun, little girls sitting in deep velvet armchairs. The very long pose times did not allow for lifelike expressions. In any case, one is reminded here, not so much of family photographs as of Manet's spiritual family, the Spanish and Dutch painters of the seventeenth century.

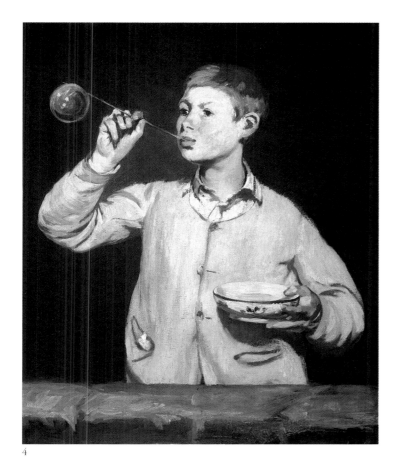

4

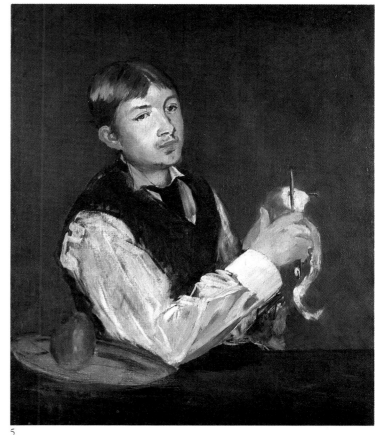

5

3
The young Léon seems very much encumbered by this big sword, which Manet had borrowed from the painter Charles Monginot. Zola commented on this child standing out on a dark background: 'It is said that Edouard Manet has some affinity with the Spanish masters, this has never been so clear as in *Child with a Sword...*'

'I name Suzanne Leenhoff, my wife, as sole beneficiary. She will leave everything I leave to her to Léon Koella, known as Leenhoff, who has looked after me devotedly, and I believe that my brothers will understand and approve of these arrangements.'

4
Léon was fifteen when he sat for *Soap Bubbles*. Rather than a scene from life, it is a naturalistic repetition of Chardin's painting which had just been auctioned in Paris.

5
Two years later Léon sat again for Manet. The young man had grown, and no doubt Manet was amused by the adolescent's nascent beard. This Dutch-inspired work was bought in 1882 by the baritone Jean-Baptiste Faure, a great collector of Manet's work.

1 *Soap Bubbles,* 1745. J.B.S. Chardin
Oil on canvas, 93 x 74.6 cm
National Gallery
(gift of Mrs J.W. Simpson), Washington

2 *Soap Bubbles,* 1859. T. Couture
Oil on canvas, 130.8 x 98.1 cm
Metropolitan Museum of Art
(gift of Mrs H.O. Havemeyer), New York

3 *Child with a Sword,* 1861
Oil on canvas, 131.1 x 93.3 cm
Metropolitan Museum of Art
(gift of Erwin Davis), New York

4 *Soap Bubbles,* 1867
Oil on canvas, 100.5 x 81.4 cm
Calouste Gulbenkian Foundation, Lisbon

5 *Young Man Peeling a Pear,* 1868
Oil on canvas, 85 x 71 cm
National Gallery, Stockholm

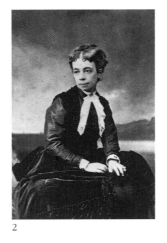

1
Charlotte von Habsburg, whose mental condition deteriorated on her husband's death, died on 15 January 1927. She murmured to the priest attending her: 'Tell the world about the beautiful stranger with blond hair. God wants us to be remembered, sadly and without hatred.'

2
One evening at the Paris Opera, the wife of the new Austrian ambassador made her first appearance. People were astonished by her strange appearance. Tall, dark and thin, she was nothing like the elegant beauties of the Court. Pauline Matternich, lively, unselfconscious and rich, was to rule Paris. She used her friendship with the Empress to influence the policies of Napoleon III.

'What a pity Edouard became so obsessed by that subject!
What beautiful things he could have painted in that time!'
(Mme Suzanne Manet)

On 10 June, after a ferocious struggle, Benito Juarez entered Mexico. He wanted his government recognised by the European powers, and had received the credentials of the French ambassador against the promise that French interests would be protected. This policy displeased the Mexican monarchist *émigrés*, who formed a committee, led by Almonte, the plenipotentiary minister in Paris, and Hidalgo, the first secretary, which asked Napoleon III for help. Until then he had not intervened, and had merely expressed sympathy with the cause. But the Empress Eugénie, who was very much attached to her Spanish origins, wanted a ruler who would re-establish European supremacy to take control of this country which had rebelled against Spanish authority. Napoleon was finally convinced of the wisdom of this enterprise with news that Juarez was cancelling previous treaties with the European powers. France, Britain and Spain decided on joint action. Empress Eugénie was infatuated with Princess Metternich and Austria in general, with its ancient links with Spain; so, as the troops were sailing towards Mexico, the Emperor of Austria's brother, Archduke Maximilian, who had been prepared by Eugénie and Pauline, accepted the crown from the *émigrés* in Paris. The Mexican expedition was a disaster both in human and financial terms; the occasional victory was not enough to gain a decisive outcome, and Napoleon was forced to withdraw his troops. Bankrupt, and without a real army, Maximilian was isolated. His wife Charlotte crossed the Atlantic in order to beg Napoleon to change his mind. The latter, already worn down by what was to be his final illness, could do nothing. Charlotte, in a deteriorating

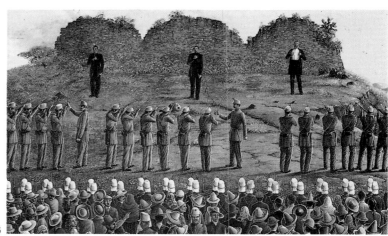

Execution of Maximilian

The Emperor Maximilian

3
This first version was painted in July or September 1867, as soon as news came of the execution of Maximilian. Manet was inspired by Goya. Here, unlike the second version (page 79), the Mexican costumes are shown as they were imagined at the time. When he had obtained more details, and after his return to Paris in September for Baudelaire's funeral, he reworked the subject: the trousers became darker, the sombreros were changed into peaked caps. So the mythical vaqueros became a regular army with a similar uniform to that of the French soldiers. This transformation was interpreted as an accusation aimed at Napoleon III about his responsibility for Maximilian's death.

5 *Execution of the Emperor Maximilian*, 1867
Oil on canvas, 196 x 259.8 cm
Museum of Fine Arts (gift of
Mr & Mrs F. Gair Macomber), Boston

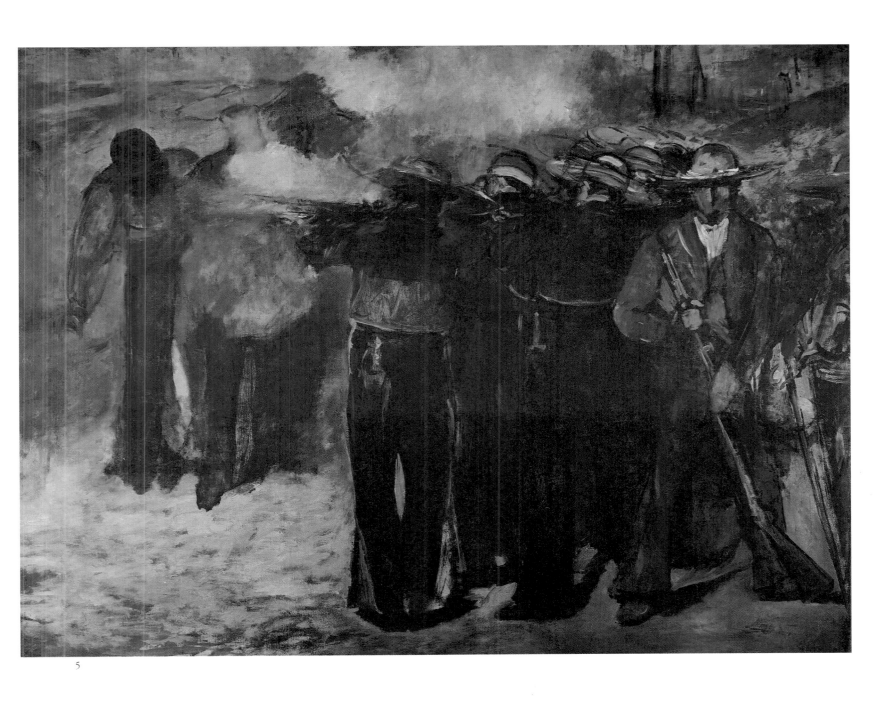

5

mental state, went to Rome in the hope of obtaining help from the Pope. Maximilian was executed on 19 June 1867 with two of his generals, Miguel Miramon and Thomas Mejia. Manet heard about the execution at the beginning of July. With the help of photographs, he planned several versions, putting all his passion and energy into this great historical painting. He worked from the summer of 1867 until the end of 1868, inspired by Goya's *3 May 1808*, which he had seen two years

1/2
Between 1950 and 1953, there was a ferocious war between Communist North Korea, supported by the USSR, and South Korea, supported by the United Nations. Inspired by Manet and Goya, Picasso depicted the soldiers as killing machines.

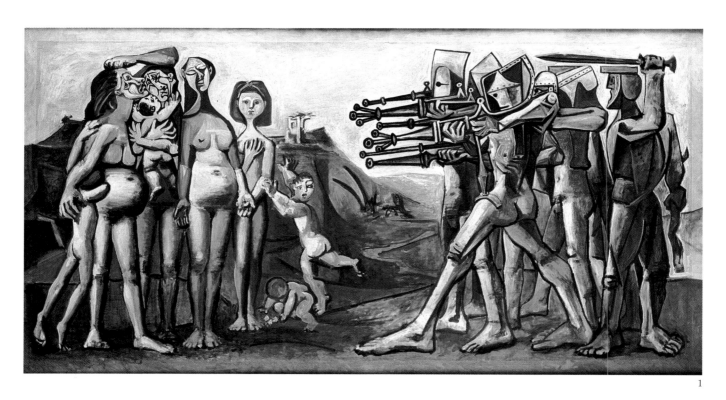

1

before on his journey to Spain. The choice of subject, a painful moment in the history of the Second Empire, was in some ways parallel to the intentions of the Spanish painter, who chose the massacres caused by the invasion of Napoleon I's troops between 1808 and 1814. By the end of 1868, after several versions, Manet was at last satisfied with the result. He intended to show it at the Salon, which was about to open, but it was made known to him that it would not be accepted: it represented a historic event that would be better hushed up, and the news was still too recent to allow a painter to defy the Emperor. So the painting remained out of sight, and only the painter's friends were allowed to see it.

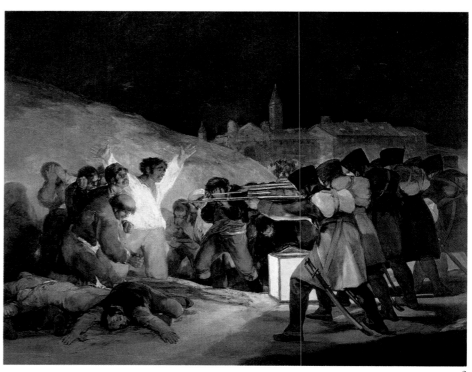

2

1 *Massacre in Korea,* 1951. Picasso
Oil on plywood, 109 x 209 cm
Picasso Museum, Paris

2 *3 May 1808,* 1814. Goya
Oil on canvas, 266 x 345 cm
Prado Museum, Madrid

'Images of heroism and love will never have
the same force as images of pain. They
represent the root of the human condition,
and its poetry.'

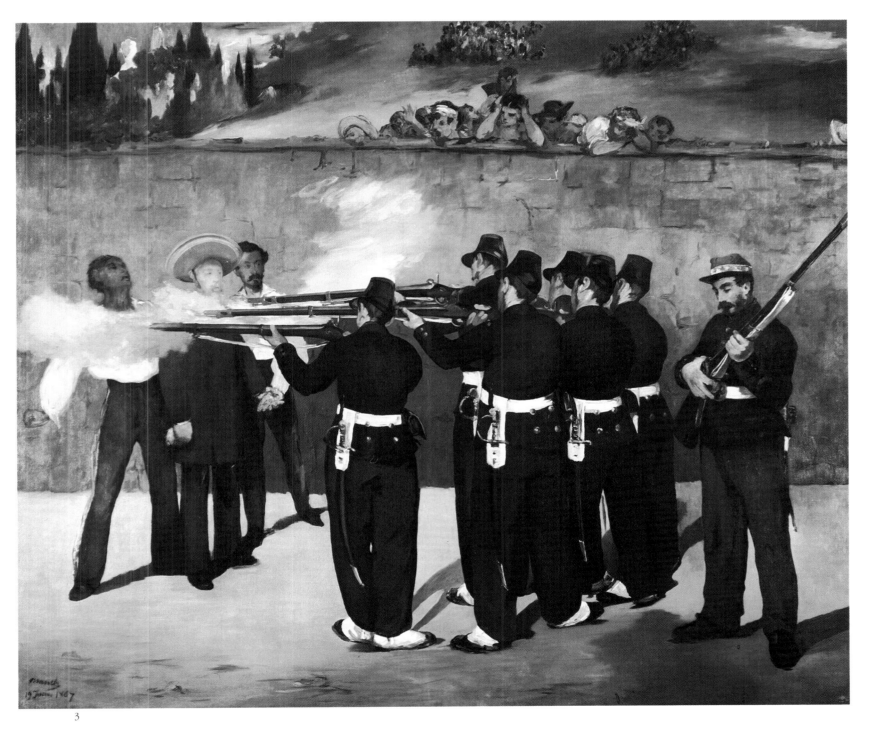

3

3 Execution of the Emperor Maximilian, 1867
Oil on canvas, 252 x 305 cm
Kunsthalle, Mannheim. Artothek

Manet painted Zola's portrait in 1868, as a gesture of gratitude for the articles he had written. Since 1864, he had entertained artists and writers at his house. The young author of *Contes à Ninon* had turned to journalism in order to defend the painters who put forward the same ideas as him in their work. He complained of the affectation of current work in the Salon: 'Faced with the great upsurge of science and industry, the artists have reacted by producing a shoddy world of tinsel and tis-

1
'The younger was impertinent, and the elder presumptuous, and neither was amusing.' This was how Trombat, Sainte-Beuve's secretary described the Goncourt brothers. Edmond, the elder, did not care for Manet's painting and wrote: 'Only the most limited people admire his talent.'

1

2

2/3
'I remember long hours of posing. My limbs became numb . . . and the same thoughts kept floating through my mind with a gentle deep sound. . . . Sometimes in my half-conscious state, I would look at the painter standing in front of his canvas, his face tense, his eye bright, completely absorbed in his work. He had forgotten me, he did not even know I was there, he was copying me as he would have copied any other human animal, with intensity and artistic awareness such as I have never seen before. Then I thought of the slovenly dauber of popular legend, the caricaturists' Manet, who painted cats as a sort of joke. One must admit that the human spirit is sometimes of a rare stupidity.' (Zola)

sue. . . Our fathers mocked Courbet, and now we admire him; nowadays we mock Manet and our sons will worship him.'

Zola appeared in Manet's life at a moment when Baudelaire could no longer support him. The poet had admired the dramatic nature of the painter's work, whereas Zola saw in it a more positive form of reality, a reflection of his own struggles. The painter's battles with the official jury would, thought Zola, guarantee him a place in the French galleries.

He confirmed his commitment to Manet's cause with an important article in the *Revue du XIXème Siècle*. Manet submitted the portrait of his defender to the Salon, along with that of a young woman, painted in 1866 and posed by Victorine Meurent. The latter was, curiously enough, more criticised than the one of Zola, although there were complaints about his lack of expression; the young Odilon Redon, an occasional art critic, wrote that it was 'more like a still life than a representation of a human being.'

'. . . I can do nothing without nature.
I cannot invent.
When I was trying to paint according to rules I had learned, I produced nothing worthwhile. If what I do now has any value, it is thanks to close analysis and precise interpretation.'

1 *Emile Zola*, 1868
Oil on canvas, 146.3 x 114 cm
Musée d'Orsay (gift of Mme Zola), Paris (RMN)

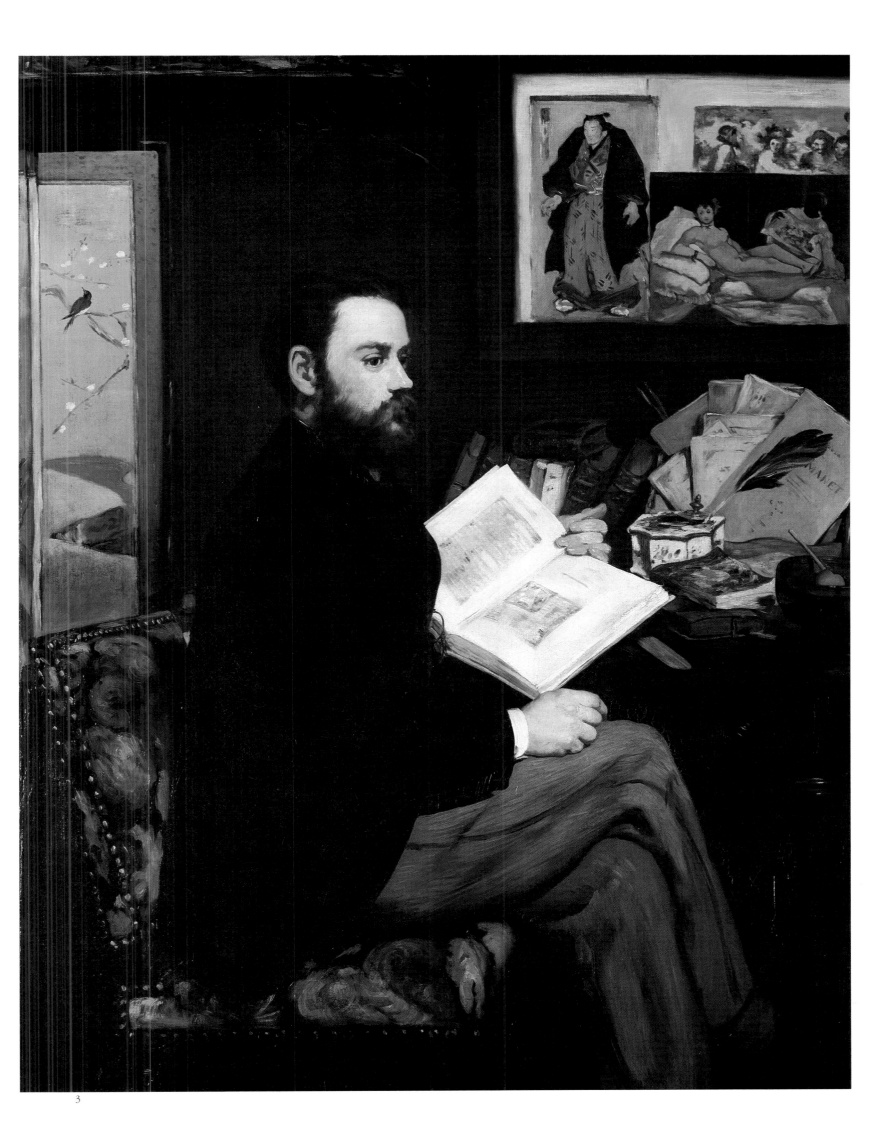

Manet's wife was a notable pianist. There is a recognisable Dutch influence in this portrait painted in the house of Manet's mother. In the background, reflected in a large mirror, is the clock which the King of Sweden gave to his god-daughter, Mme Manet senior, on her marriage in 1831.

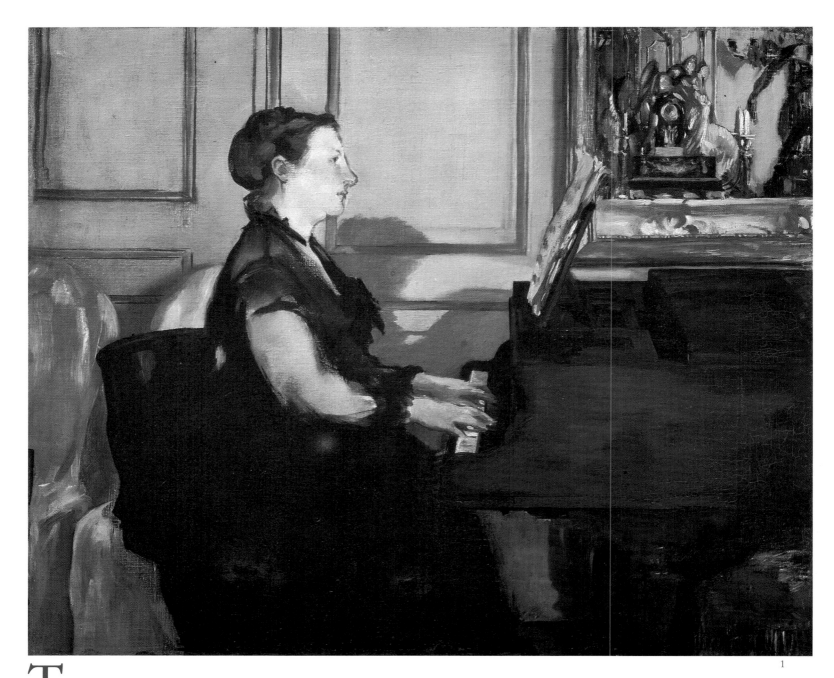

1

The Manet family had been living since 1866 at 49 rue Saint-Pétersbourg, his mother's home. Summer was spent in a rented house at Boulogne, where the painter went to rest. That year, the house they rented looked on to the port. His neighbour Auguste Rousselin, who had been a pupil of Gleyre and Couture, came to visit him, and Manet got him to pose with Léon, who had just begun work as a messenger for the banker Degas, father of the painter. Manet was preparing for the next Salon, and managed to assemble in the same composition a portrait of the adolescent and two still lifes, the one on the table and the collection of old armour, lent to him probably by his painter friend Monginot. The jury at the 1869 Salon accepted the painting, and although it regretted the 'vulgarity' of the subject, it did concede that the still lifes had some good parts. Castagnary had to admit: 'M. Manet is a true painter . . . he borrows his subjects from poets, or else plucks them from his imagination; he scatters the figures haphazardly, without any forced rules of composition.'

'The Orientals used black as a colour, particularly the Japanese in their engravings. Closer to home, I recall that in one of Manet's paintings he uses a bold and luminous black for the velvet jacket worn by the young man in the straw hat.' (Matisse)

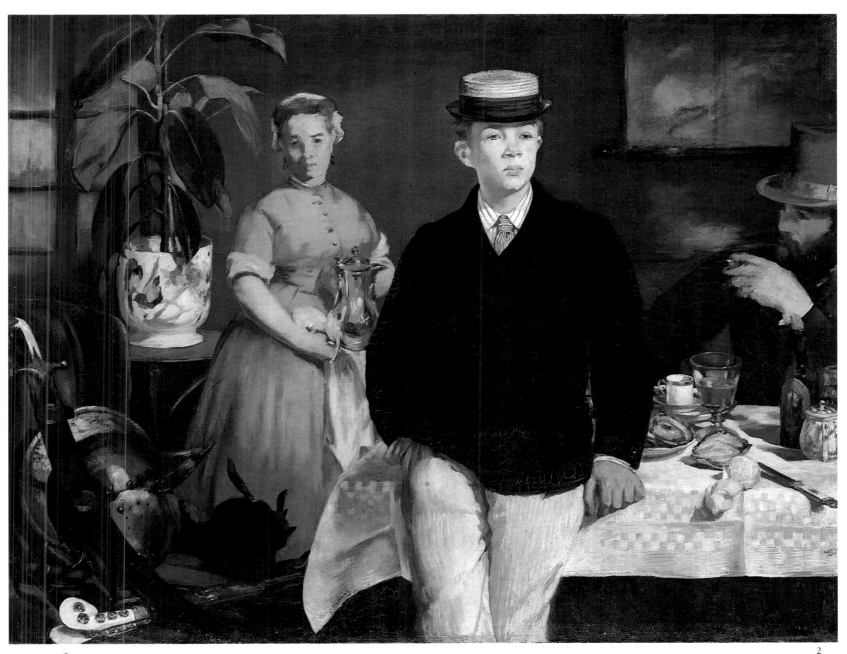

2

2

In this painting, all Manet's favourite themes recur. The cat from *Olympia*, the half-peeled lemon, the knife placed diagonally to indicate the perspective, the plant in the Japanese pot. What is new is the way Manet has placed Léon in front of the table and cut off at the knees. Manet used this theatrical arrangement for *A Bar at the Folies Bergère*, but this time placing the principal figure behind the bar rather than in front of a table.

1 *Madame Manet at the Piano*, 1867-8
Oil on canvas, 38 x 46 cm
Musée d'Orsay (Camondo legacy), Paris (RMN)

2 *Lunch in the Studio*, 1868
Oil on canvas, 118 x 154 cm
Neue Pinakothek, Munich. Artothek

The English, who were responsible for the development of racing in France, also started the fashion for seaside resorts. The court favoured Trouville (Eugénie had a villa built there), whilst the Duc de Morny launched the 'French Brighton': Deuville. Manet preferred Boulogne-sur-Mer, and had for several years spent his summer holidays there. He would go to and from the capital, do some business in Le Havre, where he was preparing an exhibition with Courbet and Monet, and cross over to England, where he hoped to show and sell his work. He came back very pleased and wrote to Fantin-latour: 'What I want to do now is earn some money; and since there's not much hope of that in this stupid country populated by government employees, I'm going to try and have an exhibition in London next year.' That year he stayed in the Hotel du Folkestone. The *Folkestone* itself was a cross-Channel steamship. In 1855, the inhabitants of Boulogne watched Queen Victoria disembarking from it and being greeted by Napoleon III and Eugénie.

The arrival of the *Folkestone* was still, just before the war, a tourist attraction and an excuse for an outing. Suzanne and Léon used to go out to meet the steamship, hoping to catch a glimpse of rich English lords arriving on the Continent. But Manet, a townsman at heart, was missing his friends in the Café Guerbois: 'I do envy you discussing the impossibility of putting art within the reach of the poorer classes with that great aesthetician Degas, and being able to deliver paintings for 13 sols. I have not been able to discuss painting with any outsider since I've been here.' His morale and his health had been affected by the years spent in lively arguments and Salon controversies.

From his window he used to paint the movements in the port of Boulogne, the tourists watching the sailing ships, and the double jetty with the picturesque wooden decking which had so attracted Boudin, and would later inspire Marquet and Vallotton.

He also used to go down at dusk to the port, where the women were waiting for the fishermen to come home. He painted cloudy skies scattered with stars, and the silhouettes of fishing boats lit by the pale light of the moon. It was on one of his holidays in Boulogne that he got the idea for a painting which was then begun in his Paris studio: *The Balcony*.

1

1
Many painters were inspired by the sea: Manet, Jongkind and Courbet all successfully brought it to life. Jongkind, like de Maris and van Gogh, had come from Holland. He very soon became linked with Manet, and was really the first Impressionist. Castagnary, as early as 1863, bore witness to his talent at the Salon des Refusés: 'With him everything lies in the *impression*: the thought leads the brush on . . . when the sketch is finished, the painting completed, you need not worry about the execution, it will vanish in the face of the delightful effect it produces.'

Arrival of the Folkestone *at the port of Boulogne* 2

'I did what I believed in. Show me a work that is more sincere, more free from convention. What could be easier than to add the sort of frills dear to M. Wolff? They argue over the bits that will please the critics as if over pieces of the true cross. In ten years none of it will be worth tuppence.'

1 *Entrance to the Port of Honfleur,* 1866. J.B. Jongkind
Oil on canvas, 42 x 56 cm
Musée du Louvre (gift of H. & V. Lyon), Paris (RMN)

3 *The Jetty at Boulogne,* 1869
Oil on canvas, 60 x 73 cm
Privat collection, Paris

3

3

This painting, inspired by Japanese engravings, is one of Manet's stranger compositions. In the centre, behind the jetty, are the masts and sails of a ship preparing to sail. On the left is the bowsprit of a second ship which seems to be sailing at high tide while the first is on a low tide. Possibly Manet painted this at several different times.

4

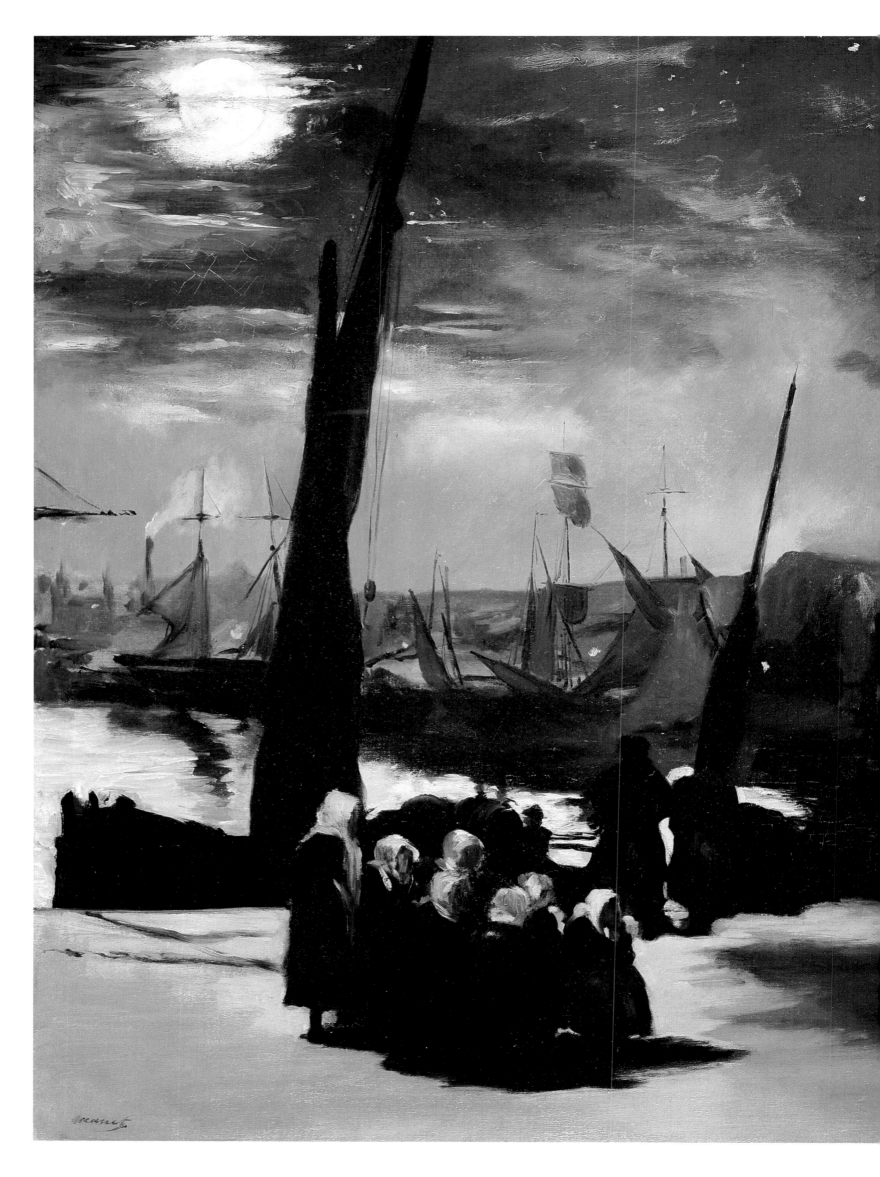

2
Manet painted this, one of his most 'patchy' pictures from his window. Mme Manet is at the front, in a white dress, holding a parasol, with Léon beside her in a felt hat.

1
Manet loved the port at twilight, when the tourists had gone and the sailors were returning to port, greeted by women in their traditional head-dresses. This painting was the first one bought by the dealer Durand-Ruel, who was to become his principal support.

1 *Moonlight over the Port of Boulogne*, 1869
Oil on canvas, 82 x 101 cm
Musée d'Orsay (Camondo legacy), Paris (RMN)

2 *Departure of the Folkestone Boat*, 1869
Oil on canvas, 60 x 73 cm
Museum of Art, (Carrol S. Tyson Coll.), Philadelphia

In 1859, Berthe Morisot met Fantin-Latour through Félix Bracquemond, whom she had known for a few months. Berthe and her sister Edma were pupils of Corot and, like Edouard Manet, came from the Parisian *haute bourgeoisie*. Their father, Edmé Tiburce, was a high official at the Audit Office, and the family lived in a large house on the Trocadéro. Mme Morisot held a salon on Thursdays, and warmly welcomed artists and writers. The two girls were able to meet other artists at these chaperoned evenings, as well as at the Louvre, where they went to copy old masters. Oddly enough, Berthe did not meet Manet until 1868. The painter at first responded mainly to the beauty of the young woman, and was only mildly interested in her talent. He wrote to Fantin-Latour from Boulogne, where he was on holiday, that the two young women 'would serve the cause of art better by each marrying an academician than by sowing discord amongst middle-aged men'. However, Manet continued to paint portraits of Berthe, and shortly after they met, he asked her to pose for a studio composition with the young cellist Fanny Claus. Taking inspiration from Goya's *Majas on a Balcony*, he put Berthe in an arresting position, sitting in front thoughtful and alone. Behind the two young women stands Antonin Guillemet holding a cigar, with a satisfied expression. The sessions were long and tedious and the young people complained. *The Balcony* was shown at the 1869 Salon, and this time the critics were less vehement. Théophile Gautier was forced to recognise that Manet could be a talented painter 'if only he took the trouble'.

When she came out of the Salon, Berthe wrote her first impressions of it to her sister: 'You can imagine, I intended to go straight to room *M*. I found Manet with his hat on in the sun, looking dazed; he begged me to go and see the picture because he could not bring himself to go in. Never have I seen such a mixture of expressions; he was laughing, looking anxious, assuring me simultaneously that the picture was very bad and that it was a great success. I find he has a charming and delightful nature. His paintings always remind me of wild or unripe fruit, but I am far from displeased. I look strange rather than ugly; apparently the word *femme fatale* has been mentioned by the onlookers.'

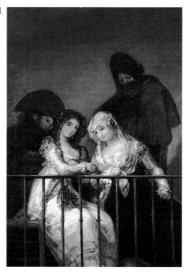

1

Berthe Morisot

1
Manet would have seen Goya's *Majas on a Balcony* in the Louvre's Spanish gallery: in it bold young women are watching French troops go by from their window.

3
Behind Berthe Morisot, Fanny Claus and Antonin Guillemet can be seen the shadowy figure of a waiter, posed by Léon Leenhoff. The three characters, framed in green, are not looking at each other, and seem to be isolated, each inhabiting her or his own psychological world. Berthe is dreamy and tormented, Fanny shy and flirtatious, Antonin jovial and self-satisfied. At Berthe's feet is a little dog instead of the usual cat, and a ball has replaced the lemon. This painting was bought by the painter Caillebotte in 1884, and was part of his legacy to the Louvre; it went into the Luxembourg in 1896, and to the Louvre in 1929.

1 *Majas on a Balcony*, 1808-12. Goya
Oil on canvas, 194.8 x 125.7 cm
Metropolitan Museum of Art
(gift of Mrs H.O. Havemeyer), New York

2 *The Balcony*, 1868-9
Oil on canvas, 170 x 124 cm
Musée d'Orsay (Caillebotte legacy), Paris (RMN)

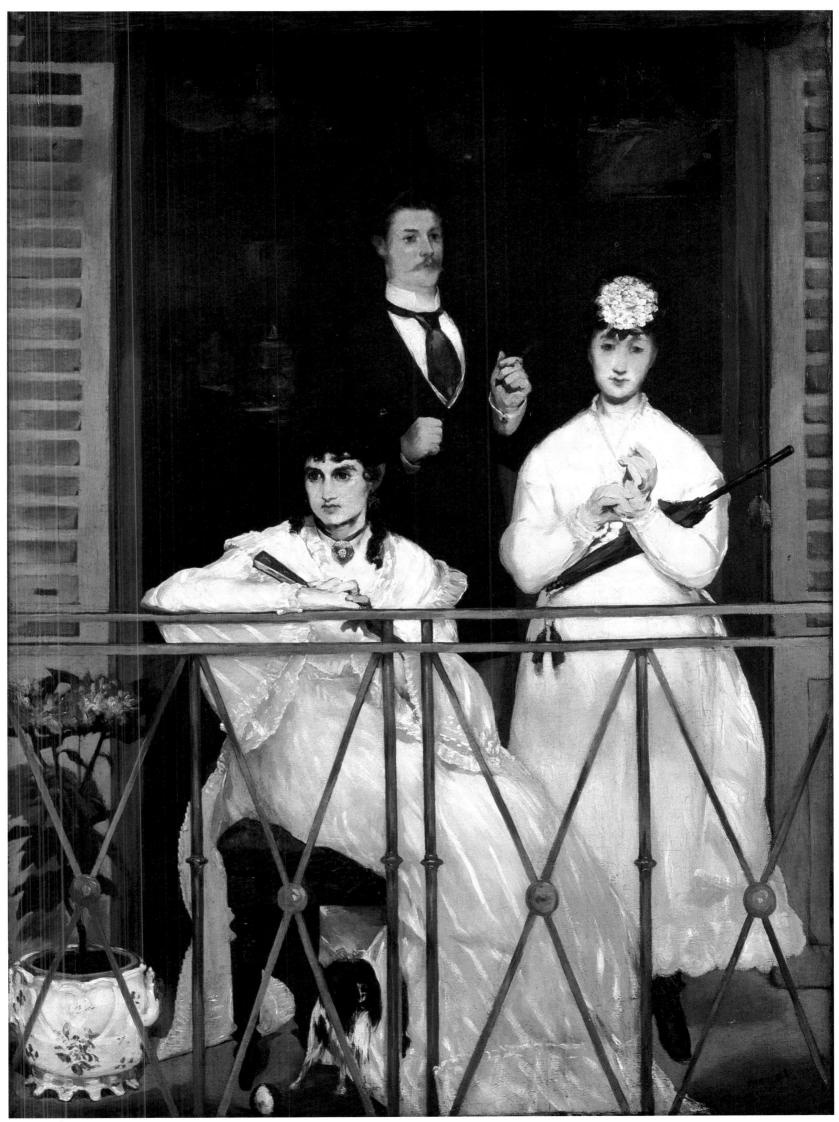

Eva Gonzales, daughter of the playwright Emmanuel Gonzales, showed unmistakable artistic talent at an early age. Taught at first by Chaplin, she met Manet in February 1869, and became his pupil and model. He admired her hair, and immediately began to paint her portrait. It was a tedious enterprise and he had to start again several times during 1869.

The painting was not a real success when it was shown at the Salon. As for Eva, she offered the Salon a *Circus Child* strongly influenced by Manet's *Fifer*. But while her style was more

'Manet has never done anything so good.'
(Berthe Morisot)

2
Although it seems that Edma Pontillon sat for this painting, replacing Valentine Carré, Tabarant claims that the sitters were Giuseppe de Nittis and his wife. Manet did indeed spend the summer at Saint-Germain-en-Laye with the Neapolitan painter. In a letter to his brother, Vincent van Gogh wrote: 'This painting is not just one of the most modern, but it also represents the highest artistic achievement. I think that those looking for symbolism need go no further than this, and the symbol is not even intentional.'

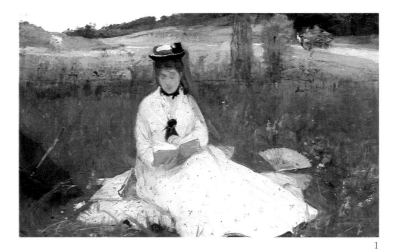

1

and more like that of his earlier style, he, under the influence of Monet and Morisot, was moving towards the bright light of Impressionism. Conscious of the artistic divide between the two young women, Manet took pleasure in arousing rivalry between them.

Berthe wrote to her sister: 'I went to the Salon with fat Valentine Carré. Manet wants to paint her . . .' The young woman was supposed to sit for her in the garden of the Morisots' house at 16 rue Franklin. But her mother refused permission for this and Edma, who was visiting her parents, sat instead for Manet. Edma also sat for her sister after the war, sitting on the grass, reading.

In the Garden represents a turning-point in Manet's artistic career. It is painted out of doors and there is no trace left of the Spanish influence. The brushstrokes are vigorous and the play of light and shade is more natural. There is no doubt that this work is much closer in spirit to that of Monet and Renoir, who were now both living between Chatou and Bougival, and painting the riverside festivities in *Bathing at La Grenouillère*.

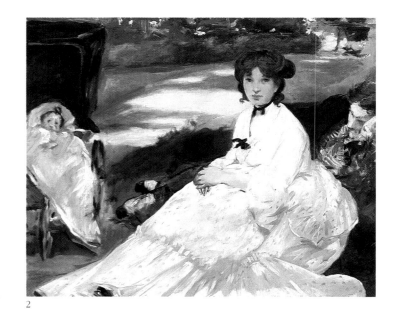

2

1 *Girl Reading*, 1873. Berthe Morisot
Oil on canvas, 45.1 x 72.4 cm
Cleveland Museum of Art
(gift of Hanna Foundation), Cleveland

2 *In the Garden*, 1870
Oil on canvas, 43 x 55 cm
Shelburne Museum, Shelburne, Vermont

3 *Portrait of Eva Gonzales*, 1870
Oil on canvas, 191 x 133 cm
National Gallery, London

3
The smiling amateur painter here is Eva Gonzales, Manet's faithful pupil. She married Henri Guerand in 1879, after a three-year engagement, and died of an embolism sixteen days after the birth of her son and five days after Manet's death. Although she did not have Morisot's courage, she did leave a respectable body of work.

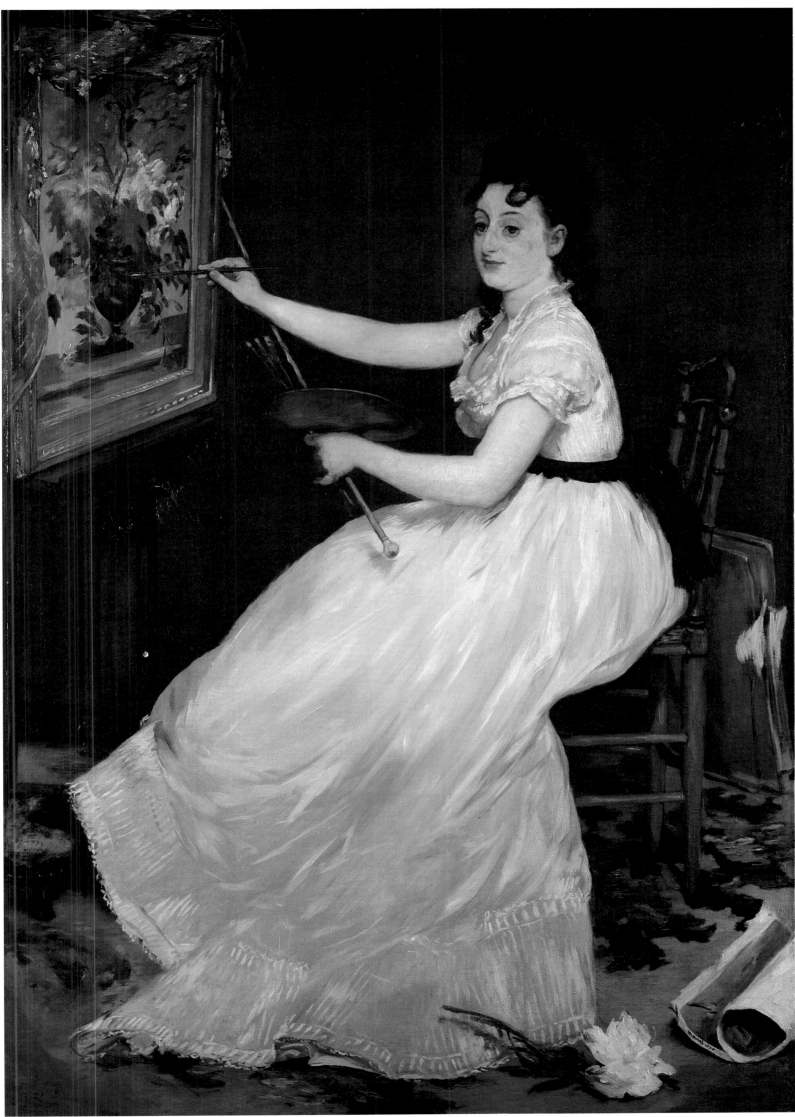

3

After he had painted his young pupil Eva Gonzales, Manet asked Berthe Morisot to sit again for him; he shows her, not at her easel, but lost in reverie. The young artist was going through a period of doubt. She felt very much alone now that her sister was married, and the artist in her was irritated and disconcerted by Manet's patronage of Eva Gonzales. She hoped to present at the Salon *The Port of Lorient*, which she had painted the previous

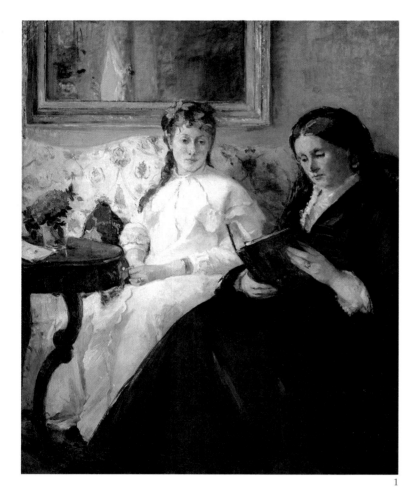

summer, while staying with her sister Edma. When he visited the Morisot family Manet recognised her talent, with its distinctive 'unfinished' look, and the grateful Berthe gave him *The Port of Lorient*. Feeling more confident, she undertook *Girl Reading*, also intended for the Salon. Once again she was seized by doubt, and she went to see Manet at his studio. The next day he visited her and 'corrected' the painting, laughing happily at the thought of helping his young colleague. Berthe, on the other hand, was so sad that her picture had been changed that she said she would rather 'be at the bottom of the river than hear that it had been accepted'. However, it was accepted by the Salon jury, and Berthe came round in the end.

'I will go and look at your painting tomorrow after my submission, and you may trust me; I will tell you what needs to be done.'

1
'He came at about one, said he found it very good except for the bottom of the dress; he took the brushes, and put a few touches which were excellent; my mother was delighted. Then my troubles began; once he had started, nothing could stop him; he went from the skirt to the bodice, from the bodice to the head, from the head to the background; he made jokes all the time, laughing like a madman, gave me the palette, took it back again, until finally, at five in the afternoon, we were left with the prettiest caricature you could ever see. They were waiting to take it away, he forced me, willy-nilly, to put it on the stretcher and I was left in confusion; my only hope was that it would be rejected; my mother thought the whole thing was funny, I found it heart-breaking.'

Berthe Morisot 2

1 *The Mother and Sister of the Artist,*
1869-70. Berthe Morisot
Oil on canvas, 101 x 81.8 cm
National Gallery (Chester Dale Collection), Washington

3 *The Rest,* 1870
Oil on canvas, 148 x 113 cm
Museum of Art (gift of Edith Stuyvesant Vanderbilt Gerry),
Providence, Rhode Island School of Design

3
Berthe Morisot, who was a descendant of Fragonard, and a pupil of Corot, poses here with a certain indolence. Manet had seen, behind her dark eyes, the anxiety of the young painter, and her fears as she approached thirty. The painting, planned for the 1871 Salon which did not take place, was shown in 1873 alongside *The Glass of Beer*.

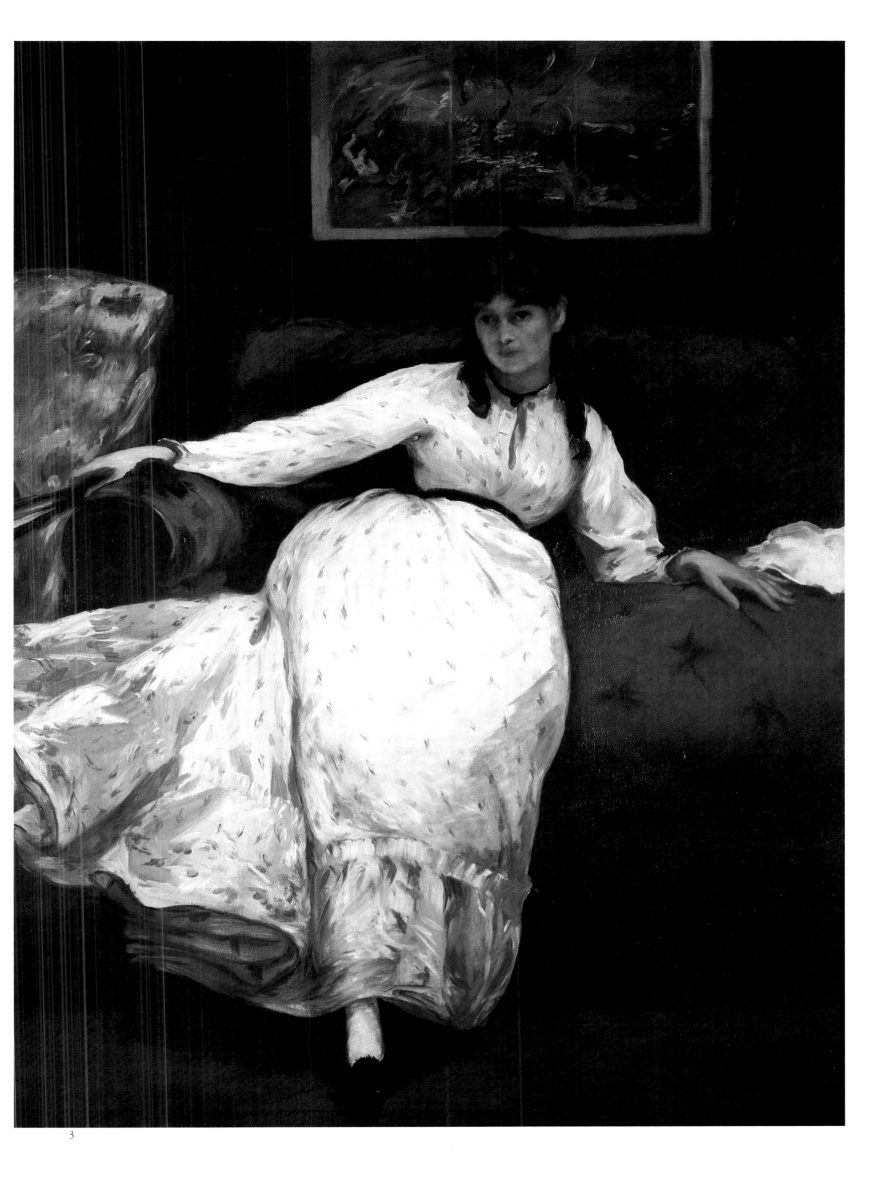

1870: the dark years

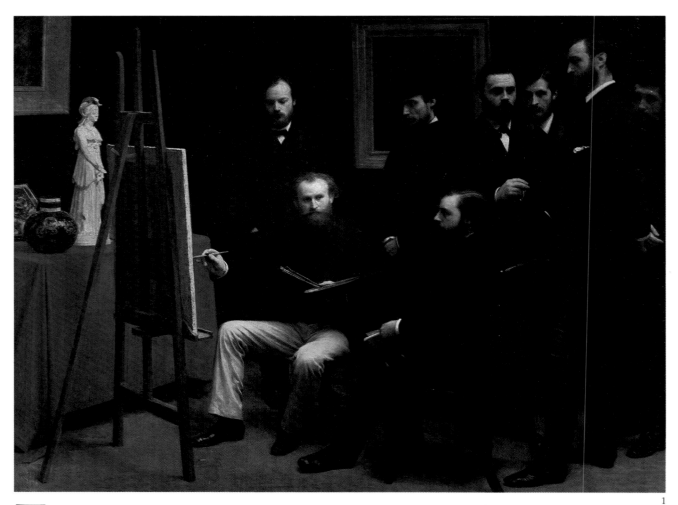

French opinion at that time was much influenced by the organisation of Napoleon III's plebiscite, and the 1870 Salon decided to open its doors to younger artists. The Academy agreed that well-known and successful painters should choose the members of the selection jury. Manet played an active part in preparing for this reform. The painter Jules de Rochenoire then suggested a very different list to the official one, including Corot, Courbet, Daubigny, Daumier, Armand Gautier, Manet, Millet, but after a few days it became clear that there was no hope of getting this list accepted. Manet did not give up, and wrote to Rochenoire: 'My dear Rochenoire, our list has no chance unless we strike some great blow. . . . Let all those who fear a refusal vote for the following men, who all support the principle that each artist has a right to show his work, and in the most favourable of conditions . . .' Despite his fears, the jury accepted 5434 submissions, showing itself to be more liberal than anyone had hoped, but turned down the works of Monet, Bazille and Cézanne.

1
'When the foolishness of today has made way for that of the future, and the attacks on Manet have died down, my picture will be seen as a studio interior, a portrait of a friend surrounded by friends. I have kept you a modest place in the corner,' wrote Fantin-Latour to Edwards, the engraver. In this painting all the Café Guerbois group are assembled: Schölderer, Manet holding his palette, Renoir, Zacharie Astruc seated, Emile Zola, Edmond Maître, Bazille and Monet.

'Candidates are invited to come and express their views on artistic organisation – or disorganisation.'

1 *A Studio in the Batignolles,* 1870. Henri Fantin-Latour
Oil on canvas, 204 x 273.5 cm
Musée d'Orsay, Paris (RMN)

2 *Westminster Bridge,* 1871. Claude Monet
Oil on canvas, 47 x 72.5 cm
National Gallery, London

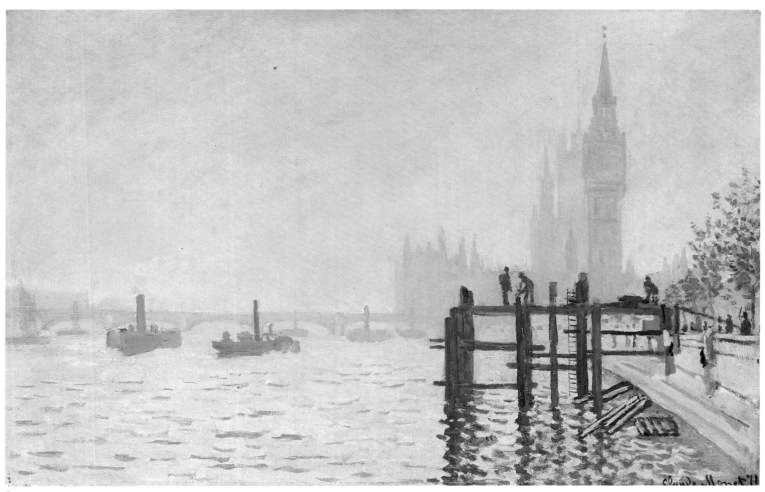

2

2

Monet and Camille were married on 28 June 1870. They went to Trouville and moved into the Hotel Tivoli. When war broke out, Monet went to Le Havre and crossed to England. He wandered miserably around London until he met Pissarro, with whom he discovered Turner and Constable in the galleries. He began to paint the fog on the Thames. Daubigny introduced him to the young dealer Durand-Ruel, which meant the end of poverty; Camille had remained in France.

3

After the siege of Paris, Manet took his family to Arcachon.

3

'I think that we miserable Parisians are about
to take part in something terrible.'

1

2

One early afternoon in January 1870, two young men presented themselves at the home of Prince Pierre Napoléon Bonaparte. Victor Noir, aged twenty-two, and Ulric de Fontvielle went into the mansion. They were witnesses for Henri Rochefort, editor of a newspaper opposed to the regime. Pierre Bonaparte would not hear of a duel and began insulting the two journalists. Victor Noir threw himself furiously at the Emperor's cousin, who

3

4

pulled out a pistol and shot him (1). There was a huge funeral, and riots were feared (2). Bazille wrote to his mother: 'I could not attend Victor Noir's funeral because it was pouring with rain and I was sitting for Fantin-Latour, a friend of mine. But I saw gangs of people heading for it on the outer boulevards. It will all end badly, you'll see, it's no joke, there is a general air of ill-temper which means that guns will go off on the first pretext, which will

5

6

certainly come soon.' When war was announced, the population gathered to fight. Manet joined the artillery as a volunteer gunner and was promoted to the staff on 28 December, on the orders of the painter Meissonier who had become a colonel (3). After only six weeks of fighting, the Prussians broke through

the French lines. Napoléon III surrendered. Edouard was able to send news to his family thanks to the balloons that were being sent off from the hill at Montmartre (4). On the evening of 4 September 1870, Paris was celebrating, with the Tuileries deserted (5). Eugénie had thought of resisting, but then decided

'It was going to be death, fire, pillage and carnage,
unless Europe arrived in time to interpose itself.'

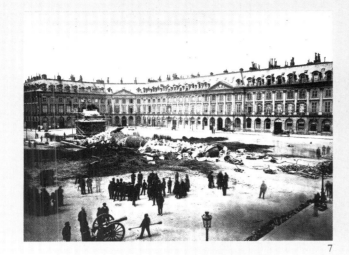

7

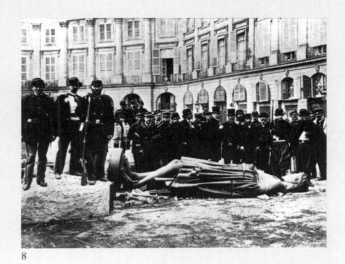

8

to flee with the help of Dr
Evans (6). She went to
England, where Napoléon
joined her in March.
After the fall of Paris, the
Assembly moved to
Versailles. The Parisians,
exhausted by their
sufferings during the siege,
were on the edge of revolt.
Some communes, such as
Montmartre and Belleville,
refused to hand over their
cannons to a state they did
not recognise. This was the
Commune, with its string of

9

summary executions and
massacres, both by the
communards and
Versaillais.
According to rumour it was
on Courbet's (9) initiative
that the Vendôme column,
symbol of the Empire, was
knocked down (7 & 8). The
painter, who was from the
Franche-Comté, had the
Louvre treasures taken into
safe-keeping and ordered
that the monuments should
be surrounded by sandbags.
He advocated the abolition
of the Beaux-Arts Academy

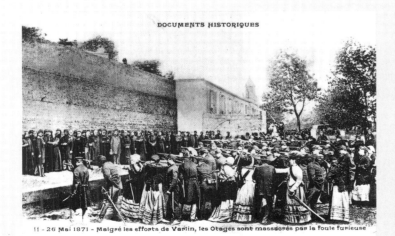

DOCUMENTS HISTORIQUES

11 - 26 Mai 1871 - Malgré les efforts de Varlin, les Otages sont massacrés par la foule furieuse

10

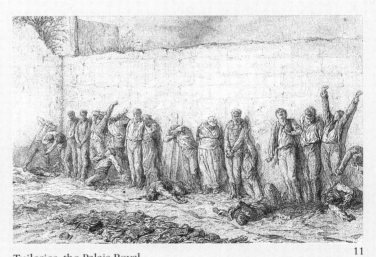

11

and its Schools and Salons.
He finally broke with the
Commune after the
summary execution of his
friend Gustave Chaudey,
ordered by Raoul Rigault.
Rigault, who was the police
superintendent and then
public prosecutor for the
Commune, ordered many
arrests and the destruction
of monuments such as the

Tuileries, the Palais-Royal,
the Mint, the Maison de la
Légion d'honneur, and the
Hôtel de Ville. Camille
Pelletan remembered
several years later: 'The
return of the government to
Paris was marked by the
massacre of 20,000-30,000
Parisians, according to
some, 17,000 according to
others (10 & 11).'

Manet, left alone in a besieged Paris, closed his studio in the rue Guyot, and moved his thirteen most important canvases into his friend Théodore Duret's cellar. With them he sent the following letter: 'My dear Duret, here are the canvases which you will be so kind as to look after for me during the siege . . . I leave you to choose which you want out of *Moonlight, Young Girl Reading*, or, if you prefer, you could have *Child Blowing Bubbles*.' Duret, a loyal friend, acknowledged the deposits, and said that he already had in his possession the *Bowing Toreador*, for which he owed 1200 francs.

Throughout the siege Manet was able to send news of his brothers to his family, thanks to balloons sent up from Montmartre. They are moving letters, written in a taciturn style: 'Paris at the moment has an extraordinarily military air. They are drilling on every street. I think they will defend themselves bravely.' He congratulates himself on having sent his family to Oloron. 'I am glad I made you go . . . Paris is gloomy and sad . . .' His drawings were done from memory, after the siege and the war, as if to fix the emotion that had gripped him at the time. 'I went this morning to Gennevilliers with Gustave, and we came back by Asnière. It was a sad sight. Everybody has gone. All the trees have been cut down, and everything has been burned. There is furniture burning in the fields. Looters are searching for any potatoes left lying on the ground. The camps are dug in, the militia is everywhere. All the talk is of guns and revolvers; I think they are ready for a courageous defence.' The atmosphere in Paris was tense, and apparently there were spies everywhere. Eventually Edouard and his brothers had to arm themselves in order to survive. 'We would each like to buy a good revolver; it is essential to have one in case of attack . . . I am going to make us each a bullet-proof vest. You need two hundred layers of tissue paper.'

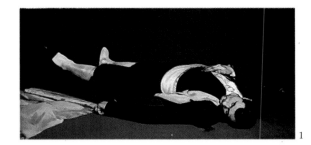

1/2/3
Returning to the theme of the *Dead Soldier*, a painting attributed at the time to Velázquez, which had been the inspiration for his *Dead Torero*, Manet painted a *Dead Soldier* behind a barricade. Away from Paris during the Commune, he did not draw from life, and in order to illustrate the 'bloody week', he repeated the arrangement for the execution of Maximilian in his painting of the barricades. He completed this water-colour in two sessions. In order to help identify the location, he added a piece of paper with Parisian buildings and lamps.

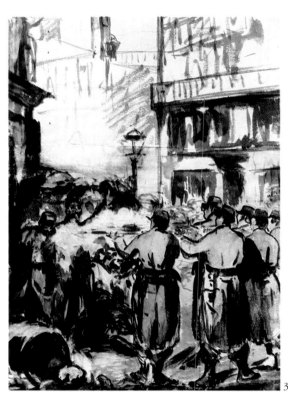

'My rucksack is also full of painting equipment, and I am soon going to start some studies from life. They will be souvenirs that one day will have some value.'

1 *The Dead Torero*, 1864
Oil on canvas, 75.9 x 153.3 cm
National Gallery (Widener Collection), Washington

2 *Civil War*, 1871-3
Lithograph
Bibliothèque Nationale, Paris

3 *The Barricade*, 1871?
Ink wash, water-colour & gouache
on pencil, 46.2 x 32.5 cm
Szepmuveszeti Muzeum, Budapest

4 *The Barricade*
Lithograph, 46.5 x 33.3 cm
Museum of Fine Arts (gift of
W.G. Russell Allen), Boston

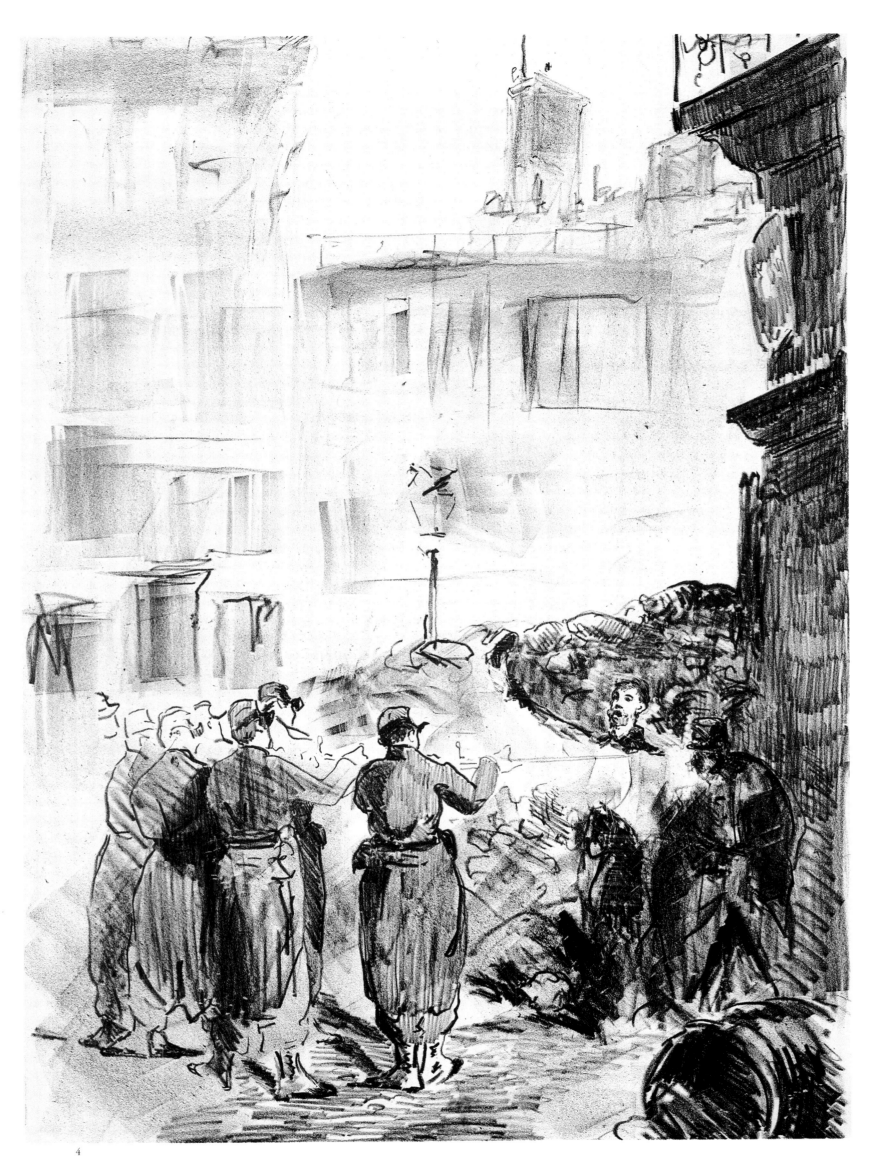

Soon, in a besieged Paris, the main problem for Manet and his brothers became food. 'It is the horses' turn now, and donkey is a great luxury.' Victor Hugo, who had returned from exile, wrote in his diary: 'We're not even eating horse now. It *might* be dog. It *might* be rat. I'm beginning to have stomach cramps. We don't know what we're eating.'

The Queue at the Butcher's illustrates the Parisians' main proccupation: 'The butchers open only three times a week, people start queuing at four in the morning, and the last get nothing.' Often Manet would sit down to table 'only by force of habit'. Life was becoming 'unbearable'. Manet continued to keep in touch with his family, betraying both his exhaustion and his stoicism: 'No more gas; black bread only; cannons going all day and all night.' Twenty-six days later, Manet learned, with some relief, that Paris had surrendered. 'It is over . . . we were dying of hunger here . . . You really have to go through all this to fully understand it.'

Having no other reason to remain in Paris, he hurried to join his family at Oloron on 12 February. Although very thin and mentally shattered, he began to paint again.

He then went to Bordeaux where, to the Parisians' amazement, the National Assembly had gathered. He thought of exhibiting at the Great Exhibition in London because, as he wrote to Félix Bracquemond: 'This damned war has ruined me for several years.'

He stayed in Arcachon, and then travelled to Royan, Rochefort and Saint-Nazaire. According to Tabarant, he took a train to the capital from Tours, arriving in paris just after the tragic 'bloody week' of 22-28 May 1871. Mme Morisot wrote to her daughter of her surprise at seeing Manet in Paris: 'It is hard to believe such folly, I rub my eyes to make sure I am really awake . . . Tiburce [Berthe's brother] met two communards in the street just when they were all being shot – they turned out to be Degas and Manet! Even now they are holding forth about the cruelties of the repression. I think they are mad, don't you?'

Without knowing it, Manet had been elected a member of the Federation of Artists. On 7 June, Courbet was arrested, and court-martialled on 14 August. The war was finished. Manet, after living through the Commune, was in an alarming nervous condition. After living through the Commune, Manet was in an alarming nervous condition.

'In Paris, now, there are butchers selling cats, dogs and rats.'

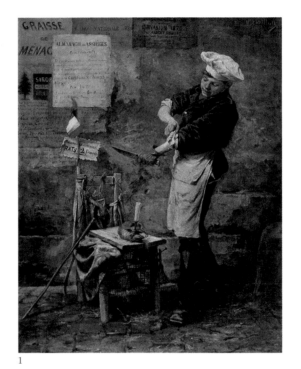
1

1
The Prussians besieging Paris left 'the pot to bubble until it went dry'. They counted on exhaustion and famine winning the battle for them. And, indeed, there was no restriction on food in the first months of the siege. In the third month, food became scarce and Parisians had to fall back on tinned food, until then much despised. Hunger no longer affected only the poorest.

2
'Bloody week' was followed by summary executions. Reprisals on one side were followed by reprisals on the other. Such retaliation led to a fratricidal struggle in which the first victims were women and children.

2

1 *A Rat for Two Francs,* Chailloux
Musée Carnavalet. City of Paris photographic archive (SPADEM)

2 *The Child had received two bullets in the head*
Engraving by P. Langlois
Bibliothèque Nationale, Paris

3 *The Queue at the Butcher's,* 1871
Etching, 16.8 x 13.7 cm
Museum of Art (George A. Lucas Collection), Baltimore

3

1

1
The artist gave this bunch of violets to his model, Berthe Morisot. In the painting he assembles a fan, a bunch of violets, the symbol of modesty, and a billet-doux, a token of love or friendship. Julie, Berthe's daughter and Edouard's niece, always kept this painting, which was a precursor of the still lifes he would paint towards the end of his life, and which he often gave to those close to him.

2
Berthe Morisot and Eugène Manet had known each other since 1871. In January 1875, she wrote: 'I have found a good and honest man, who, I think, truly loves me. I am living life positively after years of fantasy...'

Berthe Morisot's face reappears constantly in Manet's work between 1872 and 1874. She had refused to leave Passy throughout the war and the siege of Paris. Manet, as worried about her as he was about his family, wrote begging her to leave the city: 'It will be a great help for you to be crippled or disfigured.' Only in May did she agree to leave for Cherbourg. Experience of war had forced her to become more realistic. Thirty years old and unmarried, she took refuge in her painting, although her mother could not see her talent. However, Durand-Ruel, who had already bought 50,000 francs' worth of canvases from Manet, and who was looking towards the younger generation, bought four of Berthe's paintings in July. Here at last was recognition from a dealer. Manet painted her more than any other female model. After *The Balcony*, she was the model for *Portrait in Profile, Portrait with Muff, Berthe Morisot with Bunch of Violets, Berthe with a Pink Shoe, Berthe Morisot with a Fan, Berthe in a Black Hat*, and a charming watercolour in which

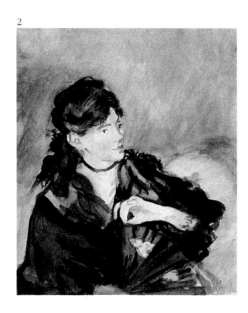

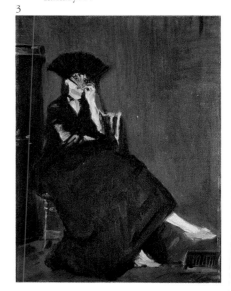

3
There is often a fan in Manet's paintings of Berthe. They were, for him, another way of emphasising her features. There is one in the last portrait he painted of her in 1874. This feminine attribute also emphasised Morisot's elegant hands.

4
In *Berthe Morisot with a Bunch of Violets*, one side of her face is lit strongly. Paul Valéry very much admired this portrait of a woman looking straight at the spectator without trying to seduce or taunt. In the opening of her dress is a bunch of violets like the one he painted for her.

'Mme Berthe has refused to do anything until now, she hasn't pushed herself; when she wants to she will get there.'

she has a ring on her finger. In 1874, she became Mme Eugène Manet. For a long time Edouard had wanted her to be his sister-in-law. In the summer of 1871, he had tried to organise a journey for Berthe and Eugène. Mme Morisot wrote to her daughter that she had seen Manet in his studio: 'He claims to have arranged it so as to compromise you both and force you to become his sister-in-law ...' Manet's artistic ties with Berthe allowed such familiarity. He used her face as a pretext for many experiments. She exhibited her work at the first Impressionist show in 1874, and then married Eugène in December. Degas' wedding present to them was a portrait of Eugène sitting on some grass.

1 *Bunch of Violets,* 1872
Oil on canvas, 22 x 27 cm
Private collection (RMN)

2 *Portrait of Berthe Morisot,* 1874
Water-colour, 20.5 x 16.5 cm
Art Institute (Joseph & Helen
Regenstein Foundation), Chicago

3 *Berthe Morisot with a Fan,* 1872
Oil on canvas, 60 x 45 cm
Musée d'Orsay
(gift of E. Moreau-Nélaton), Paris (RMN)

4 *Berthe Morisot with a Bunch of Violets,* 1872
Oil on canvas, 55 x 38 cm
Private collection (RMN)

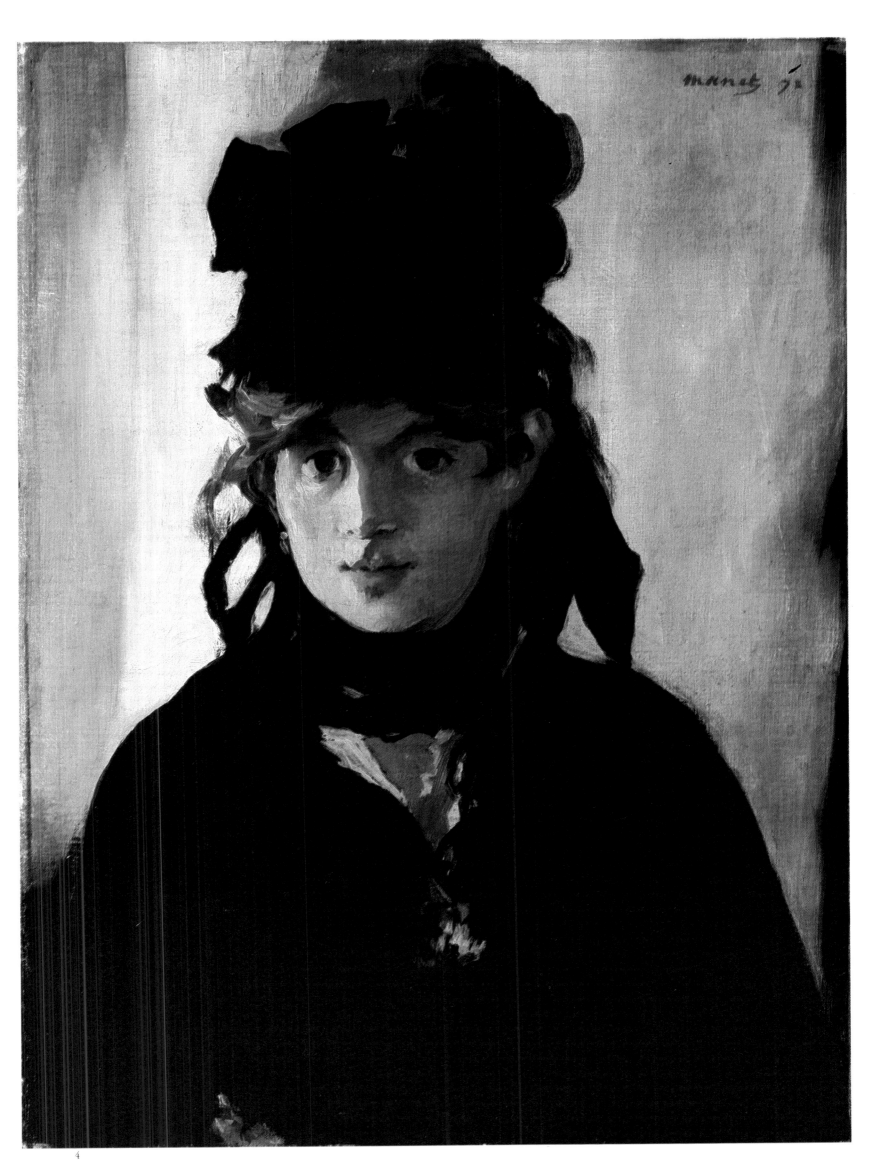

Alfred Stevens, who had become a friend of Manet's during the war, suggested that he should hang *Still Life with Salmon* and *Moonlight* at his house in the rue des Martyrs. Durand-Ruel saw them there on 11 January 1872, and bought them both for 1600 francs. The next day he went to the painter's studio and bought 35,000 francs' worth of canvases. The sale caused a sensation in artistic circles and amongst the critics. Some time later, Durand-Ruel returned to buy four pictures for 16,000 francs, one of which was *Music in*

1

Racing at the Bois de Boulogne was commissioned by a M. Barret, a sporting man. It is clearly influenced by Géricault whose *Derby at Epsom* had been bought by the Louvre in 1866.

2

Whereas Manet painted the races themselves, Degas preferred to show the moments before or after: the public arriving in carriages at the race-course, or the jockeys coming back into the paddock. More than Manet, he would centre his paintings like photographs, catching the horses in relaxed and natural positions, as he was later to do with his dancers.

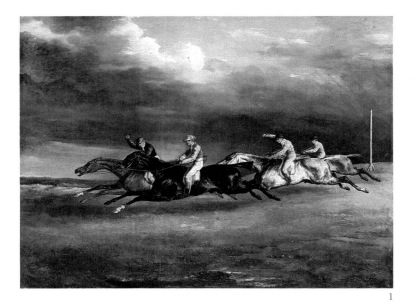

1

the Tuileries. After this more buyers appeared – the Hecht brothers, who had considered buying *Soap Bubbles* before the war, now did so. At last commissions began coming in. Manet had already, at Degas's instigation, painted the racecourse at Longchamp; in it he shows the horses in a 'flying gallop'. It took the publication of Eadweard Muybridge's photographs in *La Nature* (14 Dec. 1878) to show the error of observation here.

Like Degas, Manet used a photographic style for his compositions. Whereas Géricault had placed his riders at the centre of the picture, Manet had them surging on to the canvas, with one of the riders cut off by the edge. In the foreground, spectators are cut off at the shoulders, reinforcing the impression of immediacy, of being present at the race. The painting is more a representation of the world of racing than of the race itself. It was the last time he painted the world of horses, although in 1879, when he drew up his plan for the decoration of the new Hôtel de Ville, he included a section called 'Paris – parks and racing'.

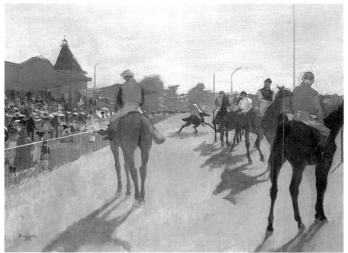

2

1 *The Derby at Epsom,* 1821. Géricault
Oil on canvas, 92 x 172.5 cm
Musée du Louvre, Paris (RMN)

2 *Racehorses in front of the Stands,*
1879. Degas
Oil on canvas, 46 x 61 cm
Musée d'Orsay, Paris (RMN)

3 *Racing at the Bois de Boulogne,* 1872
Oil on canvas, 73 x 92 cm
Mrs John Hay Whitney Collection, United States

3

Manet also modelled his work on English engravings which were then very much the fashion. Manet's jockeys sit back on the saddle – it was only later that they began to crouch up on shortened stirrups.

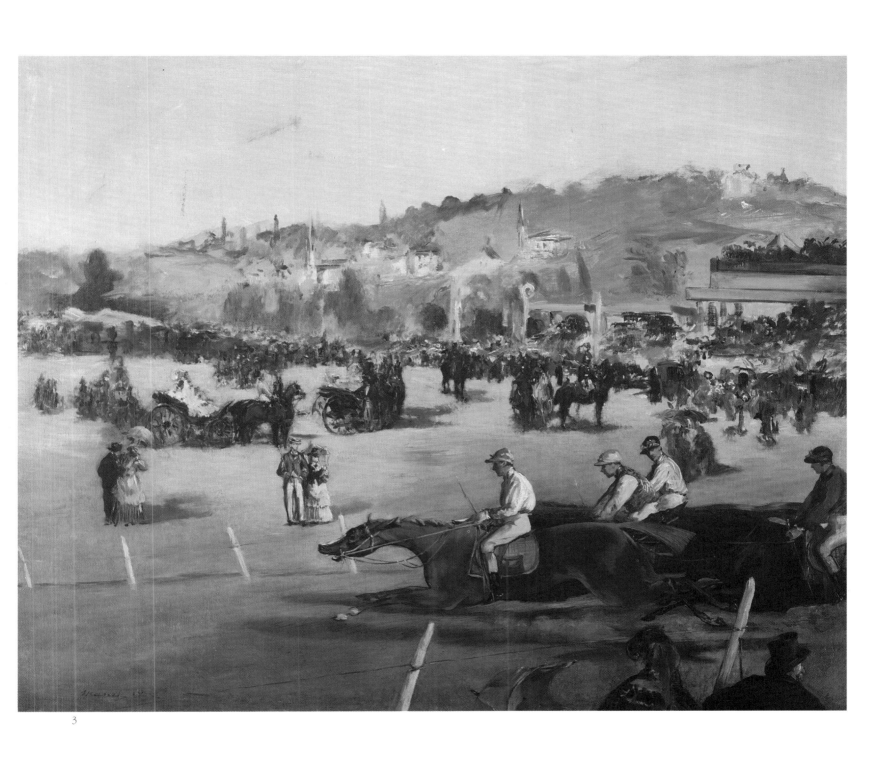

3

In July 1872, Manet moved into a new, larger studio at 4 rue Saint-Pétersbourg, near his house. He was very close to the Pont de l'Europe, which crossed the railway lines of the Gare Saint-Lazare. Installed in the centre of the city, he now embarked on urban themes. For a painting on the edge of the railway line, he needed a model from a more

2
After painting *The Railway*, Manet planned to paint an engine with its driver and mechanic, to illustrate the theme of man and machine. He had the idea for this project when he was travelling by train to Versailles every day to follow the trial of Bazaine, but it was never carried out.

Place de l'Europe at the end of the last century 1

2

modest Parisian background than the elegant Berthe Morisot, and so Victorine Meurent reappeared once again in his work. She had returned to Paris after the war from America, where a love affair had taken her, and was now a neighbour, living in the place de Clichy. The posing sessions took place in the garden next to the studio of his friend the painter Alphonse Hirsch. Philippe Burty liked the painting: 'The movement, the sun, the clear air, the reflections, all give an impression of nature, but nature shown with delicacy, conveyed with refinement.' However, other critics such as Cham chose to mock: 'These unfortunate women, seeing themselves painted in this way, wanted to escape, but he has foreseen this and placed a railing to cut their escape . . .' With this painting, which he presented to the 1874 Salon, Manet appeared to be the leader of the dissidents who were exhibiting that year at Nadar's. Jules Claretie wondered 'whether M. Manet had made some sort of bet, when one sees at the Salon paintings like the one he calls *The Railway* . . . M. Manet is one of those who claims that in painting it is enough to convey an *impression* . . . that is the entire secret of these *impressionists*, they are quite satisfied with rough indications that leave out any necessity for work or style.'

3/4
Monet produced some marvellous compositions on the Gare Saint-Lazare and the Pont de l'Europe (3). But Manet was the first to bring the industrial world into his painting. His view of it shows not so much the machines as the smoke coming out of them and enveloping the railway cutting (4). The young woman looks up from her book with an indifferent stare. The child turns her back on the spectator. This painting was bought by the singer Faure.

3

3 *The Pont de l'Europe*, 1877. Monet
Oil on canvas, 64 x 81 cm
Musée Marmottan, Paris (RMN)

4 *The Railway*, 1872-3
Oil on canvas, 93 x 114 cm
National Gallery, Washington

'Each *arrondissement* has its own character, either
because of its industries, or its inhabitants' occupations,
or its history. There must be thousands of fascinating
and instructive subjects there.'

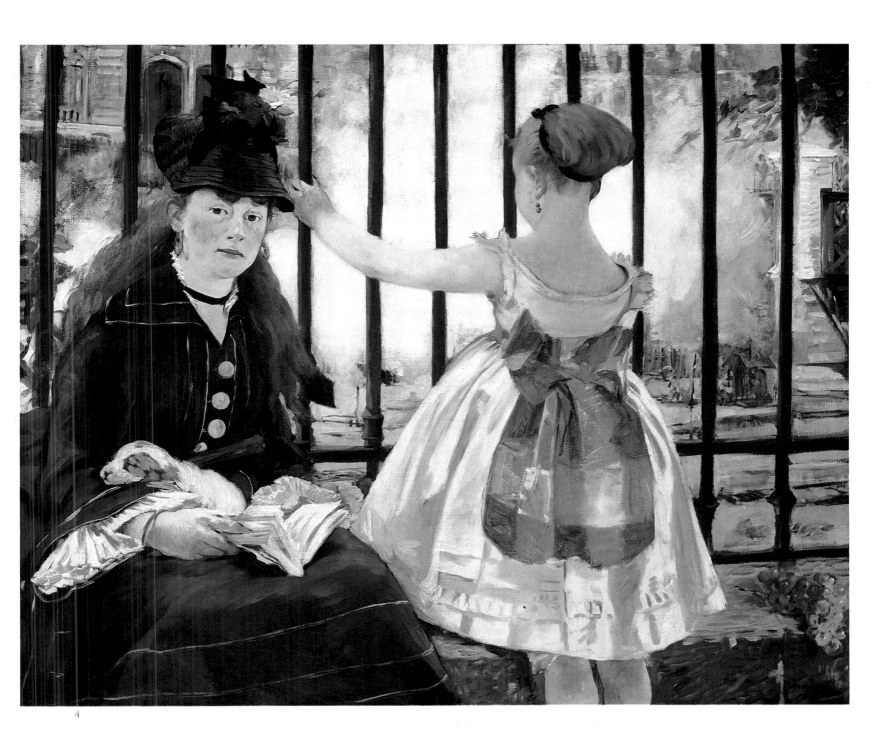

4

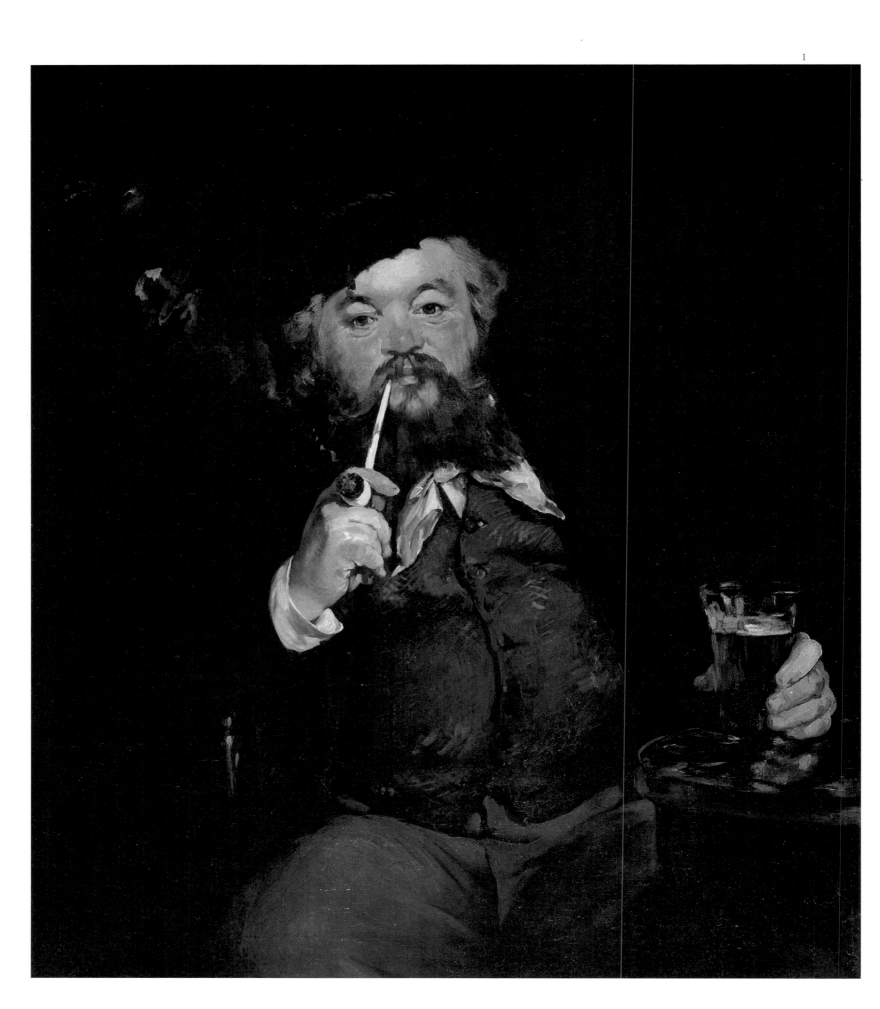

Before moving into rue Saint-Pétersbourg, Manet travelled to Holland with his wife, and visited the galleries there with his brother-in-law Ferdinand Leenhoff. He greatly admired the works of Frans Hals in Haarlem. In Amsterdam he visited the Rijksmuseum, where he looked again at the Dutch landscapes. Landscape had taken on a new importance for him; he knew and recognised Jongkind's talent, and had become very close to Monet, one of the young painters who would become famous two years later. On his return, he began to paint the portrait of Emile Bellot, an engraver who frequented the Café Guerbois. Eighty sessions resulted in *The Glass of Beer*. He presented it to the jury, where it was accepted along with *The Rest*, for which Berthe Morisot had posed. This jovial figure, smiling from his frame, rallied all the votes; everybody loved this fellow inspired by the Dutch School. Philippe Burty saw him as 'a type, the fat man . . . with simple habits, calm

'This year M. Manet has watered his beer.' (Albert Wolff)

The beach at Berck

'Happy man! He has seen the miseries of the siege;
His coat on his back, beneath snow and shells,
He bravely did his duty on the ramparts;
He paid his share of the five billion francs;
He lived through the Commune and its ugly battles;
For three years he has been reading the sermons from Versailles,
And every day in autumn, winter, spring, summer,
He drinks, eats and calmly digests his food.'
(Carjat, photographer and ex-chief-editor of the *Boulevard*)

and philosophical'. This simple, strong image became a symbol of 'eternal serenity' in these politically troubled times. At the close of the Salon Manet went away on holiday, a satisfied man. That year he had rented a villa in the popular resort of Berck. These family holidays by the sea were always very important to him. He was now forty-one and artistically more active than ever. He painted his family, Suzanne and his brother Eugène, in a manner which recalls Monet's paintings of the beach at Trouville. The new-found freedom in his work suggests that he had assimilated the technique of his younger friend.

1 *The Glass of Beer,* 1873
Oil on canvas, 94.6 x 83 cm
Museum of Art (Mr & Mrs Carroll
S. Tyson Collection), Philadelphia

anet loved the theatre and the circus, and soon embarked on a work that would recall *Music in the Tuileries – Masked Ball at the Opera*. This ball had taken place on 20 March 1873, the middle of Lent, followed ten days later by the artists' ball. At these events, a cheerful costumed crowd would invade the foyer and corridors of the Opera in the rue Le Pelletier: the palais Garnier had not yet been completed. Begun during the July monarchy, the ball had become an institution under the Second Empire. In order to get this little costumed crowd to pose, Manet made the models come to his new studio. Théodore Duret explained: 'Included in the gathering were the composer Chabrier, Roudier, a friend from college, Albert Hecht, one of his first buyers, two young painters, Guillaudin and André, and a retired colonel.'

In his pursuit of realism, Manet kept asking his models: 'How do you put on your hat without thinking, when you're having fun? Well, when you're posing, do it like that, with no preparation.'

Masked Ball at the Opera was completed in November 1873, and immediately caught the eye of the singer Jean-Baptiste Faure. The Impressionist brushstrokes, which were becoming bolder, were probably the reason for the painting being turned down by the jury for

The Opera after the fire.

1

the following year's exhibition. However, it remained a magnificent testimony to an event that would never happen again. During the night of 28 October 1873, the theatre in the rue Le Pelletier was completely destroyed by fire.

2 *Masked Ball at the Opera*, 1873
Oil on canvas, 59 x 72.5 cm
National Gallery (gift of Mrs H. Havemeyer in memory of L.W. Havemeyer), Washington

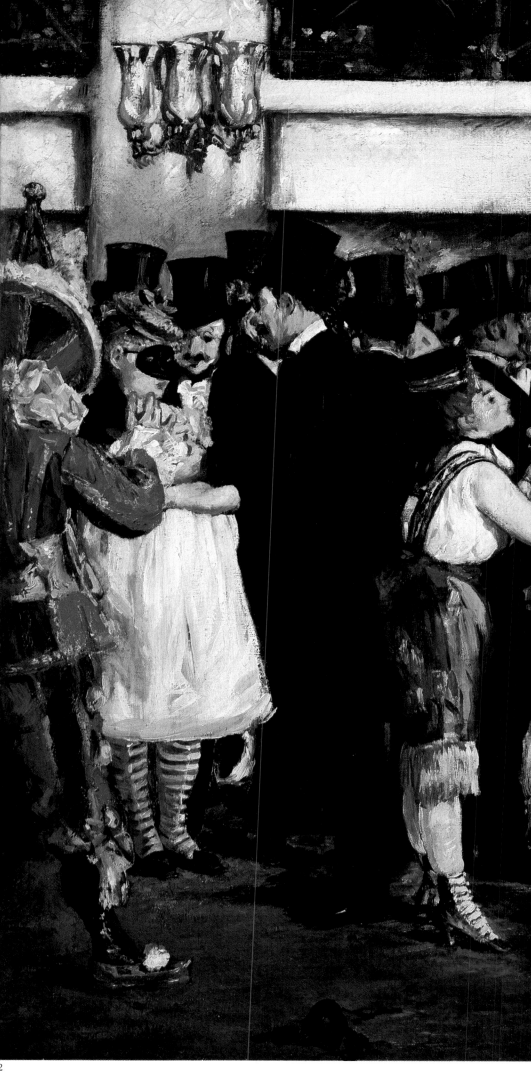

2

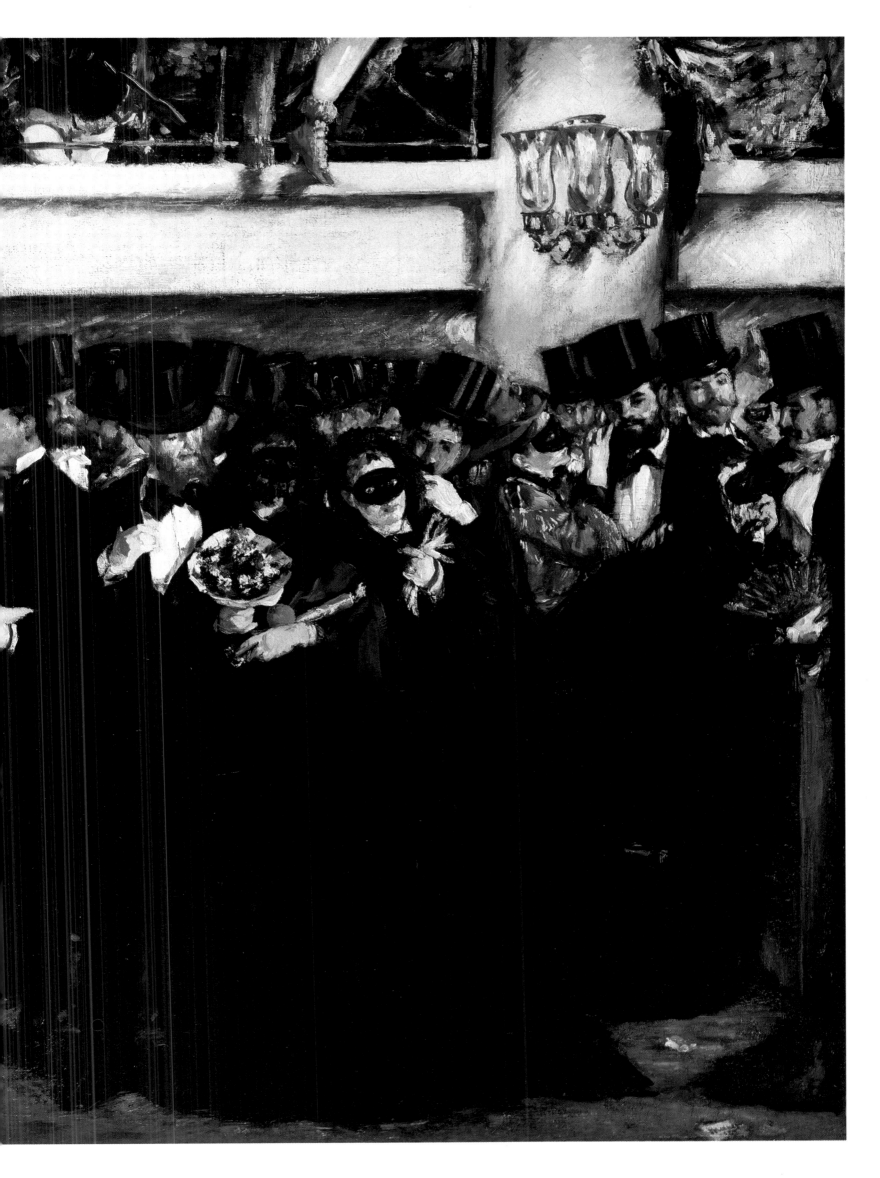

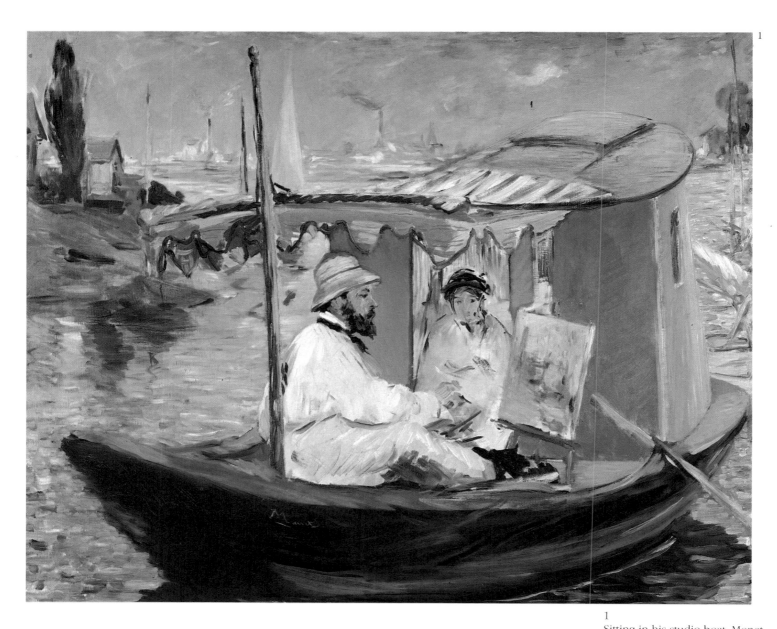

1

Sitting in his studio-boat, Monet poses for Manet. Camille is sitting at the entrance to the cabin. In the distance are visible the tall chimneys of the Argenteuil factories. One can already recognise Monet's influence in the treatment of the water. The brushstrokes touch one another, the colours are more luminous. The outlines of the boat are less clear-cut, as though dissolving in the atmosphere.

With *The Railway* at the official Salon, Manet became – slightly unexpectedly – the leader of the young painters now known as the Impressionists. He had, however, refused to exhibit alongside them. After all those years spent braving the jury, his personal style had at last been accepted. 'I will never exhibit in the shack next door; I will enter the Salon by the main door, and fight for you there.' The Impressionists had chosen to mount an exhibition in May in the studio of the photographer Nadar, who was a friend of Manet's. The artists included Berthe Morisot, Degas, Renoir, Pissarro, Cézanne, Sisley and Monet. Manet spent the following summer at his family home at Gennevilliers, on the opposite bank to Argenteuil, where Monet lived.

1 *Claude Monet painting in his studio,* 1874
Oil on canvas, 82.5 x 100.5 cm
Neue Pinakothek, Munich. Artothek

2 *The Studio-Boat,* 1874. Claude Monet
Oil on canvas, 50 x 64 cm
Rijksmuseum Kröller-Müller, Otterlo

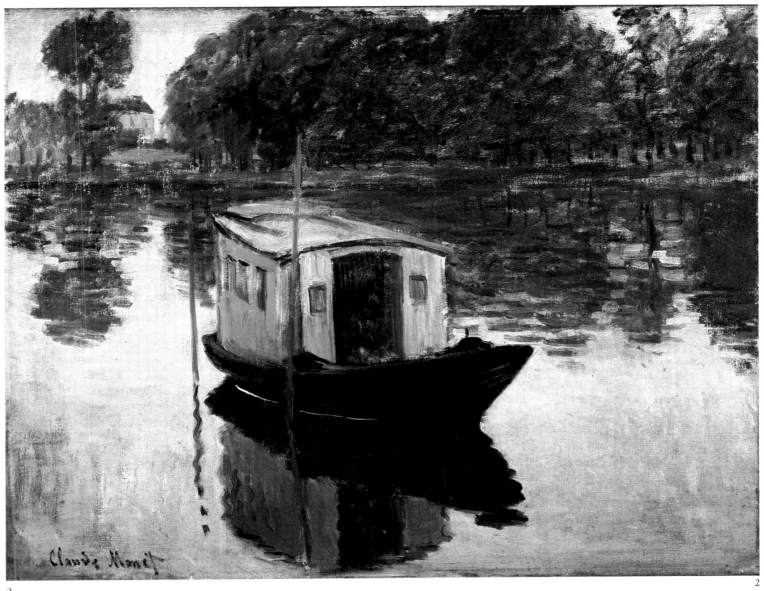

2

2

Monet, like Daubigny who used to sail up and down the Oise, had built himself a studio-boat so as to be closer to water, the element which fascinated him most. He always felt deeply attached to it and said one day: 'I would like to be always on it and in front of it and, when I die, I would like to be buried in a buoy.'

'One could almost taste the day, the exhaustion, the speed, the fresh and vibrant air, the reverberating water, the sun flashing on the ground, the stunning, dazzling, reflecting light of those river outings, that almost animal drunkenness with life that one finds in a great steaming river, when one is blinded with the light and the beautiful weather.'
(Manette Salomon,
E. and J. de Goncourt, 1865)

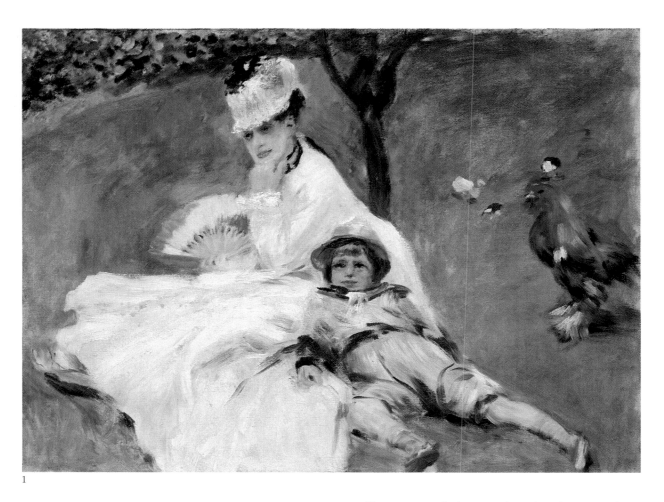

1

'I will never exhibit in the shack next door;

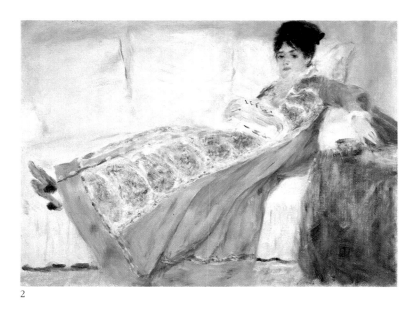

2

I don't see anybody,' wrote Zola to Guillemet, 'and I have no news. Manet has disappeared to work at Argenteuil with Monet.' That afternoon Manet had installed himself in Monet's garden. The younger painter was gardening and Camille was posing for Manet with her son Jean. Then Renoir turned up and was immediately charmed by the pose. Monet tells the story: 'This delightful painting by Renoir, which I am lucky enough to own, is a portrait of my first wife. It was painted one day in our garden at Argenteuil. Manet, seduced by the light and the colours, had begun an outdoor painting of figures beneath the trees. During the session Renoir turned up, and he too was charmed. He asked me for my palette, a brush and some canvas, and here he was painting alongside Manet. The latter watched him out of the corner of his eye, and from time to time, looked at his canvas. He made a face, and came up to me, pointing towards

1 *Madame Monet and her Son,* 1874. Auguste Renoir
Oil on canvas, 50.4 x 68 cm
National Gallery (Ailsa Mellon Collection), Washington

2 *Madame Monet Lying on a Sofa,*
1872. Auguste Renoir
Oil on canvas, 54 x 73 cm
Calouste Gulbenkian Foundation, Lisbon

2/4
Renoir, inspired by the Japanese, chose to show Camille, Monet's first wife, lying on a sofa (2). Here Renoir is very much himself, and Camille's silhouette melts into the sofa in soft blend of blue and white.
Madame Manet, in an inverse colour scheme, lies on a blue sofa (4). Manet is able to experiment with materials and colours by the use of pastels.

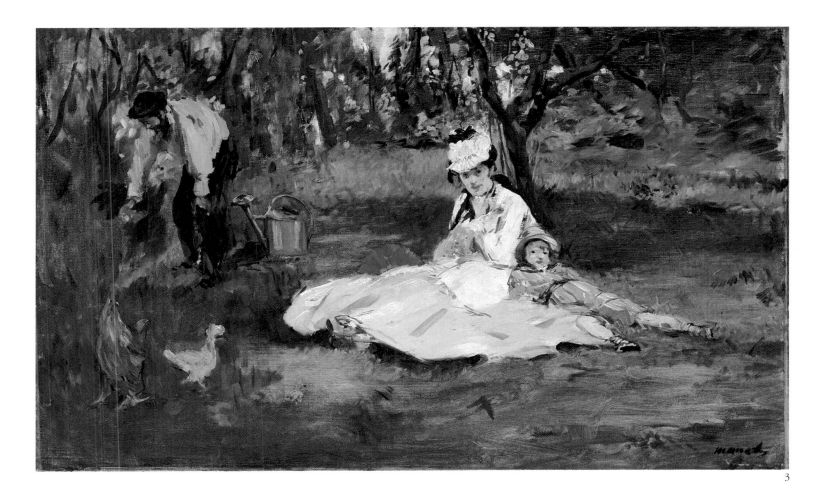

3

'I will enter the Salon by the main door, and fight for you there.'

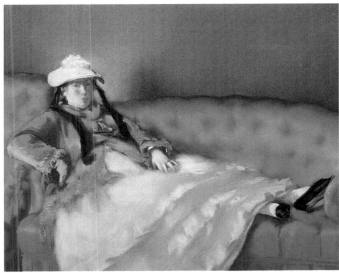

4

Whereas with Renoir everything was fluid, Manet relied on contrast: Madame Monet emerges softly from her background, Madame Manet stands out boldly from hers. One sees here not just a great colourist, but a draughtsman as well, who understood the neglected art of pastels which were just coming back into fashion amongst the Impressionists.

1 *The Monet Family in the Garden,* 1874
Oil on canvas, 61 x 99.7 cm
Metropolitan Museum (gift of J. Whitney Payson), New York

2 *Madame Manet on a Blue Sofa,* 1874
Pastel on paper mounted on canvas, 65 x 61 cm
Musée d'Orsay, Paris (RMN)

Renoir and whispering: "That boy has no talent! You're his friend, tell him to give up painting!"' This remark can be the result only of passing irritation on Manet's behalf, just when he was trying to open his mind to the Impressionists' technique. He was, in fact, a good friend of Renoir, who appears at his side in Fantin-Latour's painting *The Studio at the Batignolles*. But if Manet lacked Renoir's spontaneity, he made up for it with the strength of his composition. The canvas shows through in places, and the strength of the brushstroke makes use of both paint and backing. Claude Monet's blue shirt is echoed by his son Jean's trousers, while the centre of the canvas is taken up by the white mass of Camille's dress. Eventually Monet stopped gardening, took up his easel and began to paint Manet painting his garden in a picture that has, alas, disappeared.

Manet would probably have liked to make Monet pose for him again, but he was probably inhibited about disturbing the young painter again. He therefore brought models to Paris for what was to be the most 'impressionist' composition resulting from his stay at Argenteuil. This was a boatman modelled by his brother-in-law Rudolph Leenhoff, and a young professional model both sitting by a landing-stage. In the distance, on the other side of the river, one can see the factory chimneys of Argenteuil. Manet had successfully challenged the Impressionists on their own ground, with his mastery of light and brushstroke in this summer scene. But where the younger painters, Monet and, above all, Morisot, liked to melt together figures and background with rapidly executed contrasting touches, Manet never lost touch with form – indeed it became, if anything, more pronounced with the increased intensity of the colour.

He presented this painting to the next Salon, and it was accepted. The critics unleashed their sarcasms and insults: 'We do thank M. Manet for introducing a cheerful note to this rather gloomy Salon.' Chesneau, however, rallied the faithful in his support: 'I find that for the last three years his work has got steadily better each year ... The great complaint is that he has painted the water blue. But surely if the water *is* blue on some sunny and windy days, why *should* he do it in the traditional green? ... Let them boo, I shall cheer.' Some people misunderstood the wide space covered by the Seine, taking it for a wall. The framing became even tighter in *In the Boat*, which has the same model for the man. Here the palette is lighter, and everything is based on white, blue or brown. Manet closes the space, and makes the perspective difficult to judge. Zola was harsh about this painting, but several writers, such as Huysmans, appreciated it, seeing a Japanese influence in the composition ('This is the sort of picture we see all too few of in the fastidious Salon'), as did Jules Claretie, the voice of the avant-garde, who proclaimed: 'The painter of *The Glass of Beer* is this year showing a painting called *Argenteuil*, which the *plein air* school is proclaiming as a masterpiece.'

1

2

2
Manet often painted the little hat worn by Camille Monet in *The Monet Family in the Garden*, and also this more sporting one which Claude Monet wears here with the brim turned up, and on the studio-boat with the brim turned down against the sun.

1 *In the Boat*, 1874
Oil on canvas, 97.1 x 130.2 cm
Metropolitan Museum of Art
(gift of Mrs H.O. Havemeyer), New York

2 *Claude Monet*, 1874?
Ink wash, 17 x 13.5 cm
Musée Marmottan, Paris. Studio Lourmel

3 *Argenteuil*, 1874
Oil on canvas, 149 x 115 cm
Musée des Beaux-Arts, Tournai. Giraudon

3
In this painting, the composition is extremely rigorous, with vertical and horizontal lines corresponding to one another: the mast and the landing-stage, the mooring post in the middle of the river and the far bank, the stripes on the young woman's dress and those on the boatman's jersey.

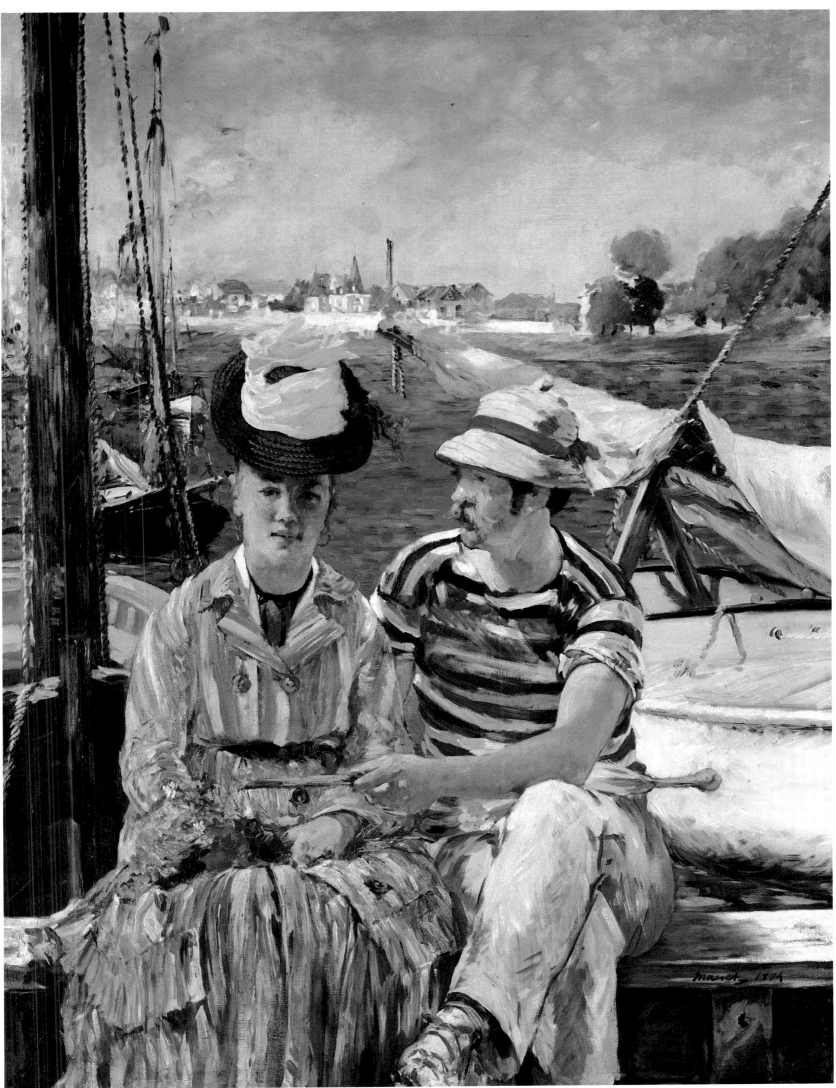

3

'My dear friend. Thank you.
If I had a few more defenders like you
I would tell the jury to go to Hell.'

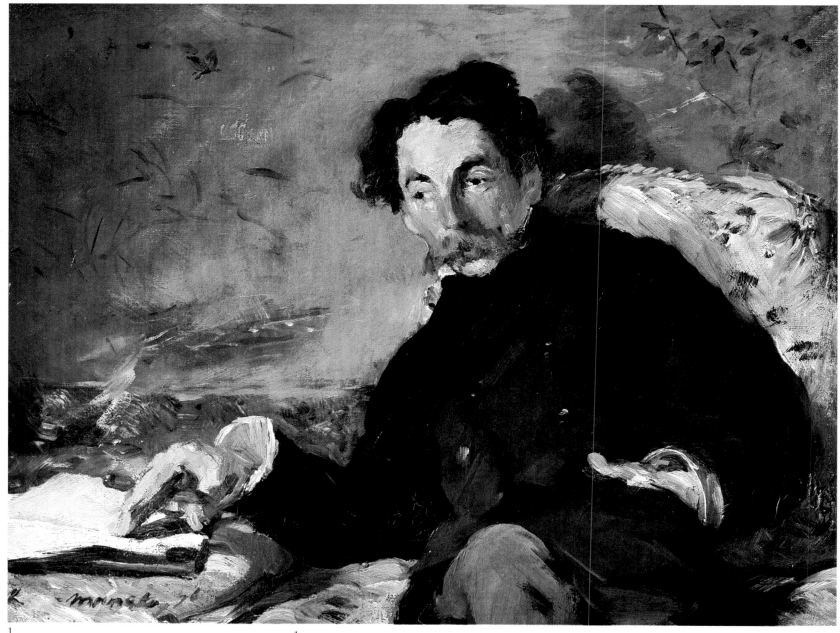

1

1
Mallarmé, aged thirty-four, sitting for
Manet. He admired the painter, who
had been a friend of the poet he
most admired, Charles Baudelaire.
After Manet's death, Suzanne wrote to
him: 'You were truly his greatest
friend.'

1 *Stéphane Mallarmé,* 1876
Oil on canvas, 27.5 x 36 cm
Musée d'Orsay, Paris (RMN)

4

In 1860 or 1862, Manet made this etching from a daguerreotype of Poe. Drawn with cross-hatching and surrounded by a ribbon, the portrait is a long way from Baudelaire's probably more romantic conception.

4

5

Marcellin Desboutin, scion of an aristocratic family, entered the Ecole des Beaux-Arts in 1845. In 1875, poor but proud, he was a typical example of the group of Impressionists who sold practically none of their work. This portrait was turned down by the jury. Manet was greatly disappointed and said at the time: 'I did not aspire to sum up a whole era, but just to have painted the most extraordinary character of a neighbourhood. I painted Desboutin with as much passion as I did Baudelaire.'

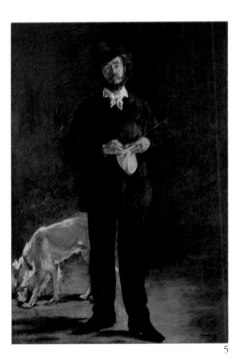

5

Mallarmé came into Manet's life at the time of the rejection of the *Masked Ball*. The poet had noticed Manet's talent as a colourist: 'As for the painting itself, there is nothing disorderly or scandalous, or anything that seems to spring out of the canvas; there is rather a noble attempt to encompass a vision of contemporary life, using only the purest methods.' Manet thanked the poet, and a firm friendship grew up between the two men. It was therefore quite natural that Mallarmé should ask his new friend to participate in the publication of a translation of Edgar Allan Poe's *The Raven*. The text was illustrated with five etchings by Manet, and the printing was completed on 20 May 1875, 240 copies at twenty-five francs each. A poster was made to advertise it. Mallarmé approached Léon Cladel, who had worked on *Paris à l-eau-forte*, and Jules Claretie, asking them to help publicise it. The latter had been friendly towards Manet in the past, and was more inclined to help than the other critics. However, the book was not the success they had hoped for and Mallarmé turned towards England, hoping to interest the market there in his work. He dedicated a copy to Mr O'Shaughnessy, which eventually found its way into the hands of the Pre-Raphaelite painter Rossetti: 'I have just received in memory of O'S an enormous folio of lithographs of *The Raven* by a French idiot called Manet, who appears to be the most proud and arrogant fool that ever lived. ... It is impossible not to burst out laughing looking at it.' This reaction was not peculiar to England. Manet was much criticised in France. As for Mallarmé, he was more or less unknown and his project was doomed to failure. Baudelaire, too, had translated the American writer, and without success.

Mallarmé used to visit Manet every day. He would come to the studio on his way back from the lycée Fontane, where he taught English. There he met Zola, Monet, and Berthe Morisot, who, before her death, entrusted her daughter to the poet; and also Méry Laurent who was to be his great love.

2 *The Raven (Le Corbeau)*, 1875
Poster. Illustration: 16.2 x 15.8 cm
Bibliothèque Nationale, Paris

3 *At the Window,* 1875
Illustration for *The Raven.* 38.5 x 30 cm
Bibliothèque Nationale, Paris

4 *Portrait of Edgar Allan Poe*, 1860-2
Etching, 19.3 x 15.3 cm
Bibliothèque Nationale, Paris

5 *Portrait of Marcellin Desboutin,* 1875
Oil on canvas, 191 x 131 cm
Museo de Arte de São Paulo, Brazil

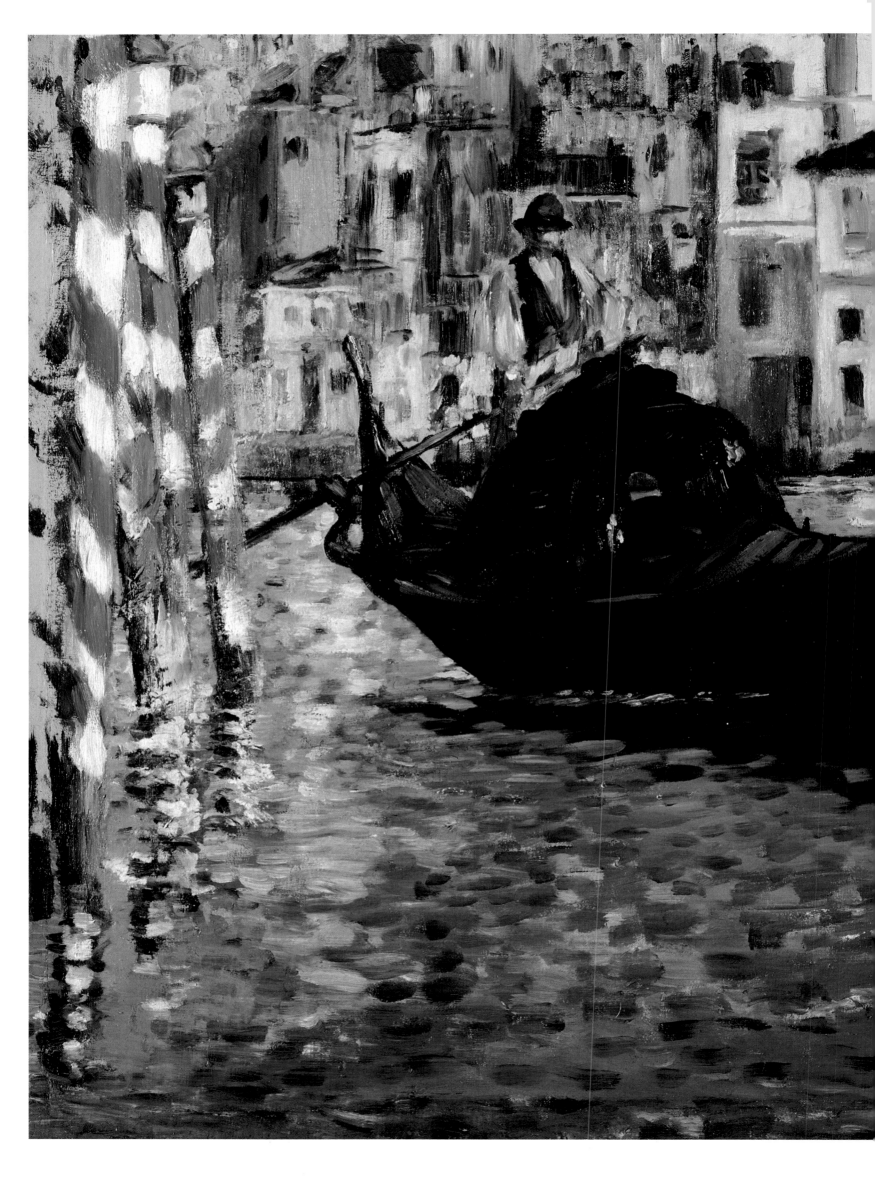

In the summer of 1875, Manet was planning a trip to Venice with James Tissot. The latter, born in Nantes, had settled after the Franco-Prussian War of 1870 in England, where he had had a successful career. He was a difficult character, and Manet was no doubt attracted by his social success. He intended, with this journey to Italy, to complete the Argenteuil experiment in the Venetian light. But his departure depended on a sale that was being delayed: 'The rich gentleman in question has not turned up. I am still waiting for him. Well, if he doesn't come, that's the end of the trip to Italy,' he wrote to Mallarmé who was staying near Boulogne-sur-Mer. In Venice at last, he met by chance the painter Charles Toche, who then followed him as he worked. Toche said to Vollard: 'I asked him if I could follow him in his gondola, and he said "As much as you like – when I work, I see only my subject."' Manet made many studies, but only two compositions on the Grand Canal. 'Manet was so enthusiastic,' recalled Toche, 'the white marble staircases against the faded pink brick

façades, and the greens of the basements! When the water was rough in the wake of passing boats, he would cry out at the oscillation of light and shade: "It's like upturned champagne bottles bobbing about." One day I was with him in his gondola, and we were admiring the domes of Guardi's beloved Salute between the giant twisted blue and white poles and he said: "In front of that I am going to put a gondola with gondolier in a pink shirt with an orange scarf, one of those handsome Arab ones."' Satisfied with his work, he gave one of his paintings to Tissot.

1 *The Grand Canal, Venice,* 1875
Oil on canvas, 57 x 48 cm
Shelburne Museum, Shelburne, Vermont

1

'The satin corset is probably the nude of our time.'

Once again, the jury of the 1876 Salon rejected Edouard Manet's submissions, and so he decided to exhibit alone in his studio, in accordance with his motto 'One must be with a thousand others or alone'. This one-man show attracted a number of people to 4 rue Saint-Pétersbourg. Encouraged by the friendly support he was receiving from all sides, he began a painting of a young woman in a petticoat turning towards the spectator (3). The jury of the 1877 Salon rejected *Nana*, whilst accepting *Portrait of Faure as Hamlet*. When Manet heard about the refusal, he said: 'A nymph offering herself to satyrs, that's fine. But a pretty girl half-dressed, that's not allowed.' Inspired by his friend Degas, Manet developed his technique with pastels, and produced four superb nudes at their toilet, one of which was posed by his friend Méry Laurent. Manet, like Degas, liked to catch a woman washing in her bathtub, exchanging a complicitous glance with the painter. This was different to Degas' manner, but it did not stop him from exclaiming: 'That Manet! He was always imitating me ... As soon as I started doing dancers, he did them too.' Manet did imitate, but it was in order to learn more; if the woman turning her back, in her corset in front of her mirror, is inspired by the eighteenth-century *galantes*, his *Woman in the Bathtub* is a forerunner of Bonnard's toilet scenes.

3

2

Manet had already aroused a lot of criticism with *Olympia*; here, posing half-dressed for *Nana*, the model seems to be enacting a naturalistic scene, dressing and powdering herself in front of a man in evening dress and top hat. The choice of model was deliberate – Henriette Hauser was an actress and *demi-mondaine*, a famous and admired beauty. She was the mistress of the Prince of Orange, son of the King of Holland, William III.

1/2/4/5
Whereas Berthe Morisot's works had a gentle modesty, Degas 'showed them without coquetry, like animals cleaning themselves'. Berthe would surprise a woman in her boudoir, at an intimate moment by her dressing table. Degas would show her in a tin bath, but although he had replaced the dressing table with a tub, he did allow a soft flowery background for the young woman to stand out against.

3

1 *The Bathtub*, c. 1866. Edgar Degas
Pastel on cardboard, 60 x 83 cm
Musée du Louvre, Paris (RMN)

2 *Woman in a Bathtub*, 1878-9
Pastel on cardboard, 55 x 45 cm
Musée d'Orsay, Paris (RMN)

3 *Nana*, 1877
Oil on canvas, 150 x 116 cm
Hamburger Kunsthalle, Hamburg

4 *Young Woman from behind at her Toilet*,
1875. Berthe Morisot
Oil on canvas, 60.3 x 80.4 cm
Art Institute (Stickney Fund), Chicago

5 *In Front of the Mirror*, 1876
Oil on canvas, 92.1 x 71.4 cm
Guggenheim Museum
(J.K. Thannhauser Collection), New York

4

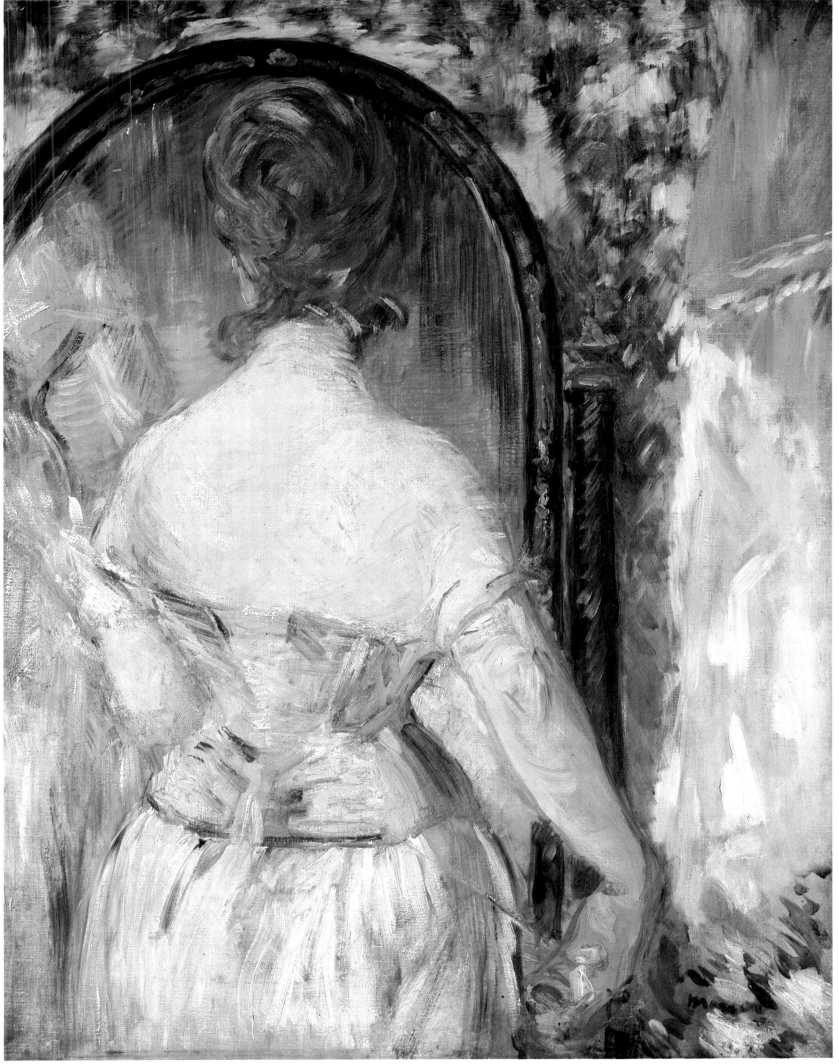

At the beginning of 1878, Manet learned that the lease on his studio at 4 rue Saint-Pétersbourg would not be renewed because the other tenants had been complaining, since his private show in 1876, of the continual stream of friends coming and going. The windows gave on to rue Mosnier, which ran along the railway leading to the Gare Saint-Lazare. This was where Madame Robert lived, one of the characters in Zola's novel *Nana*: 'It was five o'clock, and all along the deserted pavements, by the tall white houses in their stately silence, the carriages of stock-brokers and merchants were drawn up, as men darted out, looking up at the windows, where women in peignoirs seemed to be waiting . . .' The International Exhibition was

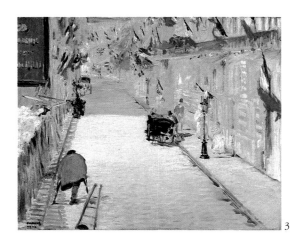

1

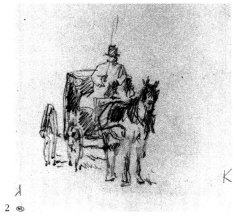

2

about to open, but Manet was planning to exhibit alone, as he had done in 1867.

Before leaving his studio, Manet made a great many sketches and paintings of the street below his window. There was one of *Pavers in the rue Mosnier*, and two of *Flags in the rue Mosnier*; they were almost like snapshots. Workers had arrived one morning to finish paving the street, the day before the national holiday on 30 June. Soon there were flags at the windows, and Manet completed his two compositions, in the manner of Monet's *Rue Montorgueil*. One of them has a red flag in the foreground, no doubt above the artist's studio. The second shows the street bedecked with flags. But the happy moment is tinged with melancholy, as a cripple limps by on crutches. This moralising invention, which does not occur in the *Pavers* painting, recurs in several other sketches. In July, Manet had no studio. A Swedish painter, Otto Rosen, offered him his for three-quarters' rent.

1/4
Behind the fence on the right, trains go by, arriving at or leaving the Gare Saint-Lazare. The passers-by, caught in action, are all moving. The woman is crossing the street, the sweepers are at their work.

2/3
After working on the life and movement in the street, Manet concentrated on single elements such as the *Man on Crutches* and *The Hackney-Carriage* which he sketched both from the front and the back.

4

1 *Rue Mosnier,* 1878
Pencil, brush & ink on paper, 27.8 x 44 cm
Art Institute (gift of Alice H. Patterson, in memory of Tiffany Blake), Chicago

2 *The Hackney-Carriage,* 1878
Pencil, 16.8 x 13 cm
Louvre/Musée d'Orsay; graphic arts archive, Paris (RMN)

3 *Rue Mosnier with Flags,* 1878
Oil on canvas, 65.5 x 81 cm
Paul Getty Museum, Santa Monica

4 *Rue Mosnier,* 1872
Pencil & ink wash, 19 x 36 cm
Szepmuveszeti Muzeum, Budapest

5 *Rue Mosnier with Pavers,* 1878
Oil on canvas, 65. 5 x 81.6 cm
In storage, Kunsthaus, Zurich

5

5
That year, 1878, saw the opening of the International Exhibition, the first since the war. Streets were decorated and lamps put up. People flocked to the Palais du Trocadéro and Parisians were thrilled by the success of the Exhibition which surpassed the previous one under the Second Empire.

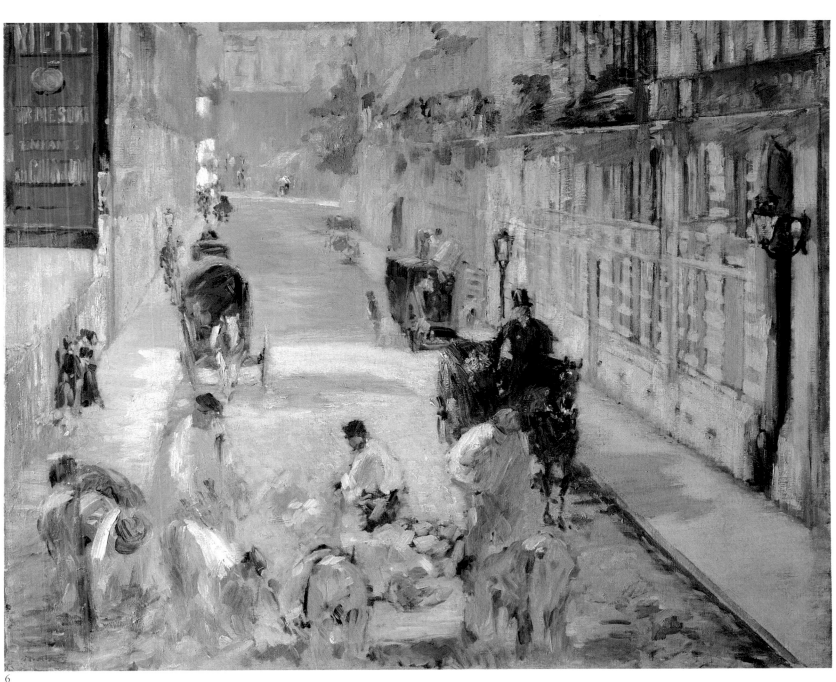

6

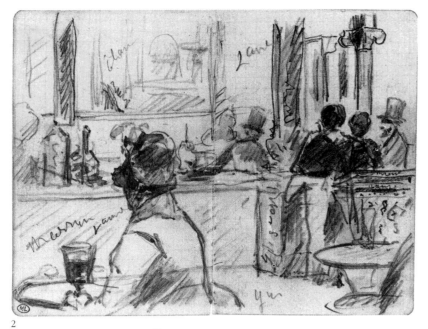

2

2

Manet created an atmosphere with
a few pencil-strokes, and would
then annotate the drawing in
order to help with another study,
and finally a canvas. In this first
drawing, one can see a woman
from behind in front of a glass.
She is no doubt a precursor of the
young woman in *The Prune*.

3/4
Café-concerts began to appear,
along with the cafés and
brasseries. Manet drew a group of
musicians, while Degas
concentrated on the singers and
dancers at the Ambassadeurs.
While the younger painters
worked in natural light, he would
observe the illumination and
shadows produced by artificial
lighting.

3

1
The actress Ellen Andrée was part
of Antoine's first troupe. She
played the canteen-keeper in the
Gaietés de l'escadron, Mme Lepic
in *Poil de carotte*, and later
appeared at the Théâtre Edouard
VII in plays by Sacha Guitry.

1 *A Café in the Place du Théâtre Français,* 1877-81
Pencil & ink wash on squared paper, 14.1 x 18.7 cm
Louvre/Musée d'Orsay; graphic arts archive, Paris (RMN)

3 *In the auditorium,* 1878-9
Ink wash, 21.5 x 27.9 cm
Louvre/Musée d'Orsay; graphic arts archive, Paris (RMN)

4 *At the Ambassadeurs,* 1877. Degas
Pastel, 36 x 27 cm
Musée des Beaux-Arts, Lyons

So Manet installed himself in July 1878 for
nine months at 70 rue d'Amsterdam. The
theme of the café began to appear in his work
at this time. He spent that autumn observing
Parisian life and sketching from life. Edouard
King, in his 1868 account of life in Paris, noted:
'The vast Parisian universe assembles two or
three times a day – at the café. It gossips in the
café, it intrigues in the café; it plots, dreams,
suffers and hopes in the café.' After 1848, bras-
series began to multiply; beer, considered
before the war to be a peasant's drink, had
become the respectable drink. Sitting in front
of a cup of coffee or a glass of beer, Manet
would observe the life of the streets, and dis-
cuss ideas with his fellow artists. Before the
war, he had frequented the Café Guerbois
along with Degas, Monet, Zola, Duranty and
Zacharie Astruc. After 1870, journalists and
writers, as well as younger artists followed
him to the Nouvelle Athènes on Place Pigalle.
He also used to go to the Café de Bade,
Pavard's Rotisserie and the Brasserie de
Reichshoffen. Along with this new café theme,

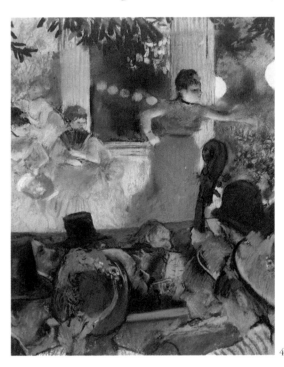

4

a new woman appeared in Manet's paintings:
Ellen Andrée. She had already been painted
by Renoir in *La Parisienne*, but she was soon
to become an integral part of Manet's and
Degas's 'atmosphere' paintings. She also
posed for Desboutin, and was the cause of the
scandal provoked by Gervex at the Salon with
Rolla. She really wanted to be an actress, and
posed to earn her living. The painters saw that
she had sex appeal, and were delighted with
the patience with which she held a pose.

She may have been the model for *The Plum*: a young woman, neatly dressed but not elegant, is sitting at a café table. In her left hand an unlit cigarette. In this composition Manet is describing rather than preaching. Who is this solitary woman? Is she bored, or just waiting for a customer? All interpretations are possible here, unlike Degas's *Absinthe*. The two figures modelled by Ellen Andrée and Marcellin Desboutin are human wrecks that the artist has observed in the early hours of the morning. The man has a cup of coffee, no doubt to cure a hangover, and the woman a glass of absinthe. This drink, which had been popular amongst the working classes since the beginning of the nineteenth century, became fashionable during the Second Empire. Until it was banned in 1915, it was a great success, largely because of its daring associations.

Manet soon denounced this danger of alcoholism in his paintings, as did Degas with *Absinthe*, and writers followed suit. The Goncourt brothers published an edifying story about the fall of a young servant girl, *Germinie Lacerteux*, which horrified its readers. Zola took up the same theme in *L'Assommoir*, in which the heroine, Gervaise, sinks into alcoholism. Degas was, more than Manet, a part of this realist tide. Such sombreness of vision was seen again only in 1901 with Picasso's *Absinthe Drinker*. Manet painted the café world in order to convey the sometimes reflective life that went on there, but he never wanted to denounce vice. Thus, in *At the Café*, a bourgeois family comes into the café for rest and refreshment. But the three, supposedly part of the same group, do not seem to be communicating with one another, unlike the happy gatherings of the Impressionists.

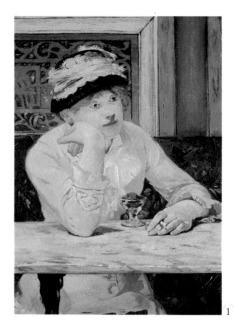
1

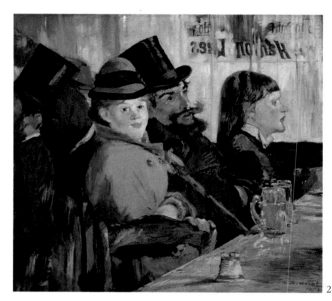
1

1
Manet emphasises his character's solitude by enclosing her in vertical and horizontal lines. It has been suggested that the décor is that of the Nouvelle Athènes, but it is more likely to be a studio composition. The table on which the young woman is leaning reappears in the portrait of *George Moore at the Café* – the writer related that Manet possessed 'a marble table with a wrought-iron pedestal like those you see in cafés'.

3
Ellen Andrée remembered long sessions sitting for Degas's *Absinthe*: 'I am in front of an absinthe, Desboutin has something more innocent, what a reversal! and we look like two idiots.'

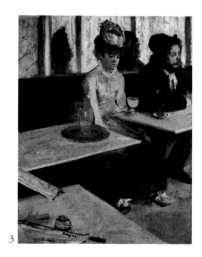
3

1 *The Prune,* 1878
Oil on canvas, 73.6 x 50.2 cm
National Gallery (gift of
Mr & Mrs Paul Mellon), Washington

2 *At the Café,* 1878
Oil on canvas, 78 x 84 cm
Oscar Reinhart Collection, Winterthur. Artothek

3 *At the Café,* (or *Absinthe*), 1876. Edgar Degas
Oil on canvas, 92 x 68 cm
Musée d'Orsay, Paris (RMN)

4 *At the Café-Concert,* 1878
Oil on canvas, 47.5 x 39.2 cm
Walter's Art Gallery, Baltimore

4
In this composition, Manet juxtaposes a bar-girl and a stockbroker, a waitress and a singer. All seem indifferent to the show and look in different directions. He sums up café life here – people mix but do not make contact.

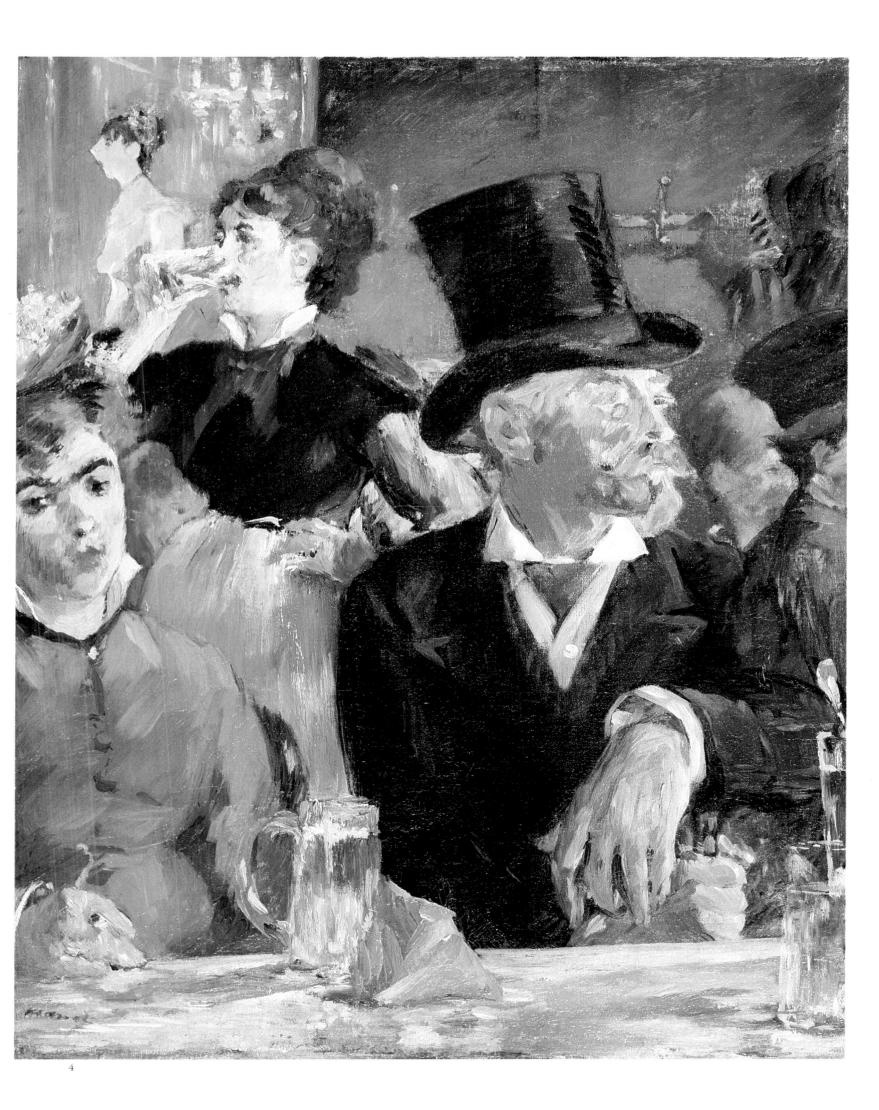

Manet gathers together the elements of an anecdote, shows a slice of life, but leaves the spectator the choice of how to interpret it: he never imposes or makes suggestions. He does not show lovers lost in the crowds at the café, but individuals with different psychological make-ups. *At Père Lathuille's* is a brilliant example of this. At first sight, it looks like the end of an amorous lunch; but closer inspection reveals otherwise. Père Lathuille kept a café-restaurant in the Batignolles, not far from the Café Guerbois and the Nouvelle Athènes. He had begun by using Ellen Andrée, but she was taken up by her theatrical career, and stopped coming to the studio; he needed a replacement and found Judith French, a cousin

'When I start something I'm always terrified that the model will let me down, and that I won't see him or her again as often as I would wish to, or in the conditions I would wish. They come, they sit, then they go away, saying to themselves, "He can finish it on his own." Well no! one cannot finish anything alone.'

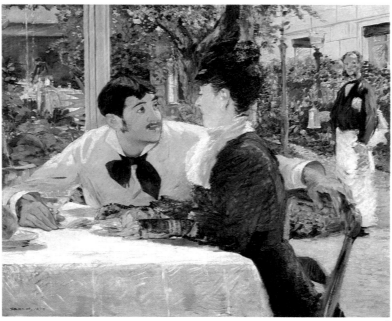

2
'As I was a young man with a fresh complexion and fair hair, the type that suited Manet's palette, he asked me at once to sit for him. His first idea was to paint me in a café; he had met me in a café, and he thought he could recreate his first impression of me in the setting he had first seen me in.' (George Moore)

1

of Offenbach. The young man, Louis Gauthier-Lathuille, was the son of the proprietor. Manet had met him when he was a volunteer in a regiment of dragoons, and had had the idea of using him as part of a pair of lovers. But with Judith French, the idea of an amorous intrigue no longer worked, so Manet asked the young man to take off his tunic and put on a jacket. A new situation was revealed: the woman was there on her own, and the young man, probably an artist, was accosting her, while the waiter was about to serve the coffee. The painting was presented to the 1880 Salon, and accepted. As usual, there was some criticism – the woman's costume and the man's hair were held up to ridicule.

At about this time, Manet got to know an Irishman who frequented the Nouvelle Athènes; George Moore had arrived in Paris in 1873, hoping to learn to paint at Cabanel's studio.

2

1 *At Père Lathuille's,* 1879
Oil on canvas, 93 x 112 cm
Musée des Beaux-Arts, Tournai (Giraudon)

2 *George Moore at the Café,* 1879
Pastel, 55.3 x 35.3 cm
Metropolitan Museum of Art,
(gift of Mrs H.O. Havemeyer), New York

3 *The Waitress,* 1879
Oil on canvas, 77.5 x 65 cm
Musée d'Orsay, Paris (RMN)

3
Manet had asked this waitress to come and pose in his studio. Fearing an immoral suggestion she had insisted on bringing a friend, shown here in his blue smock, holding a clay pipe.

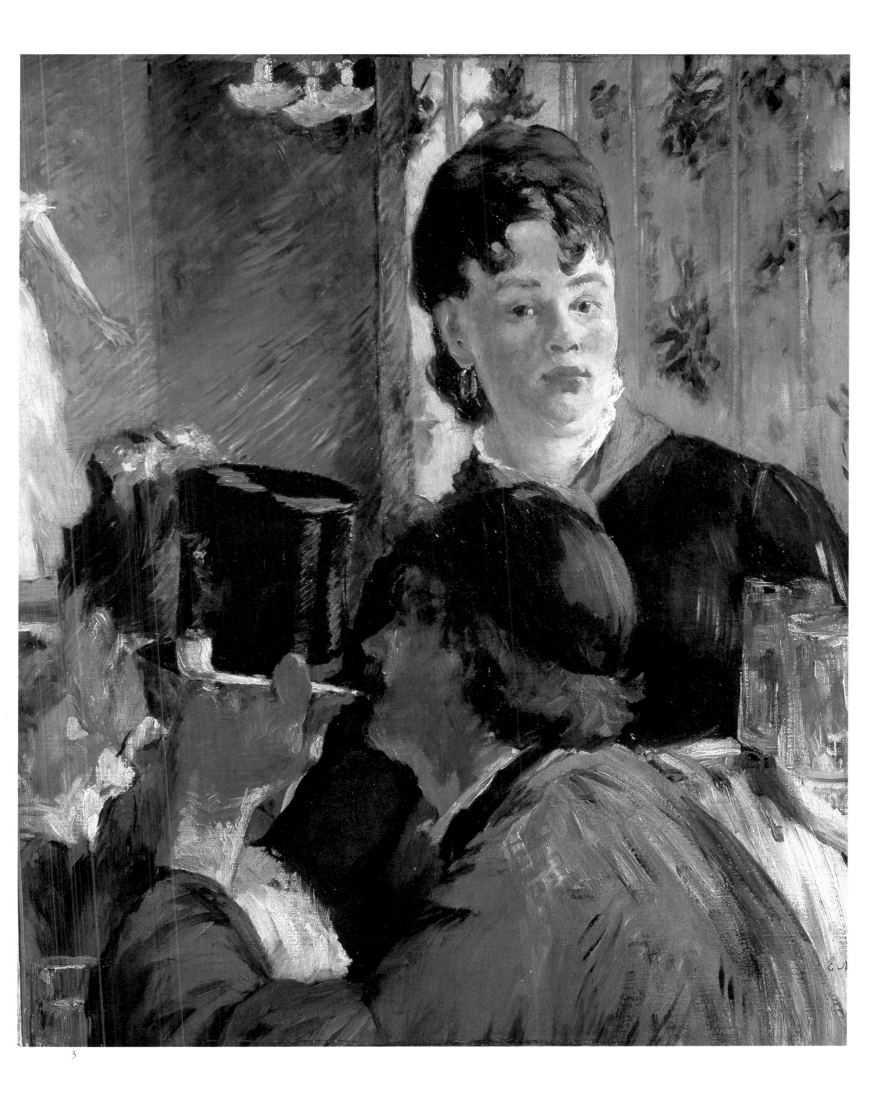

Julie Manet with her nurse

1

2

Manet uses the conservatory in this painting of his own wife. She has none of Mme Guillemet's piquant beauty, but Manet conveys her goodness and simplicity in this sympathetic portrait.

2

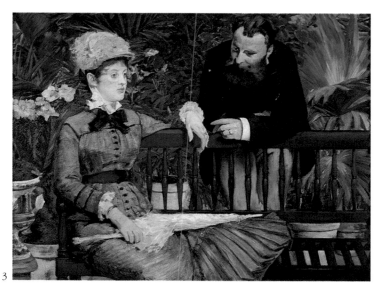

3

3

M. and Mme Guillemet sit for a rigorously composed piece centred on the two hands with their wedding rings. M. Guillemet was the owner of a famous dress shop at 19 rue du Faubourg-Saint-Honoré, which no doubt explains the refined elegance of his wife. She was of American origin, and famous for her beauty. Her fresh, lightly made-up face appears in the water-colours on the letters Manet used to write to her when he was away on holiday.

O n 14 November 1878, Berthe Morisot gave birth to a girl, Julie. The happy moment, however, was tinged with anxiety.

One evening, in that winter of 1878, Manet collapsed outside his studio. He had suffered a similar malaise in 1876, whilst spending a few days with Ernest Hoschédé at Montgeron. They were the first symptoms of syphilitic complications, which medicine at the time was still unable to deal with. Manet then produced two self-portraits, which are more like sketches than completed works. He concentrated his activity in the studio, using the magnificent conservatory for *In the Conservatory*. With this portrait of the Guillemet couple, Manet introduced bright colours to the 1879 Salon. Renoir also appeared at the Salon that year with his *Portrait of Madame Charpentier and her Children*. Manet was criticised as usual, but Castagnary observed that 'the composition was simple and the poses natural, but one other thing should be praised, which was the freshness of the tones, and the general harmony of colour'. Emboldened by success, Manet wrote to the Under-Secretary of State for the Fine Arts, expressing a wish to see one of his works bought by the state. Evidently this fell on deaf ears.

2 *Mme Manet in the Conservatory*, 1876
Oil on canvas, 81 x 100 cm
National Gallery, Oslo

3 *The Conservatory*, 1879
Oil on canvas, 115 x 150 cm
Staatliche Museen Preussicher Kulturbesitz,
National Gallery, Berlin

4 *Self-Portrait with Palette*, c. 1879
Oil on canvas, 83 x 67 cm
Private collection, New York

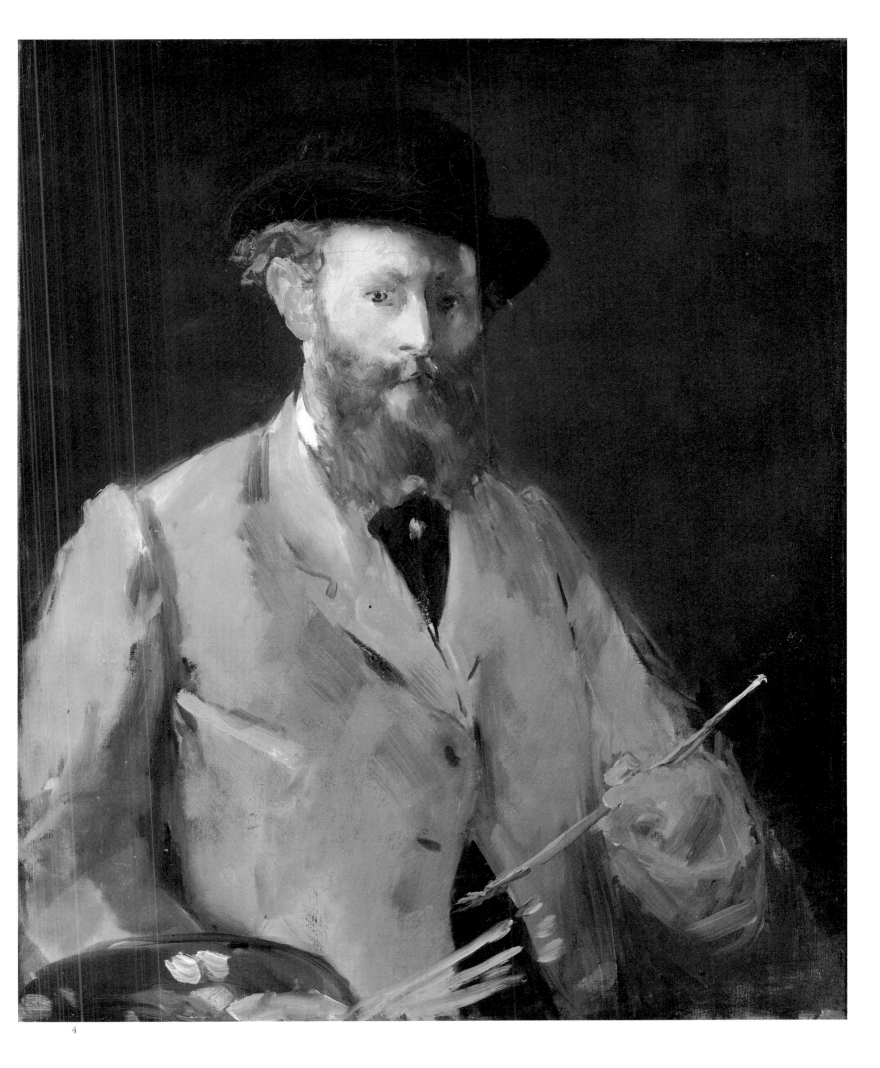

4

Everybody recognised Manet's charm, and his life is punctuated throughout with meetings with men and women who soon become close friends. He painted portraits of all of them, childhood friends, political contacts, or acquaintances from drawing-rooms or cafés.

His earliest friend, Antonin Proust, sat for Manet only later in life. The painting was presented to the 1880 Salon, and accepted, although it must be said that the political importance of the model would in itself have ensured its presence at the Salon.

Manet also painted another political personality, Georges Clemenceau. He had met him probably around 1875, through his younger brother Gustave, when he was President of the Paris Municipal Council. Clemenceau did not really have time to pose, but the sittings went by in pleasant conversation.

Manet was always afraid of losing his models and having to give up, but, as he said: 'One cannot finish anything alone, unless it is completed on the day it is begun, but one has to keep starting again, and so you need several days. Ah! but I have had some who came back without my asking them, wanting touching up, which I always refuse. For instance, the portrait of the poet Moore. One sitting was enough for me, but not for him. He kept annoying me, asking for a change here, an adjustment there. I won't change a thing. It's not my fault he's got a lop-sided face.'

He preferred painting beautiful women, and executed a pastel of Gabrielle Alexandrine Melay, who had lived with Zola since 1865. This pastel was included in an exhibition held in the offices of *La Vie Moderne*, a magazine started by Georges Charpentier, a great art-lover and friend of the Impressionists. Madame Zola had none of the lively Parisian beauty that Manet loved so much, but towards the end of his life Isabelle Lemonnier, the young and beautiful sister of Madame Charpentier, appeared and sat for Manet several times.

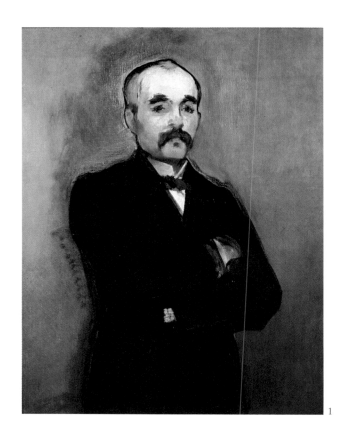

'There is no symmetry in nature. One eye is never opposite

1 *Georges Clemenceau*, 1879. Oil on canvas, 94 x 74 cm
Musée d'Orsay (gift of Mrs H.O. Havemeyer), Paris (RMN)

2 *Antonin Proust*, 1880
Oil on canvas, 129.5 x 95.9 cm
Museum of Art (gift of E.D. Libbey), Toledo

3 *Woman in Blue Dress*, (or
Portrait of Isabelle Lemonnier), 1880
Water-colour, 20 x 12.5 cm
Louvre/Musée d'Orsay;
graphic arts archive, Paris (RMN)

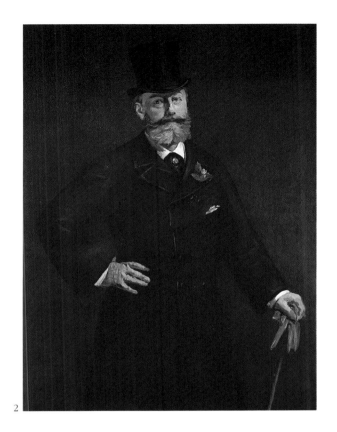

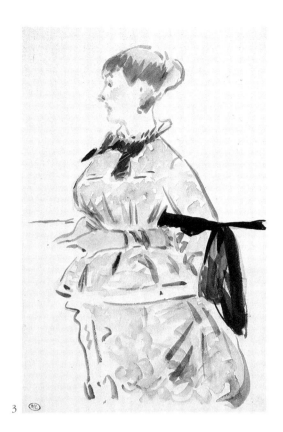

the other. We all have more or less crooked noses, or else, for example, the mouth is always irregular.'

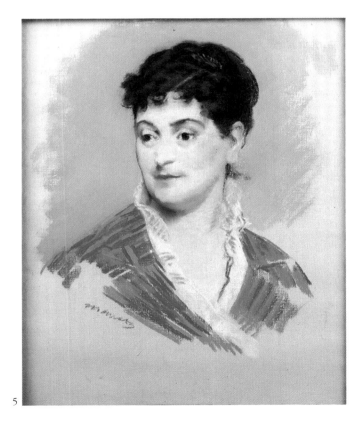

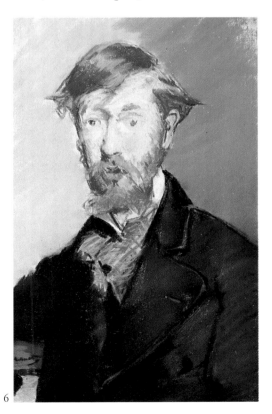

5 *Portrait of Mme Emile Zola,* 1879
Pastel on canvas, 52 x 44 cm
Musée d'Orsay, Paris (RMN)

6 *Portrait of George Moore,* 1878-9
Oil on canvas, 65.4 x 81.3 cm
Metropolitan Museum of Art
(gift of Mrs Ralph J. Hines), New York

Bellevue

Décidement vous ne vous
gâtez pas — ou vous
êtes bien [...] ou
vous êtes bien méchante
cependant on n'a pas le
courage de vous en vouloir

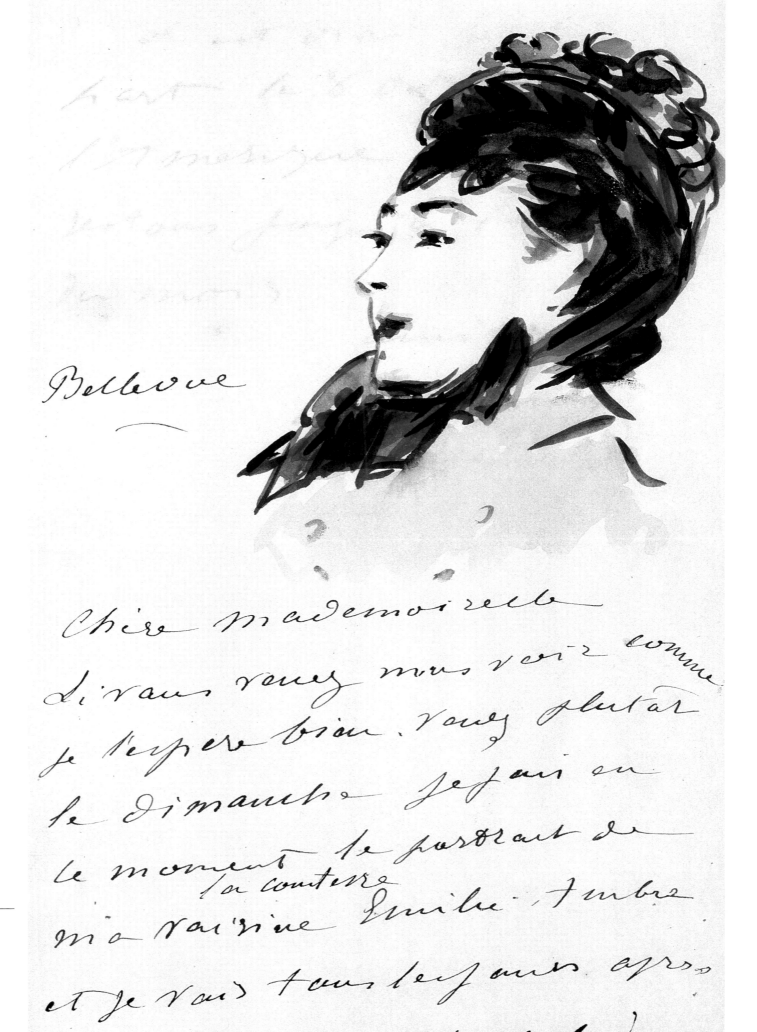

Bellevue

Chère mademoiselle si vous venez me voir comme je l'espère bien. Venez plutôt le Dimanche. Je fais en ce moment le portrait de la comtesse ma voisine Emilie Ambre et je vous ferai les jours après déjeuner aux Montalais

ML

1 *Rosebud*
Decorated letter
Musée d'Orsay/Louvre;
graphic arts archive,
Paris (RMN)

2 *Isabelle in Bonnet
with Ribbons*, 1880
Decorated letter.
20 x 12.5 cm
Musée d'Orsay/Louvre;
graphic arts archive,
Paris (RMN)

'The still life is the touchstone of painting.'

1

In 1879, Manet went to Bellevue, near Paris, to stay at a hydrotherapy clinic, where he followed a harsh regime. He returned the following year, installing his family at 41 route des Gardes, not far from the singer Emilie Ambre, whose portrait he was painting. In order to alleviate his loneliness and isolation, he corresponded with his friends who were either on holiday or had remained in Paris. These letters were illustrated with little water-colours and were often addressed to the women he loved: 'I am writing to you in the garden. The day began badly and I was expecting thunder so the easels were put away. Yesterday we had the Guillemet family, back from the seaside. I have begun painting the younger sister. I don't know if I will have time to finish it.' He illustrated his letters with fruit and the ladies' faces. He would send endless little messages to Madame Charpentier's sister Isabelle, in the Japanese haiku tradition, short poems which his friend Mallarmé was particularly fond of composing. A water-

2

As he told Berthe Morisot, Manet had undertaken the portrait of Mme Guillemet's sister Marguerite. The young woman almost disappears in the greenery of the garden, which was now the only subject he could tackle without becoming exhausted. He painted three pictures of her on the grass, the best of which was bought by his sister-in-law, Berthe Morisot.

2

3

3

Charles Ephrussi bought *Bunch of Asparagus* from Manet for 1000 francs, even though he had asked only 800. He painted and sent this single asparagus spear to Ephrussi with this note: 'There was one missing from your bunch.'

4

1 *The Lemon*, 1880
Oil on canvas, 14 x 22 cm
Musée d'Orsay (Camondo legacy), Paris

4
Manet was becoming impatient with the lack of results from his treatment. 'It would be easy to let myself slide downhill, but it's better to climb than tumble down. Let's go to the terrace at Meudon.'

2 *Marguerite in the Garden at Bellevue*, 1880
Oil on canvas, 91 x 70.5 cm
Bührle Foundation, Zurich. Artothek

3 *Asparagus Spear*, c. 1880
Oil on canvas, 16.5 x 21 cm
Musée d'Orsay (gift of Sam Salz), Paris (RMN)

colour of a plum was accompanied by this little poem to Mlle Lemonnier: *A Isabelle/cette mirabelle/et la plus belle/c'est Isabelle*. He asked her to tell him about life at Luc-sur-Mer on the Normandy coast, where she was spending her holidays. He threatened: 'I am not going to write to you any more, you never answer,' or appeared surprised not to receive a reply: 'Put the letters you write in the post, like the last one, I received it this morning.'

This exile revealed a charming, but also vulnerable, man. The enforced rest obliged him to reduce the size of his painting, and return to small-scale still lifes such as this *Lemon*, a pretext for introducing a yellow tonality, and also an opportunity to pay homage to the Dutch and Spanish schools which had so much inspired him. Manet's extremely simple study caused Alfred Stevens to remark: 'A painter who cannot render a lemon on a Japanese plate cannot deal with colour.'

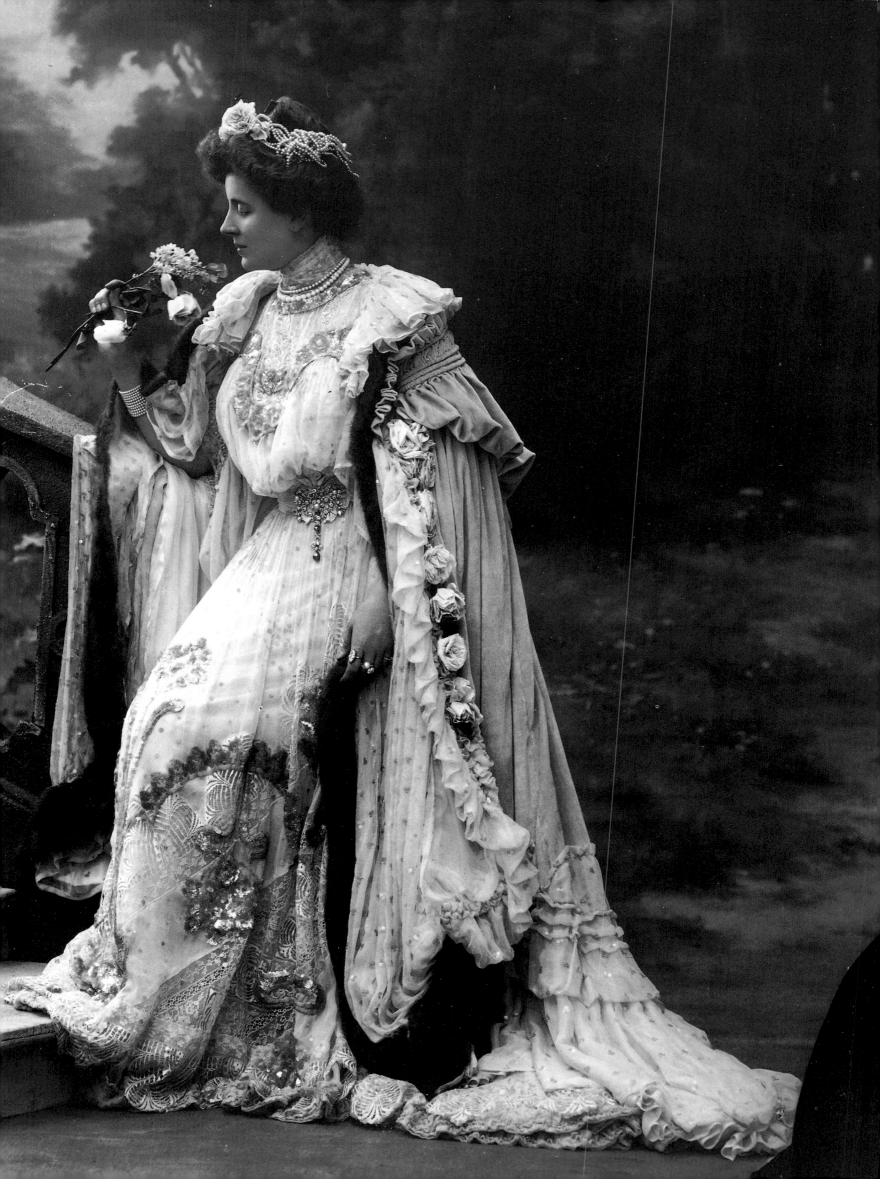

'My dear Méry, if I hadn't seen yesterday a very chatty Beni who gave me your news, I would think you had gone to India or elsewhere, still, I suppose there is more happening in Paris than in Bellevue.'

Antonin Proust commissioned his friend to paint four portraits of women representing the four seasons. It was an idea developed by the Japanese, Utamaro in particular. Jeanne Demarsy sat for *Spring*. Her beautiful face is set against a decorative leafy background which sets off the rustling parasol, the flowery hat, and the young actress's upturned nose. This portrait, shown at the 1882 Salon, was a huge success. At about the same time, Berthe Morisot took up the same idea with her

2

3

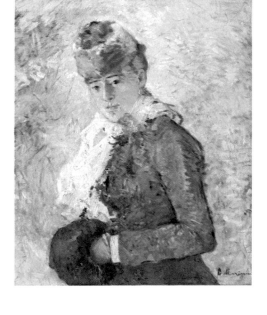

5

Anne Rose Louriot, who married a certain Laurent at the age of fifteen, was the mistress of Dr Evans before becoming interested in the literary world. As Méry Laurent, she was the friend of Banville, Coppée, Leconte de Lisle, Villiers de l'Isle-Adam, Mallarmé, who adored her, Henry Becque, Chabrier, Catulle Mendès and George Moore.

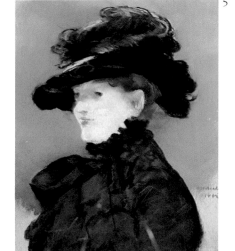

5

Winter. As with Manet, the young woman is shown against an undefined background; only the muff reminds us that this is winter. Manet next asked Méry Laurent to sit for *Autumn*. He had met her when she came to visit his one-man show in 1876. According to Proust, 'He was raving for a week after her visit, and could talk of nothing else. He said our times had been maligned – there were women who knew, who saw and understood.' Méry Laurent was not really old enough to represent autumn, but Manet found a beautiful cloak with the warm colours he was looking for: 'She has agreed to let me paint her portrait. I went to talk about it with her yesterday. She has had a cloak made at Worth. Ah! my friend, what a cloak, deep brown with a golden lining. I was paralysed.' Méry brightened the last months of Manet's life with little personal touches, such as sending her maid Elisa round with flowers and chocolates. Sadly, Manet's waning health prevented him from finishing the four seasons series.

2 *Autumn*, 1881
Oil on canvas, 72 x 51.5 cm
Musée des Beaux-Arts, Nancy

3 *Jeanne – Spring*, 1882
Etching & water-colour
Plate: 24.9 x 18.4 cm; subject: 15.8 x 10.9 cm
Bibliothèque Nationale, Paris

4 *Winter*, 1879-80. Berthe Morisot
Oil on canvas, 73.5 x 58.4 cm
Museum of Art (gift of
the Meadows Inc Foundation), Dallas

5 *Méry Laurent in a Black Hat* (detail), 1882
Pastel on canvas, 54 x 44 cm
Musée des Beaux-Arts, Dijon

1
Jeanne Demarsy was the incarnation of the Parisian woman. In 1883, she joined the repertory of the Comédie-Française. Several painters were attracted by her gentle face. Renoir made her pose with her sister, the actress Jeanne Darlau, for a painting at Chatou: *On the Terrace*.

During the night of 19 March 1874, six men escaped from the Ducos peninsula in New Caledonia; one of them was Henri Rochefort, founder of *La Lanterne*, who had been deported for having supported the Commune in 1873.

After Rochefort's amnesty and his return in 1880, Manet embarked on a composition showing the six men attempting to reach a three-master anchored at large. The question then arose as to what sort of boat they had borrowed to row out in. Mallarmé found out and sent his friend the following message: 'My dear friend, I saw Rochefort yesterday. The boat they used was a whaler. The colour was dark grey. Six people, two oars. Regards.' Later Claude Monet observed Manet's work: 'I have seen Manet, very well, very busy with a painting which will be a sensation at the Salon, *The Escape of Henri Rochefort*, in a rowing boat, in the open sea.' As well as this, Manet painted a portrait of Rochefort in a similar position to that of *Georges Clemenceau*. Rochefort is shown with his famous tuft of hair and his pockmarked skin. He did not appreciate the portrait, and even refused it when Manet gave it to him. At the 1881 Salon, it was given a number entitling it to a favoured position. As always, it was violently attacked. Here is Huysmans, for example: 'The flesh is like cheese that has been attacked by blackbirds, the hair like grey smoke. There is no tone, no life; M. Manet has completely failed to grasp the nervous delicacy of this eccentric face.' In 1881 the New Society of French Artists organised its first Salon. The organisation was overseen by Jules Ferry, President of the Council, and Minister for Education and Art, and by the Under-Secretary of State, Turquet. The new rules were drawn up by a committee of ninety members. They did not abolish the rewards system, and Manet's friends proposed his name for a medal. Twenty years after his mention in 1861, at the age of forty-nine, he received a second-class medal for the *Portrait of Henri Rochefort*. There was no first-class medal, and Baudry got the medal of honour. At the end of December, Manet was made a Chevalier de la Légion d'honneur. These rewards, coming after so many years of struggle, drew the disenchanted response: 'It is too late.'

1

2

1/2
On his return to France in 1880, Henri Rochefort started *L'Intransigeant* in which he attacked Jules Ferry's colonial policy. A deputy from 1885 onwards, he was a partisan of Boulanger's whom he followed to Belgium. Condemned once again, he exiled himself in London until his amnesty, continuing to attack the 'Panama remittance-men'. The Panama scandal had wide and immediate political and ideological consequences. By revealing the links between businessmen and politicians, he shook the regime. Old parliamentarians had to give way to men such as Barthou, Delcassé and Poincaré.

Building the Panama Canal 3

2 *Portrait of Henri Rochefort*, 1881
Oil on canvas, 81.5 x 66.5 cm
Hamburger Kunsthalle, Hamburg

4 *The Escape of Henri Rochefort*, 1881
Oil on canvas, 143 x 114 cm
Kunsthaus, Zurich

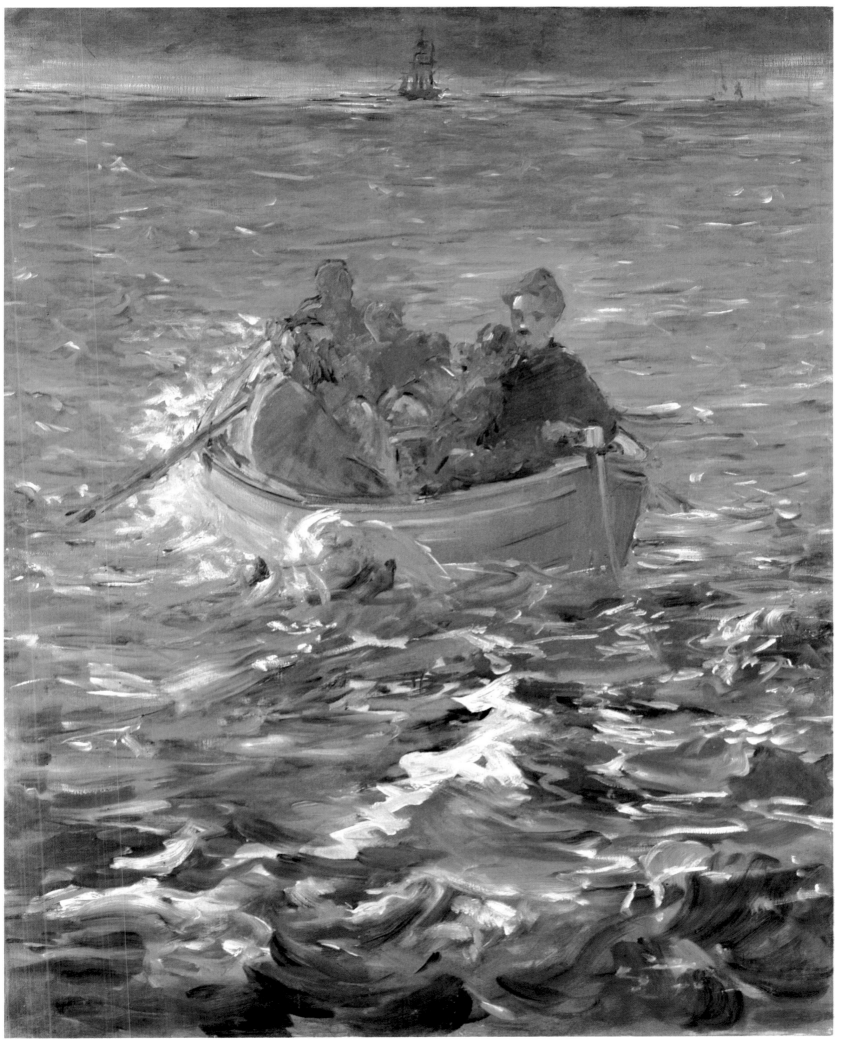

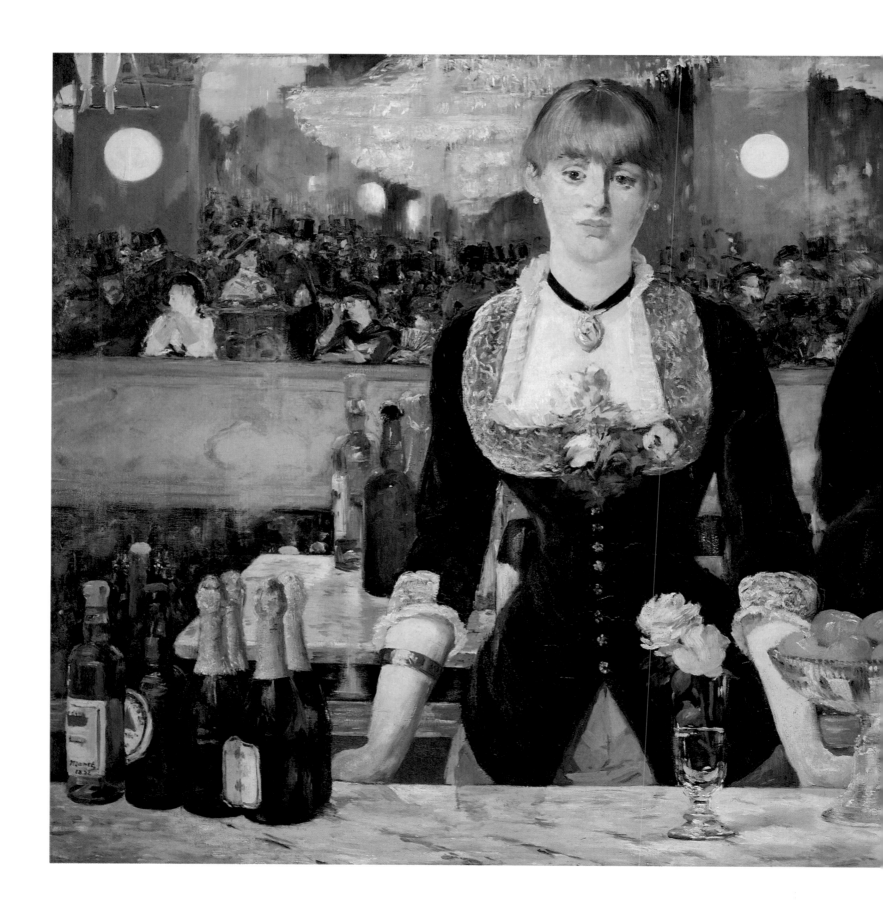

'I love this life, I love the salons,
the noise, the lights, the parties. . . ,
the colours. . .'

The Folies Bergère, the centre of Parisian high life, could hardly fail to interest Manet. His friends found him working on it in January 1882, with his health fast deteriorating. Jacques Emile Blanche visited him: 'It's a nuisance,' Manet had said, 'forgive me, but I must remain seated. Sit there.' The charm of *A Bar at the Folies Bergère* lay in the presence of the young blonde woman behind the bar. This was not the portrait of a prostitute, which

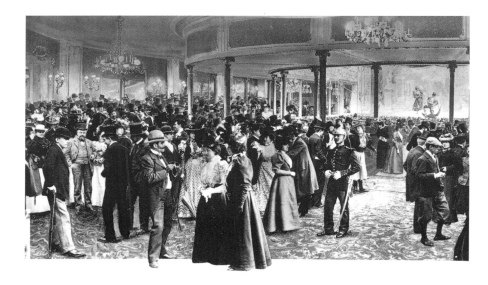

1

This 'young English girl with golden hair', this 'wine seller with a doggy hairstyle', was actually one of the waitresses at the Folies Bergère, by the name of Suzon. Her gentle face can be seen in a pastel, in which she is wearing uniform. Gaston La Touche is the mustachioed customer. The three elegant ladies in the mirror are Méry Laurent, Jeanne Demarsy and a third unknown one.

one might have expected there, but of a young woman listening to a customer. Manet suggests, with the blank expression on the girl's face, what sort of reply she is about to give. Behind her a huge mirror reflects the whole room. Unusually for the critics, they gave the painting a good reception at the 1882 Salon. There was praise for 'the beautiful blonde girl, elegantly encased in a dark blue dress' and 'the pictorial fantasy'. It would be Manet's last Salon. *A Bar at the Folies Bergère* contains his entire artistic repertoire. His talent for still lifes can be seen in the objects on the counter. His love of beautiful faces and his Impressionist brushstrokes are evident in the sparkling reflections in the mirror.

1 *A Bar at the Folies Bergère,* 1881-2
Oil on canvas, 96 x 130 cm
Courtauld Institute, London

Manet was tired and, deciding to rest, moved to a villa with a garden at Rueil. There he found himself more than ever 'in exile', far from Paris. However he was comfortable, and he spent his days painting the garden and small arrangements of flowers in glasses. 'I would like to paint them all, not the artificial ones, the others, the real ones.' Suzanne picked them for him to paint, as by now he could not even walk around the little garden. He went on writing to Méry, telling her about his health: 'I needed to work to feel better.' His return to Paris was a painful effort. He reproached his mother for his illness: 'One should not have children if they are going to be like this.' The various hydrotherapy treatments had failed. One doctor had prescribed split rye; the remedy proved worse than the illness. His own doctor, Siredey, tried to warn him of the dangers of abusing such remedies. Manet, depressed by the thought of approaching death, castigated him: 'I am becoming gloomy. It's all Siredey's fault. When I see doctors they seem to me like sergeants or undertakers.'

He made his will on 30 September, leaving everything to Suzanne, and after her to Léon Leenhoff. He named Théodore Duret as his executor, with the heavy responsibility of choosing which pictures in the studio to sell, and which to burn. He was very anxious at the thought of his work being dispersed. He had once confided to Antonin Proust: 'I do not want to enter the galleries in bits and pieces. I want all of it to go or nothing. Can you see me in the Luxembourg with just one painting, *Olympia* or *At Père Lathuille's*? I would not be complete, and I must be seen completely.' He was constantly visited by his friends throughout the winter.

On 31 December 1882, he heard about the death of Gambetta, whose portrait he would have liked so much to have painted. In February, he showed *Corner of the Café-Concert* at the Salon des Beaux-Arts in Lyon. As spring came and he was forced to stay in bed, and he asked the miniaturist Defeuille to give him lessons. But his condition worsened, and he had to have his left leg amputated on 20 April. This marked the end, and he died ten days later on 30 April 1883.

1

Announcement of the death of Léon Gambetta

3
Manet had suggested a mural based on images of Paris to decorate the new Hôtel de Ville. His plan was not even looked at. At the inauguration, he said: 'To paint the life of Paris in the house of Paris. What have they done? First of all allegory. . . . Then the history of Paris, the past of course, as one might say the Old Testament. As for the New one, forget it!'

1 *The House at Rueil,* 1882
Oil on canvas, 78 x 92 cm
Staatliche Museen Preussicher Kulturbesitz,
National Gallery, Berlin

4 *Path in the Garden at Rueil,* 1882
Oil on canvas, 61 x 50 cm
Musée des Beaux-Arts, Dijon

4

1/4
Manet painted Impressionist, light-filled subjects in the garden at Rueil. Although he fully rendered the charm of the Restoration-style house, he did not like the country. For him it had attractions only 'for those who were not forced to stay there'.

'Oh, I do not doubt the good faith of those who preach the methods I so disapprove of. When Viollet-le-Duc introduced workshops at the Ecole, he thought he was doing the right thing – but he was wrong. He did not realise that by introducing licensed "opticians", he was destroying both the independent studios and the example they set. These "opticians", used to painting by numbers, would train their pupils to see in numbers too – hence all this longsightedness and myopia that we see everywhere. . . . There are pupils who, once outside, use their own eyes and are most surprised to see something quite different to what they have been taught. They, of course, are excommunicated . . . , but, if successful, are then re-accepted as having belonged to the original foundation.'

Catalogue of other principal works

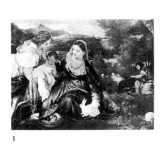
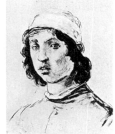

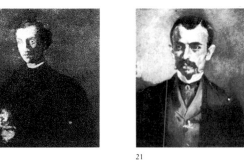

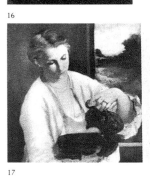

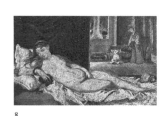
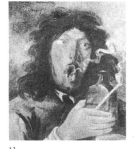

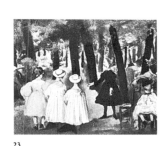

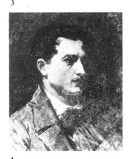

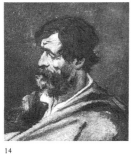

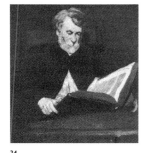

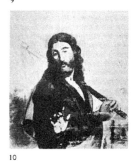

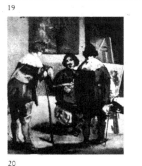

1 *The Virgin with a Rabbit,* 1854
Oil on canvas, 70 x 84 cm
Private collection, New York

2 *The Pardo Venus,* 1854
Oil on canvas, 47 x 85 cm
Private collection, Paris

3 *Dante's Ferry-Boat,* 1854?
Oil on canvas, 33 x 41 cm
Metropolitan Museum of Art,
New York

4 *Portrait of a Man,* 1855-6
Oil on canvas, 56 x 47 cm
National Gallery, Prague

5 *Christ with a Reed,* 1856
Oil on wood, 45 x 36 cm
Private collection, Stuttgart

6 *Portrait of Filippino Lippi
by himself,* 1856?
Oil on wood, 41 x 32 cm
Priv. coll., Switzerland

7 *The Anatomy Lesson,* 1856
Oil on canvas, 25 x 39 cm
Private collection, Paris

8 *Venus of Urbino,* 1856
Oil on wood, 24 x 37 cm
Private collection, Paris

9 *Boy with a Dog,* 1860
Oil on canvas, 92 x 72 cm
Private collection, Paris

10 *Christ as a Gardener,* 1856
Oil on canvas, 68 x 58 cm
Private collection, Stuttgart

11 *Ship's Deck,* before 1858
Oil on canvas, 54 x 43 cm
National Gallery of Victoria,
Melbourne

12 *Woman with Dogs,* 1858
Oil on canvas, 92 x 65 cm
Private collection, Texas

13 *The Smoker*
or *The Drinker,* 1858?
Oil on canvas, 41 x 32 cm
Private collection, Rome

14 *Man's Head,* 1859
Oil on canvas, 55 x 46 cm
Priv. coll., New York

15 *Study of Trees,* 1859?
Oil on canvas, 54 x 30 cm
Private collection, Gand

16 *Portrait of Abbé Hurel,* 1859
Oil on canvas, 47 x 37 cm
Location unknown

17 *Woman with a Jug,* 1858
Oil on canvas, 55 x 45 cm
Ordrupgaardsamlingen,
Copenhagen

18 *Child with Lamb,* 1859
Oil on wood, 19 x 17 cm
Private collection, Paris

19 *Students in Salamanca,*
1859-60. Oil on canvas, 79 x 92 cm
Private collection, London

20 *Scene in a Spanish Studio,* 1860
Oil on canvas, 46 x 38 cm
Galerie Brame, Paris

21 *Portrait of a Man,* 1860
Oil on canvas, 61 x 50 cm
Rijksmuseum Kröller-Müller,
Otterlo

22 *The Italian Girl,* 1860
Oil on canvas, 74 x 60 cm
Priv. coll., New York

23 *Children in the Tuileries,*
1860. Oil on canvas, 38 x 46 cm
Rhode Island School of Design,
Providence

24 *Man Reading,* 1861
Oil on canvas, 98 x 80 cm
City Art Museum, St Louis

25 *Peonies in a Jug,* 1861
Oil on canvas, 46 x 38 cm
Priv. coll., New York

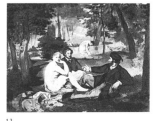

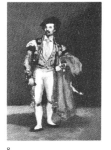

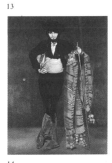

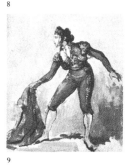

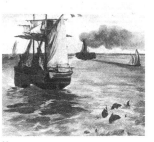

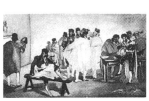

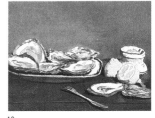

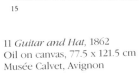

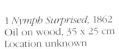

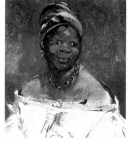

1 *Nymph Surprised,* 1862
Oil on wood, 35 x 25 cm
Location unknown

2 *Nymph Surprised,* 1862
Oil on wood, 35 x 46 cm
National Gallery, Oslo

3 *Bathers in the Seine,* 1862
Oil on canvas, 132 x 98 cm
Museu de Arte, São Paulo

4 *Woman with a Glove,* 1862
Oil on canvas, 132.5 x 100 cm
Priv. coll., New York

5 *The Old Musician,* 1862
Oil on canvas,
187.4 x 248.3 cm
National Gallery, Washington

6 *The Gypsy,* 1862
Oil on canvas, 90.5 x 74 cm
Location unknown

7 *The Drinker,* 1862
Oil on canvas, 57 x 48 cm
Art Institute, Chicago

8 *Portrait of Mariano Camprubi*
1862. Oil on canvas, 46 x 33 cm
Priv. coll., New York

9 *Young Woman in Toreador
Costume,* 1862
Oil on canvas, 43 x 40 cm
Priv. coll., New York

10 *The Dish of Oysters,* 1862
Oil on canvas, 39.1 x 46.7 cm
National Gallery, Washington

11 *Guitar and Hat,* 1862
Oil on canvas, 77.5 x 121.5 cm
Musée Calvet, Avignon

12 *Little Lange,* 1862
Oil on canvas, 116 x 72 cm
Staatliche Kunsthalle, Karlsruhe

13 *Déjeuner sur l'Herbe,* 1863
Oil sketch, 89.5 x 116 cm
Courtauld Institute Galleries,
(Home House Trustees), London

14 *Young Man in Majo
Costume,* 1863
Oil on canvas, 188 x 124.8 cm
Metropolitan Museum, N.Y.

15 *La Posada,* 1863?
Oil on canvas, 49.5 x 86.5 cm
Hill-Stead Museum, Farmington

16 *The Negress,* 1863
Oil on canvas, 58.4 x 48 cm
Priv. coll., Switzerland

17 *Mme Manet snr,* 1863
Oil on canvas, 105 x 80 cm
I.S. Gardner Museum, Boston

18 *Bullfight,* 1864
Oil on canvas, 47.9 x 108.9 cm
Frick Collection, New York

19 *The Kearsarge off
Boulogne,* 1864
Oil on canvas, 78 x 99 cm
Museum of Art, Philadelphia

20 *Ships at Sea with Dolphins,*
1864? Oil on canvas, 81.3 x 100.3 cm
Museum of Art, Philadelphia

21 *Vase of Peonies
on a Tray,* 1864
Oil on canvas, 59 x 34 cm
Payson Collection, New York

22 *Peonies in Bottle,* 1864
Oil on canvas, 63.5 x 53.5 cm
Priv. coll., New York

23 *Salmon, Pike and Shrimps*
1864. Oil on canvas, 45 x 71 cm
Norton Simon Collection, L.A.

24 *Eel and Red Mullet,* 1864?
Oil on canvas, 38 x 46.5 cm
Musée du Jeu de Paume, Paris

25 *Basket of Fruit,* 1864
Oil on canvas, 37 x 44 cm
Museum of Fine Arts, Boston

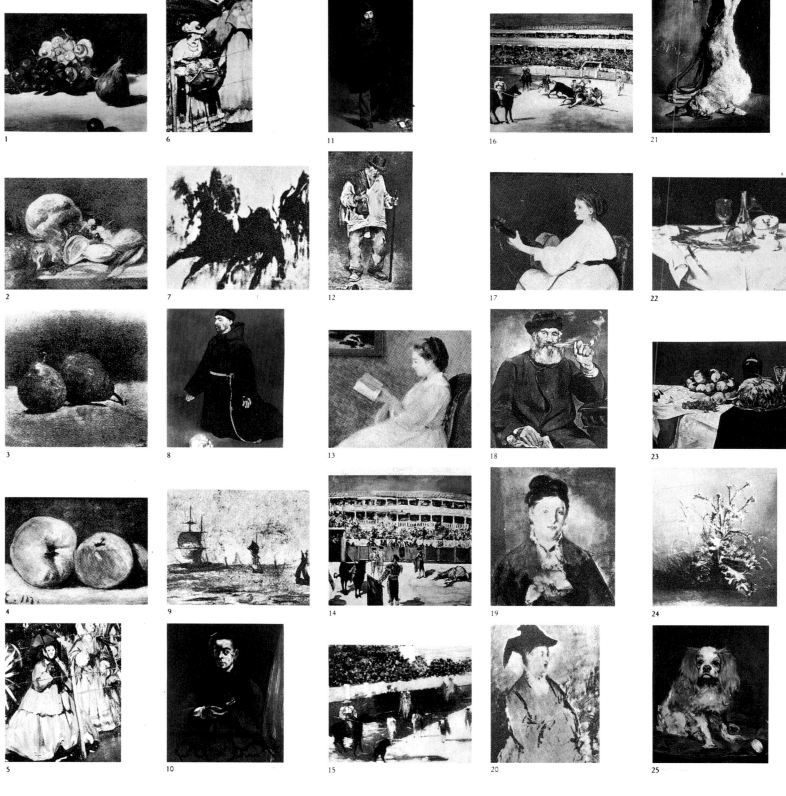

1 *Figs and Grapes,* 1864
Oil on canvas, 21 x 26 cm
Priv. coll., Cannes

2 *Almonds, Redcurrants, Peaches*
1864. Oil on canvas, 17 x 22 cm
Private collection, USA

3 *Two Pears,* 1864
Oil on canvas, 28 x 32 cm
Private collection, Paris

4 *Two Apples,* 1864
Oil on wood, 13.6 x 18 cm
Musée Magnin, Dijon

5 *Races at Longchamp,* 1864
Oil on canvas, 42 x 32 cm
Art Museum, Cincinnati

6 *Races at Longchamp,* 1865
Oil on canvas, 38 x 23.5 cm
Location unknown

7 *Racing at Longchamp*
Oil on canvas, 32 x 41 cm
Private collection, USA

8 *Monk Praying,* 1865
Oil on canvas, 143.5 x 109 cm
Museum of Fine Arts, Boston

9 *Naval Scene,* 1865?
Oil on canvas, 21 x 26 cm
Priv. coll., New York

10 *Angelina,* 1865
Oil on canvas, 92 x 73 cm
Musée du Jeu de Paume, Paris

11 *The Philosopher,* 1865
Oil on canvas, 187.3 x 108 cm
Art Institute, Chicago

12 *The Beggar*
or *The Rag Man,* 1865
Oil on canvas, 195 x 130 cm
Norton Simon Foundation, L.A.

13 *Girl Reading,* 1865?
Oil on canvas, 64 x 80 cm
Priv. coll., New York

14 *Bullfight,* 1865
Oil on canvas, 48 x 60.8 cm
Art Institute, Chicago

15 *Bullfight,* 1866
Oil on canvas, 67 x 78 cm
Location unknown

16 *Bullfight,* 1866
Oil on canvas, 90 x 110 cm
Musée d'Orsay, Paris

17 *The Guitar Player,* 1866
Oil on canvas, 63.5 x 80 cm
Hill-Stead Museum, Farmington

18 *The Smoker,* 1866
Oil on canvas, 100 x 80 cm
Institute of Arts, Minneapolis

19 *Portrait of Mme Edouard
Manet,* 1866
Oil on canvas, 60 x 50 cm
Norton Simon Foundation, L.A.

20 *Mme Edouard Manet,* 1866
Oil on canvas, 100 x 76 cm
Metropolitan Museum, N.Y.

21 *A Rabbit,* 1866
Oil on canvas, 62 x 48 cm
Private collection, Paris

22 *The Salmon,* 1866?
Oil on canvas, 73.5 x 94 cm
Shelburne Museum, Vermont

23 *Melon and Fruit
on a Sideboard,* 1866
Oil on canvas, 69 x 92.2 cm
National Gallery, Washington

24 *Thistles,* 1866?
Oil on canvas, 65 x 54 cm
Thannhauser coll., Berlin

25 *Spaniel,* 1866
Oil on canvas, 47 x 37 cm
Private collection, USA

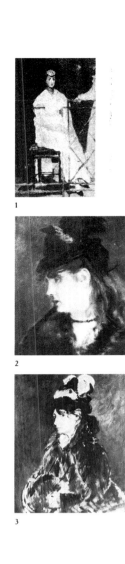

1

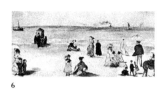

6

11

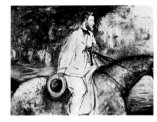

16

21

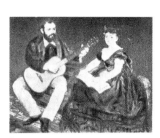

2

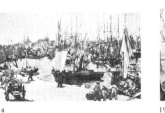

7

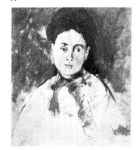

12

17

22

3

8

13

18

23

4

9

14

19

24

5

10

15

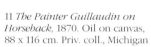

20

25

1 *The Balcony*, 1868
Oil on canvas, 71 x 43 cm
Private collection, London

2 *Berthe Morisot in Feathered Hat*, 1869. Oil on canvas,
41 x 32 cm. Priv. coll., Paris

3 *Berthe Morisot with Muff*
1868-9. Oil on canvas,
73.6 x 60 cm. Museum of Art
(gift of C.J. Hanna Jr), Cleveland

4 *Steamship leaving Folkestone*, 1869
Oil on canvas, 63 x 100 cm
Oscar Rheinhart coll., Winterthur

5 *The Jetty at Boulogne*, 1869
Oil on canvas, 33 x 45 cm
Priv. coll., New York

6 *On the Beach at Boulogne*, 1869
Oil on canvas, 32.5 x 65.5 cm
Paul Mellon coll., Upperville

7 *The Music Lesson*, 1869
Oil on canvas, 97 x 82 cm
Private collection, Houston

8 *The Music Lesson*, 1870
Oil on canvas, 140 x 173 cm
Museum of Fine Arts, Boston

9 *Eva Gonzales Painting in Manet's Studio*, 1870
Oil on canvas, 56 x 46 cm
Location unknown

10 *Brioche, Peaches, Plums*
1870. Oil on canvas, 65 x 81 cm
Priv. coll., New York

11 *The Painter Guillaudin on Horseback*, 1870. Oil on canvas,
88 x 116 cm. Priv. coll., Michigan

12 *Bust of Woman*, 1870
Oil on canvas, 57 x 46.5 cm
R. Staechlin Foundation, Basle

13 *Petit Montrouge During the War*
1870. Oil on canvas, 61 x 50 cm
Nat. Museum of Wales, Cardiff

14 *The Port of Bordeaux*, 1871
Oil on canvas, 66 x 100 cm
Bührle collection, Zurich

15 *Oloron Sainte-Marie*, 1871
Oil on canvas, 62 x 46.5 cm
Staatsgalerie, Stuttgart

16 *The Young Cyclist*, 1871
Oil on canvas, 53 x 20 cm
Private collection, Paris

17 *On a Pillared Gallery at Oloron*, 1871
Oil on canvas, 40 x 60 cm
Bührle collection, Zurich

18 *The Dock at Arcachon*, 1871
Oil on canvas, 25 x 30 cm
Private collection, Basle

19 *The Dock at Arcachon*, 1871
Oil on wood, 37 x 56.5 cm
Bührle collection, Zurich

20 *Thunderstorm, Arcachon*, 1871
Oil on canvas, 34 x 49 cm
Kunstmuseum, Basle

21 *Fine Weather, Arcachon*, 1871
Oil on canvas, 25 x 42 cm
Priv. coll., New York

22 *Game of Croquet at Boulogne*, 1871
Oil on canvas, 46 x 73 cm
Private collection

23 *The Port of Calais*, 1871
Oil on canvas, 81.5 x 100.7 cm
Priv. coll., New York

24 *Green Almonds*, 1871
Oil on canvas, 21 x 26 cm
Location unknown

25 *A Street*, 1871?
Oil on canvas, 40 x 24 cm
Private collection, Geneva

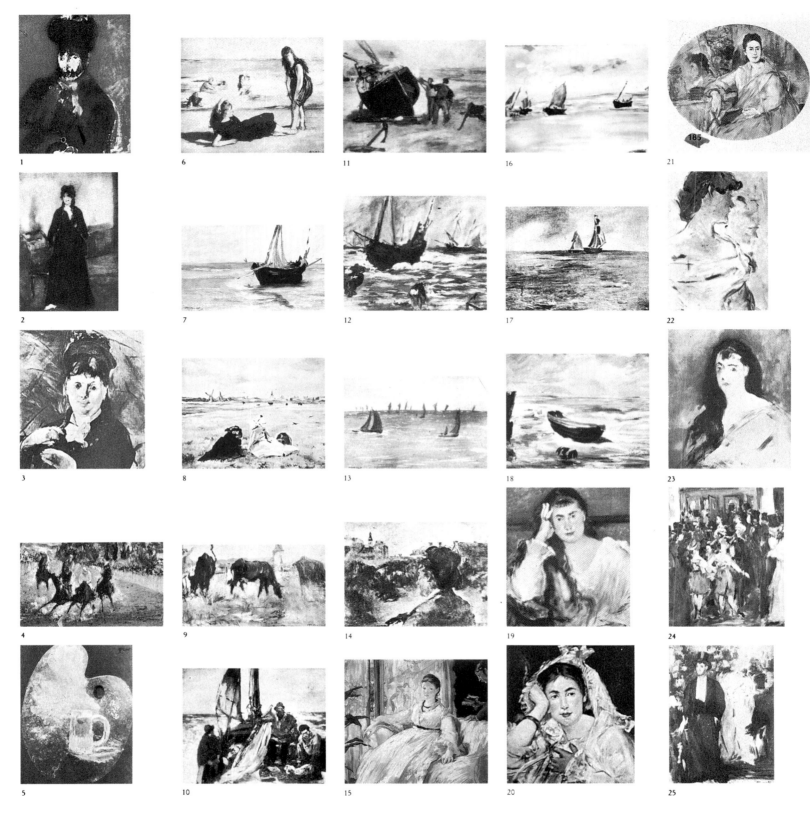

1 *Young Woman with Violet,* 1872
Oil on canvas, 61.5 x 47.5 cm
Beyeler Gallery, Basle

2 *Berthe Morisot with a
Pink Shoe,* 1872
Oil on canvas, 46.5 x 32 cm
Private collection, Japan

3 *Woman with Parasol,* 1872
Oil on canvas, 52 x 32 cm
Priv. coll., Los Angeles

4 *Racing at Longchamp,* 1872
Oil on canvas, 12.5 x 21.5 cm
National Gallery, Washington

5 *Palette and Glass of Beer*
1873. Oil on wood,
50 x 38 cm. Location unknown

6 *Bathers on the Beach,* 1873?
Oil on canvas, 38 x 44 cm
Institute of Arts, Detroit

7 *Black Boat at Berck,* 1873
Oil on board
20.3 x 33.2 cm
Private collection, USA

8 *The Swallows,* 1873
Oil on canvas, 65.5 x 81 cm
Bührle Collection, Zurich

9 *Three Cows in a Field,* 1873?
Oil on wood, 12 x 21 cm
Location unknown

10 *Fishermen at Sea,* 1873
Oil on canvas, 63 x 80 cm
Priv. coll., Los Angeles

11 *The Tarred Boat,* 1873
Oil on canvas, 59 x 60 cm
Barnes Foundation , Merion

12 *Boats Coming In,* 1873
Oil on canvas, 50 x 61 cm
Priv. coll., New York

13 *Boat at Sea,* 1873
Oil on canvas, 34 x 53 cm
Museum of Art, Cleveland

14 *Mme Edouard Manet
at Berck,* 1873
Oil on canvas, 46 x 50 cm
Private collection, Paris

15 *The Reading,* 1865-73?
Oil on canvas, 61 x 74 cm
Musée d'Orsay, Paris

16 *Calm Seascape,* 1873
Oil on canvas, 55 x 72 cm
Wadsworth Atheneum, Hartford

17 *Stormy Seascape,* 1873
Oil on canvas, 55 x 72 cm
Private collection, Japan

18 *Rising Tide,* 1873
Oil on canvas, 47 x 58 cm
Bührle Collection, Zurich

19 *Marguerite de Conflans
Leaning,* 1873
Oil on canvas, 53.5 x 45 cm
Smith College, Northampton

20 *Marguerite de Conflans
with Hood,* 1873
Oil on canvas, 56 x 46 cm
Oscar Reinhart Coll., Winterthur

21 *M. de Conflans at her
Dressing-Table,* 1873
Oil on canvas, 53.5 x 64.5 cm
Musée du Jeu de Paume, Paris

22 *M. de Conflans in Ball-
Gown,* 1873. Oil on canvas
54 x 35.5 cm. Courtauld Institute
Galleries, London

23 *M. de Conflans with Hair
Undone,* 1873. Oil on canvas,
65 x 50 cm. Priv. coll., N.Y.

24 *Masked Ball at Opera,* 1873
Oil on canvas, 46.5 x 38.5 cm
Bridgestone Gallery, Tokyo

25 *Masked Ball at Opera,* 1873
Oil on canvas, 50 x 32 cm
Private collection, Paris

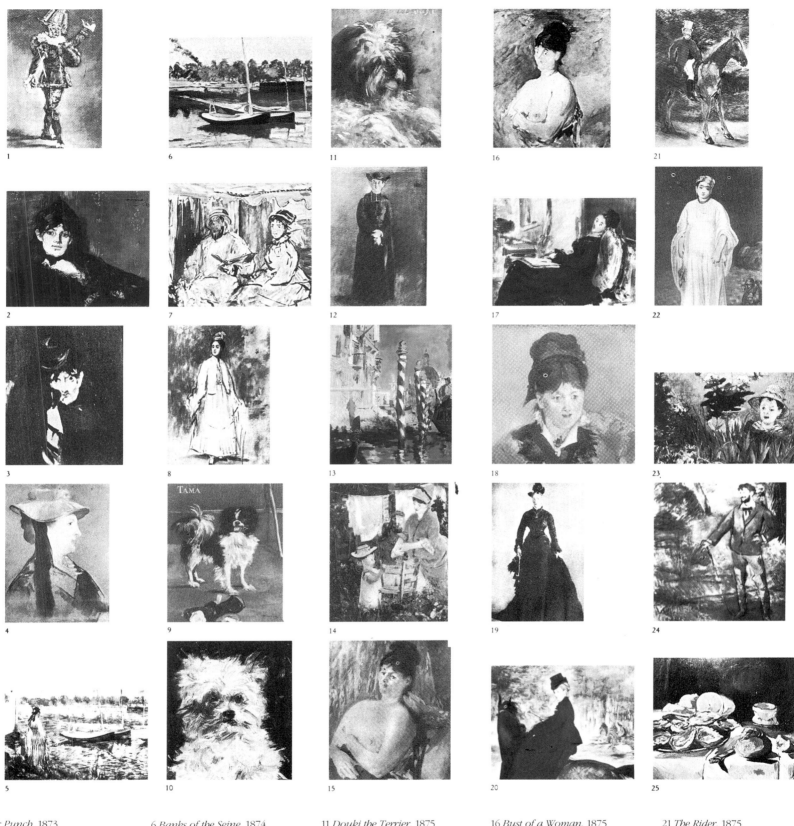

1 *Mr Punch,* 1873
Water-colour, 34 x 23.5 cm
Private collection, Paris

2 *Berthe Morisot Reclining,* 1873
Oil on canvas, 26 x 34 cm
Private collection, Paris

3 *Berthe Morisot in
Funeral Hat,* 1873
Oil on canvas, 62 x 50 cm
Private collection, Zurich

4 *Mme Edouard Manet in Profile,*
1873, Pastel on board, 61 x 49 cm
Museum of Art, Toledo

5 *On the Banks of the Seine,* 1874
Oil on canvas, 62.3 x 103 cm
Private collection, London

6 *Banks of the Seine,* 1874
Oil on canvas, 59 x 81.3 cm
National Museum of Wales,
Cardiff

7 *Claude Monet in his Studio*
1874. Oil on canvas, 106 x 134.6 cm
Staatsgalerie, Stuttgart

8 *Young Woman in Garden,* 1874
Oil on canvas, 41 x 33 cm
Private collection, Frankfurt

9 *Tama, Japanese Dog,* 1875
Oil on canvas, 61 x 49.5 cm
Paul Mellon Coll., Upperville

10 *Bob the Terrier,* 1875
Oil on canvas, 27.5 x 21.5 cm
Priv. coll., New York

11 *Douki the Terrier,* 1875
Oil on canvas, 32.5 x 25.5 cm
Private collection, Paris

12 *Abbé Hurel,* 1875
Oil on canvas, 42 x 30 cm
Museo Nacional de
Arte Decoratico, Buenos Aires

13 *Grand Canal, Venice,* 1875
Oil on canvas, 57 x 48 cm
Private collection

14 *The Washing,* 1875
Oil on canvas, 145 x 115 cm
Barnes Foundation, Merion

15 *Bust of a Woman,* 1875
Oil on canvas, 73.5 x 60 cm
Location unknown

16 *Bust of a Woman,* 1875
Oil on canvas, 71 x 57 cm
Priv. coll., New York

17 *Young Woman with Book,* 1875
Oil on canvas, 24 x 32 cm
Private collection, Paris

18 *Portrait of Alice Legouvé,* 1875?
Oil on canvas, 26.5 x 28 cm
Bührle collection, Zurich

19 *Parisian Woman*
or *Dress with Train,* 1875
Oil on canvas, 192 x 125 cm
Nationalmuseum, Stockholm

20 *The Horsewoman,* 1875
Oil on canvas, 90 x 116.5 cm
Museu de Arte, São Paulo

21 *The Rider,* 1875
Oil on canvas, 222 x 157 cm
Galleria d'Arte Moderna, Milan

22 *Young Woman
in Oriental Costume,* 1876
Oil on canvas, 92 x 73 cm
Bührle Collection, Zurich

23 *Child Among Flowers,* 1876
Oil on canvas, 60 x 98 cm
Private collection, Paris

24 *Portrait of Carolus Duran,*
1876. Oil on canvas,
190 x 171 cm, Barber Institute
of Fine Arts, Birmingham

25 *Oysters, Lemon and Brioche*
1876. Oil on canvas,
38 x 46 cm. Priv. coll., Zurich

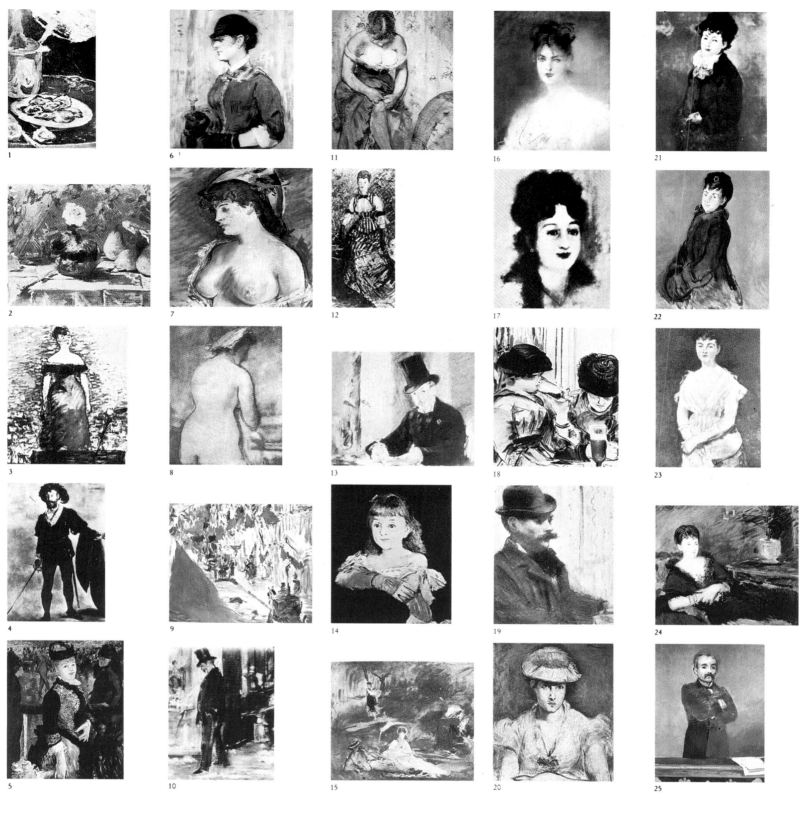

1 *Oysters and Champagne Bucket,*
1876? Oil on canvs, 55 x 35 cm
Private collection, London

2 *Flowery Brioche with Pears,*
1876. Oil on canvas, 46 x 54 cm
Private collection, France

3 *Singer at the Café-Concert,*
1876?
Oil on canvas, 81 x 65.5 cm
Priv. coll., New York

4 *Faure as Hamlet,* 1877
Oil on canvas, 193 x 131 cm
Folkwang Museum, Essen

5 *Skating,* 1877
Oil on canvas, 92.5 x 72 cm
Fogg Art Museum, Cambridge

6 *Young Woman with
Round Hat,* 1877
Oil on canvas, 55 x 46 cm
Priv. coll., New York

7 *Blonde with Bare Breasts,* 1878
Oil on canvas, 62.5 x 52 cm
Musée du Jeu de Paume, Paris

8 *Nude from Behind,* 1878
Pastel on board, 55 x 45 cm
Bührle Collection, Zurich

9 *Rue Mosnier with Flags,* 1878
Oil on canvas, 65 x 81 cm
Bührle Collection, Zurich

10 *Passer-by,* 1878
Oil on canvas, 24 x 20 cm
Private collection, Paris

11 *Woman with Garter,* 1878
Pastel on board, 53 x 44 cm
Ordrupgaardsamlingen,
Copenhagen

12 *Woman in Evening Dress*
1878. Oil on canvas, 180 x 85 cm
Guggenheim Museum, N.Y.

13 *The Journalist,* 1878
Oil on canvas, 27 x 35 cm
I.S. Gardner Museum, Boston

14 *Girl (half-length),* 1878
Oil on canvas, 55.8 x 47 cm
Nelson-Atkins Gall., Kansas City

15 *Under the Trees,* 1878
Oil on canvas, 65 x 81 cm
Private collection, Paris

16 *Head of Young Woman,* 1878
Pastel on board, 61.5 x 50.5 cm
Musée du Louvre, Paris

17 *The Box at the
Italian Opera,* 1878
Pastel on board, 42 x 33 cm
Private collection, Paris

18 *Women Drinking,* 1878?
Pastel on canvas, 61 x 50.8 cm
Burrell Coll., Glasgow

19 *Portrait of Moreau,* 1878-9
Pastel on canvas, 54.7 x 45.2 cm
Art Institute, Chicago

20 *Portrait of Mlle Gauthier-
Lathuille,* 1879
Oil on canvas, 61 x 50 cm
Musée des Beaux-arts, Lyons

21 *Isabelle Lemonnier with
Scarf,* 1879. Oil on canvas
86.5 x 63.5 cm. Ny Carlsberg
Glyptotek, Copenhagen

22 *Isabelle Lemonnier with
Muff,* 1879. Oil on canvas
81.5 x 74 cm. Priv. coll., Switz.

23 *Isabelle Lemonnier in Evening
Dress,* 1879. Oil on canvas
101 x 81 cm. Priv. coll., Paris

24 *Mlle Lemonnier Seated,* 1879
Oil on canvas, 32.5 x 41 cm
Priv. coll., Pennsylvania

25 *Clemenceau at the Rostrum*
1879-80
Oil on canvas, 116 x 94 cm
Kimbell Art Museum, Fort Worth

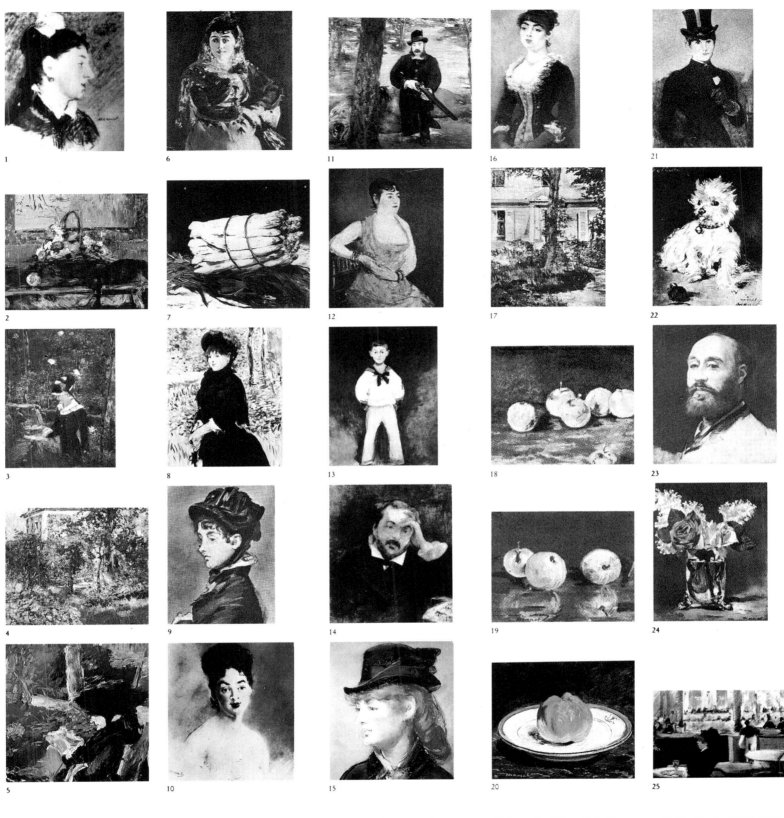

1 *Woman with Broken Collar*
1879. Pastel on board
48 x 39 cm. Priv. coll., Paris

2 *Basket of Flowers,* 1880
Oil on canvas, 65 x 82 cm
Private collection, USA

3 *Young Woman on garden step
at Bellevue,* 1880
Oil on canvas, 151 x 115 cm
Private collection, Paris

4 *Corner of Garden at Bellevue*
1880. Oil on canvas, 54 x 65 cm
Private collection, Paris

5 *Manet's Mother in the
Garden at Bellevue,* 1880
Oil on canvas, 82 x 65 cm
Private collection, Paris

6 *Portrait of Emilie Ambre
as Carmen,* 1879-80
Oil on canvas, 91.5 x 73.5 cm
Museum of Art, Philadelphia

7 *Bunch of Asparagus,* 1880
Oil on canvas, 46 x 55 cm
Wallraf-Richartz Museum,
Cologne

8 *The Walk,* 1880
Oil on canvas, 93 x 70 cm
Paul Mellon Coll., Upperville

9 *Mme Jules Guillemet,* 1880
Pastel on canvas, 55 x 35 cm
City Art Museum, St Louis

10 *Bust of Nude,* 1880
Pastel on board, 53.5 x 46.5 cm
Musée du Jeu de Paume, Paris

11 *Portrait of Pertuiset, the
Lion Hunter,* 1880-1
Oil on canvas, 150 x 170 cm
Museu de Arte, São Paolo

12 *Woman in Pink,* 1881
Oil on canvas, 94 x 75 cm
Gemäldegalerie, Dresden

13 *Henry Bernstein as a
Child,* 1881. Oil on canvas
135.5 x 97 cm. Priv. coll., Paris

14 *Emmanuel Chabrier,* 1881
Pastel on canvas, 65 x 45 cm
Fogg Art Museum, Cambridge

15 *Model for A Bar at the Folies
Bergère,* 1881
Pastel on board, 54 x 34 cm
Musée des Beaux-Arts, Dijon

16 *Portrait of Mme Michel Levy*
1882. Pastel on board
74.4 x 51 cm. National Gallery
Washington

17 *The House at Rueil,* 1882
Oil on canvas, 92 x 73 cm
National Art Gallery, Victoria

18 *Plums,* 1882
Oil on canvas, 18.5 x 24 cm
Priv. coll., New York

19 *Three Apples,* 1882
Oil on canvas, 17 x 23 cm
Priv. coll., New York

20 *Apple,* 1882
Oil on canvas, 21 x 26 cm
Priv. coll., Lausanne

21 *The Horsewoman,* 1882
Oil on canvas, 74 x 52 cm
Private collection, Berne

22 *Follette the Terrier,* 1882
Oil on canvas, 37 x 32 cm
Private collection, Paris

23 *Portrait of Jean-Baptiste
Faure,* 1882-3
Oil on canvas, 46 x 37.8 cm
Metropolitan Museum
of Art, New York

24 *Roses and Lilac,* 1882-3
Oil on canvas, 32.5 x 24.5 cm
Priv. coll., New York

25 *A Café, Place du Palais-
Royal,* 1881. Pastel on canvas
Burrell Collection, Glasgow

	Life of Manet	Principal Works
1832	Born in Paris on 23 January; father official in the Ministry of Justice, mother daughter of a diplomat *en poste* in Stockholm	
1833	Birth of his brother Eugène	
1835	Birth of his brother Gustave	
1838	Sent to the Institut Poiloup at Vaugirard until 1840	
1844	Enters the Collège Rollin where he meets Antonin Proust. During his school years he is taken to the Louvre with his friend and maternal uncle, Colonel Fournier	
1848	Leaves the Collège Rollin. Fails entrance to naval college. Sets sail on the training ship *Le Havre et Guadeloupe*, bound for Rio de Janeiro; draws caricatures while on board, which delight the crew	
1849	Stays in Rio for two months. Once again fails naval college entrance. His family allow him to pursue an artistic career. Suzanne Leenhoff gives piano lessons to his brothers	
1850	Joins the list of copyists at the Louvre, as a pupil of Thomas Couture. Enters Couture's studio in September	
1851	Goes down into the streets with his friend Proust during the *coup d'état*. Goes with fellow pupils of the Couture studio to the Montmartre cemetery to see the victims of Louis-Napoléon	
1852	Birth of Léon-Edouard Koella, known as Leenhoff, natural son of Suzanne, and presumed son of Manet. Continues copying in the Louvre. Goes to Holland where he visits Rijksmuseum, Amsterdam	
1853	Travels, probably, to Kassel, Dresden, Prague, Vienna and Munich. Walks in Normandy, and then in Italy with his brother Eugène. Meets Emile Ollivier in Venice. Visits Florence and Rome	
1855	Visits Delacroix in his studio in the rue Notre-Dame-de-Lorette	*Dante's Ferry-Boat*, after Delacroix
1856	Leaves Couture's studio, and sets up with a friend, the animal painter le comte de Balleroy, in a studio in the rue Lavoisier	
1857	Meets Fantin-Latour at the Louvre. Continues to copy masterpieces in the Louvre. Travels to Italy with Eugène Brunet	
1858	Joins the register of the Cabinet des estampes at the Bibliothèque Nationale	
1859	*The Absinthe Drinker* turned down despite Delacroix's opinion. Leaves the rue Lavoisier studio for the rue de la Victoire. Registers himself at the Louvre as an artist copyist. Meets Degas	*Spanish Cavaliers, The Absinthe Drinker*
1860	Leaves studio after his young assistant hangs himself (inspiring Baudelaire's *The Rope*). Moves into rue de Douai, finding an apartment with Suzanne and Léon in the Batignolles	*Portrait of M. and Mme August Manet, Portrait of Mme Brunet, Boy with a Dog, The Spanish Singer* or *Guitarrero, Bather, Emerging from the Bath*
1861	At the Salon: *Portrait of M. and Mme Manet, The Spanish Singer. Nymph Surprised* at Saint Petersburg	*Fishing, Child with a Sword, Nymph Surprised, La Toilette*
1862	Founds Soc. of Etchers with Bracquemond, Jongkind, Fantin-Latour, Stevens, Chevalier, Legros, Ribot. Frequents Café Tortoni. Paints Spanish dancers. Death of father. Meets Victorine Meurent	*Portrait of Victorine Meurent, The Street Singer, Mlle Victorine in Espada Costume, The Little Cavaliers, Music in the Tuileries, The Ball, The Spanish Ballet, Lola de Valence*
1863	Exhibits at the Martinet gallery. Illustrates Astruc's courtship with *Lola de Valence*. Founding of the Salon des Refusés. Delacroix's funeral. Marries Suzanne Leenhoff at Zalt-Bommel, Holland	*Lola de Valence* (lithograph), *Portraits of Baudelaire* (etchings), *Le Déjeuner sur l'Herbe, Olympia*

Artistic Life	History
Roi s'amuse by Victor Hugo shown at the Théâtre-Français and then banned. George Sand: *Indiana*. Birth of Lewis Carroll	Republican uprising suppressed at the Saint-Merri cloister. Death of Casimir Perier. Soult, Guizot and Thiers in the government
Mlle George and Frédérick Lemaître act in Victor Hugo's *Lucrétia Borgia*. Musset: *Les Caprices de Marianne*	Beginning of Carlist war
Bellini's *Norma* performed in Paris. At the Comédie-Française, Mlle Mars and Marie Dorval perform Victor Hugo's *Angelo, tyran de Padoue*. Vigny: *Chatterton*	Fieschi's assassination attempt against Louis-Philippe, on 25 July, using 'diabolical machine'
Birth of Villiers de l'Isle-Adam	Creation of the port of Constantine, Philippeville, during the conquest of Algeria
Berthe Morisot is three years old, and Zola four. Birth of Le Douanier Rousseau, Anatole France, Nietzsche and Verlaine	Bugeaud's victory at l'Isly over Abd el-Kader, who had fled to Morocco
Daumier: *La Révolte*. Birth of Octave Mirbeau, Huysmans and Caillebotte	Revolution, followed by reaction and repression throughout Europe. Guizot resigns. Shootings in the boulevard des Capucines. Universal suffrage, Louis-Napoléon elected President of the Republic
Courbet: *After Supper at Ornans*. Georges Sand's *François le Champi* performed at the Odeon. First use of electricity for the stage lighting at the Opera. Death of Marie Dorval. Birth of Strindberg	Elections to legislature. Victor Hugo elected. Popular demonstrations in Paris and Lyons
Courbet: *Funeral at Ornans*. Return of censorship in the theatre. Death of Balzac. Birth of Pierre Loti and Maupassant	Laws restricting universal suffrage
First Great Exhibition in London, organised by Henry Cole. Corot: *Entrance to the Port of La Rochelle*. Victor Hugo flees to Belgium. Death of Turner	*Coup d'état* on 2 Dec. by Louis-Napoléon Bonaparte. Shooting on the boulevards. Gold rush in Australia. Beginning of sea transport of parcels. Telegraph link between Dover and Calais
Corot in Geneva. The baritone Faure makes his debut at the Opera. Alexandre Dumas junior: *The Lady with the Camellias*. Opening of the Cirque d'Hiver. Death of Gogol. Beginning of re-building of Paris.	Expulsion of seventy deputies, one of whom is Victor Hugo. Censorship of the press. Crédit mobilier founded by the Pereires. Opening of Bon Marché. Empire re-established
Courbet's *Bathers* at the Salon. Nadar's first photographic studio. First appearance in Paris of the great tragic actress Adélaïde Restori. Hugo: *Les Châtiments*. Verdi: *La Traviata, Trovatore*	Napoléon III marries Eugénie de Montijo. American fleet in Japan demands opening of ports to American trade
International Exhibition of 1855, with a photographic section. Courbet exhibits alone because the Salon turns down *The Studio*. Death of François Rudé and de Nerval	Queen Victoria visits Paris. Alexander II crowned Tsar of Russia. Powers of East India Company pass to the British Crown. Opening of Magasins du Louvre
Production in Paris of *La Traviata*. Duranty publishes his magazine, *Le Réalisme*, from November 1856 until May 1857. Birth of Freud	End of Crimean War. Reform of French laws on associations. Congress and Treaty of Paris. Birth of Imperial Prince Eugène Louis Napoléon, the son of Napoléon III
Baudelaire: *Les Fleurs du Mal*. Flaubert: *Madame Bovary*. Banville: *Odes funambulesques*. Production of Verdi's *Rigoletto*. Death of Alfred de Musset	Napoléon III at Le Havre. End of conquest of Algeria. General Randon defeats Kabylia. Anglo-French expedition to China to open a port of commerce. Sepoys revolt in India.
Pissarro works at Montmorency. Whistler visits northern France. Daumier: *The Third-Class Carriage*. Construction of the Bibliothèque Nationale. Nadar takes first photograph from a balloon	Assassination attempt by Orsini against Napoléon III. French move in to Cochin. Founding of the Kingdom of Italy. Beginning of American Civil War. Liberation of imperial serfs in Russia
Millet finishes *The Angelus*. Boudin meets Baudelaire and Courbet. The Morisot sisters meet Fantin-Latour at the Louvre. Gounod: *Faust*. Darwin: *Origin of the Species*. Birth of Seurat	Victories at Magenta and Solferino. Building of the Suez Canal. French in Saigon. Numbered *arrondissements* in Paris. Broca founds first anthropology society. First oil extraction in Pennsylvania
Whistler: *The Thames Frozen*. Degas: *Young Spartans Wrestling*. Renoir frequents the Louvre. Dostoevsky: *Crime and Punishment*. Death of Schopenhauer	Nice and Savoy are joined to France. Anglo-French troops in Peking. Second Tientsin treaty. Summer Palace burned down by Lord Elgin. French expedition to Syria. Lincoln President of United States
Dickens: *Great Expectations*. Monet joins the Chasseurs d'Afrique. The Morisot sisters study under Corot. Building of the Opera. Scandal about Baudelaire applying to join the Académie Française	Mexico occupied by French, British and Spanish troops. Victor-Emmanuel II becomes King of Italy. Cavour dies in Rome. Spanish authority re-established in Santo Domingo
Ingres: *The Turkish Bath*. Carpeaux: *Ugolino and his Sons*. Flaubert: *Salâmmbo*. Hugo: *Les Misérables*. Birth of Debussy. Great Exhibition in London	French expeditionary party, 23,000 strong, sent to Mexico. Bismarck becomes Prime Minister. Garibaldi defeated at Aspromonte
Salon des Refusés. Reform of the Ecole des Beaux-Arts. Cabanel: *Birth of Venus*. Jules Verne: *Five Weeks in a Balloon*. Death of Delacroix and de Vigny. Birth of Signac	Cambodia becomes French protectorate. Opening of London Underground. *Petit Journal* appears. Founding of Crédit Lyonnais. Berthelot synthesises acetylene. Solvay soda-making developed

	Life of Manet	Principal Works
1864	Sits for *Homage to Delacroix*. Shows *Episode from a Bullfight* and *Christ and the Angels* at the Salon. Moves into an apartment at 34 boulevard des Batignolles	*The Dead Torero, Christ and the Angels, Branch of White Peonies with Secateurs, Peonies and Secateurs, Battle between the Kearsarge and the Alabama, The Kearsarge at Boulogne*
1865	Baudelaire's agent. Salon: *Jesus Mocked by the Soldiers; Olympia*. Paintings turned down by Royal Academy. Frequents Café de Bade. Visits Spain. Summer in Sarthe. Falls ill in cholera epidemic	*Jesus Mocked by the Soldiers* or *The Outrage of Christ, The Tragic Actor* or *Portrait of Rouvière as Hamlet, The Philosopher, Bullfight*. Begins *The Reading*, finishing it in 1873
1866	*The Fifer* and *The Tragic Actor* are turned down by the Salon. Meets Cézanne, then Monet. Exhibits at Bordeaux. Frequents Café Guerbois. Moves with his family to 49 rue Saint-Pétersbourg	*The Matador* or *Matador Saluting, The Fifer, Portrait of Zacharie Astruc, Moorish Lament* (lithograph), *Young Woman in 1866* or *Woman with Parrot*
1867	Zola publishes a critical piece on Manet. Decides to organise a one-man show near the Champ-de-Mars. Spends a few days at Trouville with Antonin Proust. Goes to Baudelaire's funeral	Begins *The Funeral, Racing at Longchamp, The Soap Bubbles, The Execution of the Emperor Maximilian*
1868	Zola sits for portrait. Holidays with family at Boulogne. London to sell pictures. *The Dead Man* wins award, Bordeaux. Meets Gambetta at Café de Londres, Morisot sisters through Fantin-Latour	*Portrait of Emile Zola, Mme Manet at the Piano, Portrait of Théodore Duret, Lunch in the Studio*, lithographs for Champfleury's anthology *Ca , The Balcony*
1869	Eva Gonzales becomes his pupil and model. At the Salon: *The Balcony* and *Lunch in the Studio. The Execution of the Emperor Maximilian* rejected. Family holidays, Hotel Folkestone, Boulogne	*Moonlight at Boulogne, The Jetty at Boulogne*
1870	Fights a duel with Duranty over an article. Sits for Bazille. At the Salon: *The Music Lesson* and *Portrait of Eva Gonzales*. The family moves to Oloron-Sainte-Marie; he joins artillery of National Guard	*The Rest* or *Portrait of Berthe Morisot, In the Garden*
1871	Goes to Oloron-Sainte-Marie, then to Bordeaux, Arcachon and Tours. Elected to the artist's committee of the Commune. Returns to Paris at the end of May. Fails to get Gambett to sit for him.	*The Queue at the Butcher's* (etching), *The Barricade* (lithograph), *Interior ar Arcachon*
1872	Durand-Ruel buys 24 canvasses. At the Salon: *Battle between the Kearsarge and the Alabama*. With Frederick Leenhoff, visits Frans Hals museum and Rijksmuseum. Studio in rue Saint-Pétersbourg	Begins *Boats at Sea, Setting Sun, Brunette with Bare Breasts, Berthe Morisot with Bunch of Violets, The Bunch of Violets, Racing at the Bois d Boulogne, The Railway*
1873	At the Salon: *The Glass of Beer* and *The Rest*. Goes to Etaples and Berck-sur-Mer with family. Back in Paris, meets Mallarmé. Attends trial of maréchal Bazaine. Sells five paintings to Faure, the baritone	*On the Beach, Woman with Fans*, or *Portrait of Nina de Callias, Masked Ball at the Opera*
1874	Salon accepts *The Railway* and water-colour *Mr Punch*, turns down *The Swallows* and *Masked Ball at the Opera*. Refuses to exhibit alongside Impressionists. Eugène Manet marries Berthe Morisot	*Argenteuil, In the Boat, The Monet Family in the Garden, Mme Manet on a Blue Sofa* (pastel), *Portrait of Berthe Morisot in a Black Hat, Berthe Morisot with a Fan*
1875	Shows *Argenteuil* at the Salon. Plans to go to London but travels instead with Tissot to Venice	*The Artist, Portrait of Marcellin Desboutin, The Grand Canal in Venice, The Grand Canal in Venice* or *Venice in Blue*
1876	The Salon jury turns down *The Washing* and *The Artist*. Decides then to open his studio to the public. With his wife stays with Ernest Hoschédé at Montgeron	*Portrait of Stephane Mallarmé*, lithographs for *The Raven*, by Edgar Alla Poe, translated by Mallarmé, *In Front of the Mirror, Faure as Hamlet*
1877	Shows *Faure as Hamlet* at the Salon. *Nana* is turned down. Supports his Impressionist friends. *Nana* is shown at Giroux's in boulevard des Capucines	*Nana*
1878	Plans a private exhibition on the edge of International Exhibition. Moves with his family to 49 rue Saint-Pétersbourg, and has his studio at 70 rue d'Amsterdam	*Rue Mosnier with Pavers, Rue Mosnier with flags, The Plum, Café-Concer Young Blonde with Blue Eyes, Blonde with Bare Breasts, Woman in Bat tub*
1879	Plans decoration of new Hôtel de Ville. Shows *In the Boat* and *The Conservatory*. Meets George Moore and the singer Emilie Ambre. Quarrels with Zola. Takes a cure at Bellevue	*Self-Portrait with Palette, Corner of the Café-Concert, The Waitress, Girl Reading, George Moore at the Café, Portrait of George Moore, The Conservatory, Portrait of Clemenceau at the Rostrum*
1880	Exhibits on premises of *La Vie Moderne*. At the Salon: *Portrait of Antonin Proust* and *At Père Lathuille's*. Resting at Bellevue, follows a course of hydrotherapy. Exhibits at Marseilles and Besançon	*Portrait of M. Antonin Proust, The Lemon, A Bunch of Asparagus, Asparagus Spear*. Letters decorated with water-colours sent to Isabelle Lemonnier, Mme Guillemet and Méry Laurent
1881	At the Salon: *Portrait of M. Perthuiset* and *Portrait of Henri Rochefort* (awarded a medal). Antonin Proust becomes Minister of Fine Arts, Manet becomes Chevalier de la Légion d'honneur	*Portrait of Henri Rochefort, The Escape of Henri Rochefort, Portrait of th Child Henry Bernstein, My Garden* or *The Bench. A Bar at the Follies Bergère*, finished in 1882, *The Hat-Maker, Autumn*
1882	Health worsens. At the Salon: *A Bar at the Folies Bergère*. Stays at Rueil. Makes Duret his executor, leaving everything to Suzanne, and after her to Léon Leenhoff	*Spring, Portrait of Méry Laurent, Viennese Woman* or *Portrait of Irma Brunner, The House at Rueil, A Path in the Garden at Rueil, Pinks and Clematis in a Crystal Vase*
1883	Shows *Corner of Café-Concert* at the Beaux-Arts in Lyons. Francis Defeuille gives him lessons in miniature painting. Left leg amputated 20 April, dies 30 April. Buried at cemetery at Passy	

Artistic Life	History
...noir: *Esmeralda*. Fantin-Latour: *Homage to Delacroix*. Gleyre closes ...s studio. Offenbach: *La Belle Hélène*. Goncourt: *Germinie Lacerteux*. ...rth of Toulouse-Lautrec. Death of Meyerbeer	Laws on workers' assemblies. Florence replaces Turin as Italian capital. First Workers' International in London. Pasteur invents pasteurisation. Cadart founds the Artists' Union. Foundation of the Red Cross
...vis de Chavannes: *Ave Picardia Nutrix*. Bazille: *Studio in the rue ...rstenberg*. Tolstoy: *War and Peace*. Lewis Carroll: *Alice in Wonderland*. ...rth of Vallotton and Sérusier	Abolition of slavery in USA, Lincoln assassinated. Death of the Duc de Morny. Monnier invents reinforced concrete. Mendel establishes laws of genetic inheritance. Bunsen invents gas burner.
...onet: *Camille*. Renoir: *At Mother Antony's*. Degas: *Steeplechase Scenes*. ...audet: *Lettres de mon Moulin*. Offenbach: *La Vie Parisienne*. Birth of ...G. Wells	Failed assassination attempt on Alexander II. Economic crisis in London. Austro-Prussian War. First transatlantic telegraph cable. Nobel invents dynamite. First typewriter in United States
...omage to Millet at International Exhibition. Renoir: *Lise*. Gounod: ...meo and Juliet*. Karl Marx: *Das Kapital*. Ibsen: *Peer Gynt*. Death of ...udelaire and Ingres. Birth of Bonnard	Emperor Maximilian shot. Franz-Joseph crowned in Hungary. Tellier invents machine for refrigerating by compression. Lister introduces antiseptic methods in surgery. Birth of Marie Curie
...auguin embarks on a cruiser. Mussorgsky: *Boris Godunov*. Daudet: *Le ...tit Chose*. Death of Rossini. Birth of Gorky and Vuillard	Relaxation of laws on censorship. First trades unions congress in England. Mitsu-Hitu, Emperor of Japan, start of Meiji era. Jansen and Lockyer discover helium
...onet and Renoir: *La Grenouillère*. Carpeaux: *La Danse*. Hugo: *L'Homme ...i Rit*. Hartmann: *Philosophie de l'inconscient*. Death of Lamartine and ...erlioz. Birth of Matisse	Gambetta elected Deputy for Belleville. Opening of Suez Canal. Watt: first electric motor in USA. Completion of transcontinental railway in USA. Mendeleïev painting
...ntin-Latour: *Manet's Studio*. Renoir: *Women of Algiers*. Wagner marries ...osima Liszt. Dostoevsky: *The Possessed*. Death of Merimée, Lautréamont ...d Dickens. Birth of Maurice Denis	Victor Noir assassinated. Plebiscite on Napoléon III. War declared on 19 July. 1 Sept: defeat at Sedan. 4 Sept: Third Republic declared, siege of Paris. Rockefeller establishes Standard Oil. Birth of Lenin
...ezanne: *Melting Snow at l'Estaque*. Durand-Ruel exhibition in London. ...ola: *La Fortune des Rougons*. Rimbaud: *Le Bateau Ivre*. Verdi: *Aïda*. ...eath of Bazille. Birth of Rouault and Proust	The Commune, 'Bloody Week' (April). second siege of Paris. William I Emperor. Communards deported to New Caledonia. Algerian revolt. Rome becomes capital of Italy
...noir turned down at the Salon with *Parisian Women in Algerian ...ostume*. Carrier-Belleuse: *Portrait of M. Thiers*. Toulouse-Lautrec at the ...ée Condorcet. Bizet: *L'Arlésienne*	Meeting of the three emperors. Secret ballot becomes law in Britain. Beginning of *Kulturkampf* in Germany. Invention of bakelite. Vesuvius erupts
...erthe Morisot at the Salon for the last time. Bizet: *Carmen*. Rimbaud: ...e saison en enfer*. Jules Verne: *Round the World in Eighty Days*. Death ...Winterhalter. Birth of Colette, Edgar Faure, Jarry, Péguy	Napoléon III dies in England. Thiers resigns. Russians seize Khiva. Opera in rue Le Pelletier burns down. Agfa company founded. Maxwell develops electromagnetic theory of light
...rst Impressionist exhibition at Nadar's. Puvis de Chavannes decorates ...e Pantheon. Wagner: *Twilight of the Gods*. Alexandre Dumas Jr admitted ...Académie Française. Death of Michelet and Gleyre	Death of Guizot. Rochefort escapes. Law on child labour. Stanley crosses Africa from the west. Creation of universal postal system. Cantor establishes theory of matter. Birth of Churchill
...sley: *Snow at Marly-le-Roi*. Saint-Saëns: *Danse Macabre*. Viollet-le-Duc: ...atretiens sur l'architecture*. Death of Corot and Millet. Birth of Marquet ...d Rilke	Parliamentary system established. Birth of German Social Democratic Party. Opera re-established. Ascension of *Zenith* with three balloonists on board. Savorgnan de Brazza in the Congo
...mpressionist exhibition at Durand-Ruel's. Renoir: *Le Moulin de la ...ulette*. Degas: *Absinthe*. Building of the Sacré-Coeur. Tolstoy: *Anna ...arenina*. Death of Diaz and George Sand. Birth of Vlaminck	Queen Victoria becomes Empress of India. Left takes power in Italy. First workers' international ends. Alexander Graham Bell invents the telephone. Beau de Rochas and Otto invent the four-stroke engine
...ouguereau: *Vierge consolatrice*. Rodin: *The Age of Bronze*. Hugo: *La ...gende des siècles (2nd part)*. Zola: *L'Assommoir*. Saint-Saëns: *Samson ...d Delilah*. Death of Courbet. Birth of Van Dongen	Government resigns on 16 May, Chamber dissolved. Great Britain annexes the Transvaal. Revolt of Samurais in Japan. Education compulsory in Italy. Edison and Cros invent the phonograph
...ervex: *Rolla*. Tchaikovsky: *Eugene Onegin*. Nietzsche: *Man and ...uperman*. Rimbaud in Cyprus. Wilde finishes his studies at Oxford. ...ternational Exhibition. Death of Daubigny	Bismarck dissolves the Reichstag and bans the Socialist party. Death of Victor-Emmmanuel II in Italy. Election of Pope Léon XIII. Edison invents the electric light
...ourth Impressionist exhibition. Renoir: *Mme Charpentier and her ...ildren*. Carrière: *The Young Mother*. Death of Couture and Daumier. ...rth of Picabia and Klee	Jules Grévy becomes President. French workers' party constituted. Death of Imperial Prince Eugène Louis Napoléon in Zululand. Pasteur tests vaccination. Birth of Stalin, Trotsky and Einstein
...oreau: *Helen on the Ramparts of Troy*. Bartholdi: *The Lion of Belfort*. ...aupassant: *Boule de Suif*. Dostoevsky: *The Brothers Karamazov*. Birth of ...ollinaire and Derain. Death of Offenbach	'La Marseillaise' becomes national anthem, 14 July national holiday. Tahiti becomes a French colony. Creation of lycées for girls. Free primary education. Siemens invents first electric lift in New York
...vis de Chavannes: *The Poor Fisherman*. Renoir in Algeria. Seurat ...olves a theory of colour. Fauré: *Ballade*. Birth of Picasso, Léger and ...rtok. Death of Mussorgsky	Jules Ferry law on free education. Boulevards lit by electricity. Assassination of Alexander II. Freedom of the press established. Michelson experiments on speed of light
...ezanne accepted by the Salon. Rodin: *Bust of Carrier-Belleuse*. Fauré: ...quiem*. Zola: *Pot-Bouille*. Creation of Union des arts décoratifs with its ...wn museum in Paris. Birth of Braque, Giraudoux and Joyce	Building of Corinth Canal. British occupy Cairo. Koch discovers tuberculosis bacillus. Death of Gambetta and Garibaldi. Birth of Roosevelt
...histler: *Portrait of the Artist's Mother*. Exhibition of Japanese engravings ...the Petit Gallery. Nietzsche: *Thus Spake Zarathustra*. Death of Wagner ...d Gustave Doré. Birth of Kafka and Utrillo	Second Ferry government. Tonkin and Annam become French protectorates. Dion and Bouton produce steam cars. Krebs discovers diphtheria bacillus. Death of Karl Marx. Birth of Mussolini

Selected Bibliography

Mon Salon, M. Manet, Emile Zola. 1866. (Editions Hermann, 1966).

Edouard Manet: étude biographique et critique, Emile Zola. Paris, 1867.

Confessions of a Young Man, Moore. London, 1888.

Notes et souvenirs, De Nittis. Paris, 1895.

Histoire d'Edouard Manet et de son œuvre, Duret. Paris, 1902, 1906, 1919, 1926.

Edouard Manet, Tschudi. Berlin, 1902.

Manet: graveur et lithographe, Moreau-Nélaton. Paris, 1906.

Edouard Manet, Meier-Graefe, Munich, 1912.

Edouard Manet: Souvenirs, Proust. Paris, 1913.

Edouard Manet: sein leben und sein kunst, Waldemann. Berlin, 1923.

Manet: aquafortiste et lithographe, Rosenthal. Paris, 1925.

Lettres de jeunesse, Manet. Paris, 1929.

Manet: histoire catalographique, Tabarant. Paris, 1931.

Manet, Jamot, Wildenstein, Bataille. Paris, exposition 1932.

Une correspondance inédite d'Edouard Manet, Tabarant. Mercure de France. Paris, 1935.

L'Œuvre Gravé de Manet, Guérin. Paris, 1944.

Manet, Florisone. Monaco, 1947.

Manet: pastels, John Rewald. Oxford, 1947.

Manet et les impressionnistes au musée du Louvre, J. Leymarie. Paris, 1948.

Manet, Cooper. London, 1949.

Manet, Pierre Courthion & Pierre Cailler. La Guilde du livre. Lausanne, 1953.

Three Studies in Artistic Conception, Sandblad. Lund, 1954.

Manet and His Critics, Hamilton. London & New Haven, 1954.

Manet, G. Bataille. Lausanne, 1955, 1983.

La Vie de Manet, Henri Perruchot. Paris, 1959.

Edouard Manet, Coffin-Hanson. Philadelphia, 1966.

The Drawings of Edouard Manet, Leiris. Berkeley & Los Angeles, 1969.

Manet and Spain: Prints and Drawings, Isaacson. University of Michigan. Ann Arbor. 1969.

Manet: Tout l'œuvre peint, Denis Rouart. Flammarion, 1970.

L'Aveuglement devant la peinture, Pierre Daix. Gallimard, 1971.

Manet, Germain Bazin. Fratelli Fabbri Editori. Milan, 1974.

Edouard Manet. Catalogue raisonné, Rouart & Wildenstein. Lausanne/Paris, 2 vol, 1975.

Manet: peintre philosophe (a study of the painter's theme), Mauner. University Park (Pa). London, 1975.

Manet: Olympia, Reff. New York & London, 1976.

Manet: Dessins, aquarelles, eaux-fortes, lithographies, correspondance, Wilson. Huguette Berès. Paris, 1978.

Manet, Pierre Courthion. Editions du Cercle d'Art, 1978.

L'Impressionnisme et son époque, Sophie Monneret. Editions Denoël, 1978-9.

Manet et son temps, Pierre Schneider. Time-Life, 1981.

Edouard Manet: Paintings and Drawings, Richardson. London, 1958 & 1982.

Manet and Modern Paris, T. Reff. Washington, 1982.

Bonjour Monsieur Manet. Catalogue d'exposition, Centre G. Pompidou, Musée National d'Art Moderne, 1983.

La Vie de peintre d'Edouard Manet, Pierre Daix. Paris, 1983.

Manet: Catalogue d'exposition. F. Cachin, Ch. Muffett, Jiwilson Bareau. Editions de la Réunion des Musées Nationaux. Paris, 1983.

The Painting of Modern Life, Clarke, Thames & Hudson. London & New York, 1984.

Manet, Pierre Courthion. Harry N. Abrams. New York & Ars Mundi, 1985.

Les Dernières Fleurs de Manet, Robert Gordon & Andrew Forge. Editions Herscher. Paris, 1987.

Edouard Manet: voyage en Espagne, Wilson Bareau. L'Echoppe, 1988.

L'Impressionnisme, Herbert. Paris, 1988.

Manet, Eric Darragon. Librairie Arthème Fayard, 1989.

Manet. Catalogue d'exposition, Mikaël Wivel. Ordrupgaard. Copenhagen, 1989

Photographic Credits

Roger Viollet	5 (5), 8 (3), 28, 52, 62 (1), 71, 84, 85 (4), 87 (3), 95, 106 (1, 2), 109 (3), 139 (4), 145.
Photothèque des Musées de la Ville de Paris, SPADEM	4 (2, 3), 5 (6, 7), 8 (4), 9 (5, 7), 49 (6), 64 (1), 96 (5, 6), 97 (7, 8, 10, 11).
Fonds Nadar, Archives Photos Paris/SPADEM	2, 6 (2, 3), 7 (5, 6), 49 (7), 76 (2), 80 (1, 2), 96 (3, 4), 97 (9), 109 (2), 126, 134 (4), 140.
Bibliothèque Nationale, Paris	4 (1, 4), 6 (1), 8 (2), 9 (8, 10), 36, 43, 49 (4, 5), 58, 62 (3), 64 (2), 66 (2), 68, 69 (4), 76 (1, 3, 4), 96 (1, 2), 110, 121, 124 (5), 132 (1), 142 (3), 146 (2, 3).
Galerie Hopkins, Atelier 53	88, 92.
Droits réservés	142.